AT HOME WITH
JANE AUSTEN

Kim Wilson

AT HOME WITH JANE AUSTEN

Abbeville Press Publishers
NEW YORK · LONDON

First published in the United States of America
in 2014 by Abbeville Press, 137 Varick Street,
New York, NY 10013

First published in the United Kingdom in 2014
by Frances Lincoln, Frances Lincoln Limited,
74–77 White Lion Street, London N1 9PF

Library of Congress Cataloging-in-Publication Data

Wilson, Kim, 1959–
 At home with Jane Austen / Kim Wilson.
 — First edition.
 pages cm
 Summary: "With gorgeous photography and
illustrations, At Home with Jane Austen explores
Austen's world, her physical surroundings, and
the journeys the popular author took during her
lifetime"— Provided by publisher.
 ISBN 978-0-7892-1209-2 (hardback)
 1. Austen, Jane, 1775-1817. 2. Austen, Jane,
1775-1817—Homes and haunts. 3. Austen, Jane,
1775-1817—Friends and associates. 4. Novelists,
English—Homes and haunts—England. 5. Novelists,
English—19th century—Biography. 6. Literary
landmarks—England. I. Title.
 PR4036.W55 2014
 823 .7—dc23
 2014011182

First edition
10 9 8 7 6 5 4 3 2 1

For bulk and premium sales and for text adoption
procedures, write to Customer Service Manager,
Abbeville Press, 137 Varick Street, New York, NY
10013, or call 1-800-ARTBOOK.

Visit Abbeville Press online at www.abbeville.com.

TITLE PAGE Blush Noisette roses frame the
door to the historic kitchen at Chawton
Cottage, Jane Austen's House Museum.

PREVIOUS PAGE Columbines and Lady's
Mantle from the garden adorn a windowsill
at Chawton Cottage.

RIGHT Hampshire countryside.

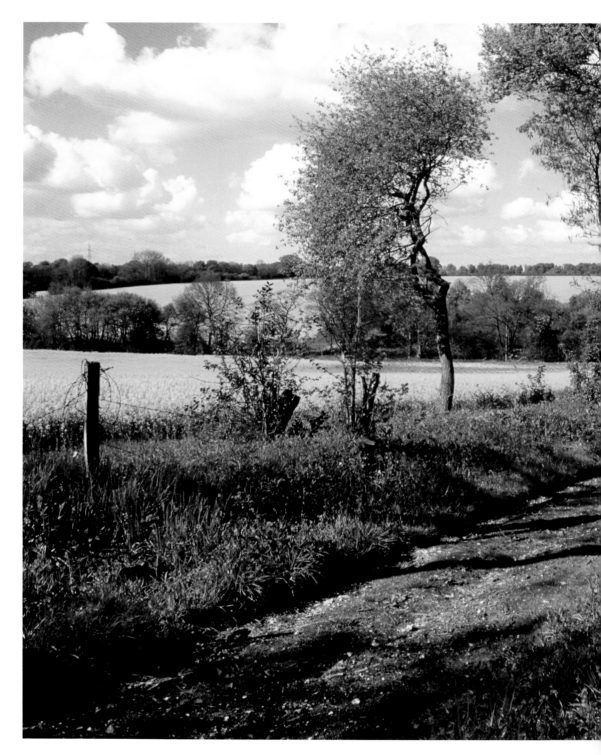

CONTENTS

FOREWORD

As a child I would walk past an Austen residence on my way to and from school. A small stone plaque hung on the wall, competing for attention with the polished brass nameplate of the current occupant. The brief inscription explained that a man called Francis Austen had once lived in the house, and more importantly, that he was the uncle of someone called Jane Austen. Prompted by this everyday engagement with a historic site, I looked up Jane's name and quickly realized why *she,* unlike her uncle, had required no introduction.

Given that bricks and mortar, not books, were my original way into the world of Jane Austen, it is a great pleasure to have Kim Wilson here to guide me through the range of homes known to the novelist in her lifetime. From grand mansions to village rectories, from temporary lodgings to country cottages, this insightful new book makes the relationship between Austen's social and domestic life and her writing ever more clear. Its chapters also remind us that while the author's addresses changed, the constant elements of her home life were provided by friends and family members, ink and paper for writing, books for reading and all the routine occupations of a woman in her position.

Writing this book has required much detailed research and sensitivity to the ways in which English domesticity and landscapes have changed since Jane's day. Each is delivered with a lightness of touch and Kim Wilson clearly relishes the opportunity to share this continuing history with us all. Whether you are a newcomer, or a longtime Austen devotee, this book cannot fail to encourage your own further exploration of her life, times, and work.

MARY GUYATT, CURATOR OF JANE AUSTEN'S HOUSE MUSEUM, CHAWTON

OPPOSITE Pencil and watercolor portrait of Jane Austen by Cassandra Austen, circa 1810.

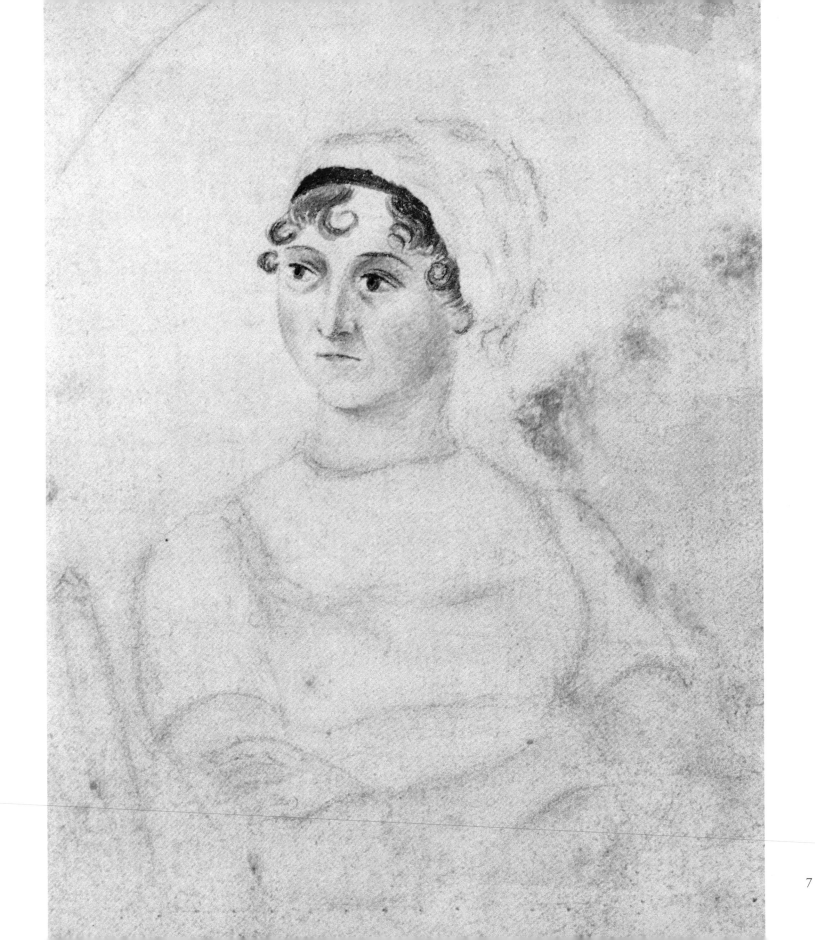

AT HOME WITH JANE AUSTEN

THE AUTHOR

I shall be very glad to see you at home again, and then… who will be so happy as we?
LETTER FROM JANE AUSTEN TO HER SISTER, CASSANDRA, JANUARY 22, 1799

Jane Austen is among the most widely read and beloved authors in English literature. Her novels vividly depict the society and world in which she lived with humor and sharp social commentary. Jane's own life and emotional experiences, deeply influenced by where she lived in Southern England and her travels to other parts of the country, are reflected in her works and in the importance of house and home to her characters. Although the Austens moved several times, from Steventon in the Hampshire countryside, to the cities of Bath and Southampton, and finally to Chawton in rural Hampshire again, Jane carried her own notion of home with her wherever she went. As one of a large, loving family, Jane neither needed nor depended on the outside world. Her home, a great-nephew noted, "was wherever her own people were, and whether at Steventon, Bath, or elsewhere, her cheerful temperament was even and unvaried, and assured her own happiness as well as that of those with whom she lived."

Her father's parsonage at Steventon in Hampshire gave Jane her love of country life. A spacious, old-fashioned building set in a quiet village near flower-filled meadows and ancient hedgerows, the parsonage provided a secure and peaceful home for Jane for the first 25 years of her life. The sunny garden, green terrace, and wood walks behind the house were favorite spots, and inspired scenes in several of her novels, especially *Northanger Abbey,* whose heroine also grew up at a country parsonage. Steventon, wrote her nephew, "was the cradle of her genius. These were the first objects which inspired her young heart with a sense of the beauties of nature. In strolls along those wood walks… fancies rose in her mind, and gradually assumed the forms in which they came forth to the world." Jane was the seventh of eight children, part of a warm, loving family who valued creativity and humor. With her family Jane read and enjoyed a wide variety of books. "Our family," she wrote, "are great novel readers and not ashamed of being so." The Austens put on family theatricals and wrote comic verse, and supported Jane enthusiastically when she showed early talent as a writer while still a teenager. Beginning when she was about twelve years old, Jane wrote many short stories, plays, and other pieces to amuse her family. As she grew older, she began to experiment with different forms of writing, including a novella, *Lady Susan.* It is thought that *Sense and Sensibility,* her first novel, then named *Elinor and Marianne,* started as an epistolary novel, as did *Pride*

OPPOSITE Morning Dress, from Ackermann's *Repository of Arts,* August 1813.

and Prejudice, which began as *First Impressions*. The first draft of *Northanger Abbey*, then called *Susan*, was also written at Steventon.

Her father's retirement to Bath in 1801, when Jane was 25 years old, brought a complete change of scene. Trading quiet country life for the bustle of the city, the Austens moved to a narrow, stone house near Sydney Gardens, and later, after the Reverend Austen's death, to a series of lodgings. No stranger to Bath, Jane had also visited the city as a young woman, providing a wealth of material she would later use in *Northanger Abbey* and *Persuasion*. Bath offered, as her heroine Catherine finds in *Northanger Abbey*, "a variety of amusements, a variety of things to be seen and done all day long… I do like it so very much… Oh! Who can ever be tired of Bath?" But the adult Jane may have shared the opinions of her heroine Anne Elliot in *Persuasion*, who "persisted in a very determined, though very silent disinclination for Bath." Certainly she seems not to have written much while in Bath, whether because she was busy or because she was unhappy or uninspired. But she revised *Susan* at Bath, and was able to place it with a London publisher in 1804, though he never did publish it. She began *The Watsons* about the same time, but put it aside indefinitely after completing just a few chapters.

Lengthy visits to the houses and mansions of friends and family and tours to other parts of England gave inspiration to Jane as well. Her brother Edward's houses at Chawton in Hampshire and Godmersham in Kent and the homes of other family and friends were models for the various country houses in *Pride and Prejudice, Sense and Sensibility, Mansfield Park,* and her other novels. Jane's love of the sea, born of numerous visits to seaside resorts such as Lyme Regis, and her residence at Southampton after leaving Bath, finds expression in *Persuasion,* whose characters stroll along the seashore, "as all must linger and gaze on a first return to the sea, who ever deserved to look on it at all." One of the few hints of romantic love in Jane's life was a meeting that took place, according to her niece, while on holiday on the shores of Devon.

Staying at her brother Henry's London houses for weeks while correcting the proofs of her novels exposed Jane to the busy, cosmopolitan city that plays such a crucial role in *Sense and Sensibility* and *Pride and Prejudice* and in the lives of the characters in several of her other novels. She made the most of her trips to London, combining business with rounds of social events, extensive shopping, and trips to the theater, valuing the opportunities that only a large city affords. "When I am in the country," says her character Mr. Bingley in *Pride and Prejudice,* "I never wish to leave it; and when I am in town it is pretty much the same. They have each their advantages, and I can be equally happy in either."

Jane returned to rural Hampshire in 1809 at the age of 33 when her brother Edward offered Jane, her mother and sister, and their friend Martha Lloyd a house he owned in Chawton. Chawton Cottage, Jane's last home, was a pleasant, roomy dwelling, improved by Edward to "a comfortable and ladylike establishment." The house most closely associated with Jane Austen as an author, Chawton Cottage provided her with an environment perfectly suited to her creative needs. There she revised *Sense and Sensibility, Pride and Prejudice,* and *Northanger Abbey,* and there wrote her last three novels, *Mansfield Park, Emma,* and *Persuasion,* and began *Sanditon,* which she laid aside only in the final months of her last illness.

Though Jane changed her residence many times, family and home remained the emotional center of her life. She expressed her love of home in her work, creating heroes and heroines who also cherish the idea of home, even when, like Fanny Price in *Mansfield Park,* they are uprooted and must learn to love a new one: "When [Fanny] had been coming to Portsmouth, she had loved to call it her home, had been fond of saying that she was going home; the word had been very dear to her; and so it still was, but it must be applied to Mansfield. *That* was now the home. Portsmouth was Portsmouth; Mansfield was home."

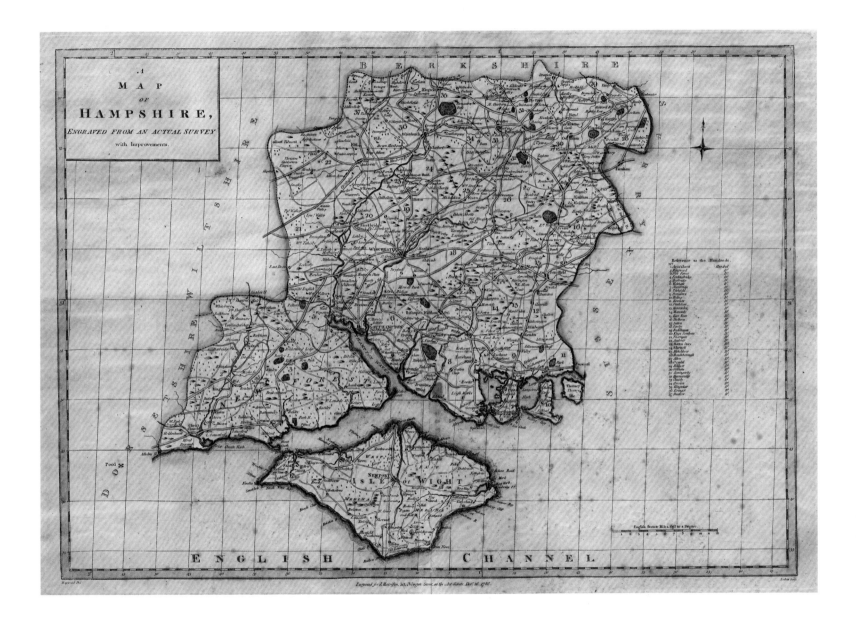

A Map of Hampshire Engraved from an Actual Survey with Improvements, by John Harrison, 1788.

THE AUTHOR

STEVENTON

There was nothing so charming to her imagination as the unpretending comfort of a well-connected parsonage. NORTHANGER ABBEY

Steventon Rectory, Jane Austen's birthplace and residence for her first 25 years, was located in the small, quiet village of Steventon, which lies nestled in the green Hampshire countryside some 55 miles southwest of London, near Basingstoke. Like her heroine Catherine Morland in *Northanger Abbey,* Jane was the daughter of the parish priest. Her father, the Reverend George Austen, was in charge of Steventon Parish and that of nearby Deane as well, thanks to the generosity of his relatives. With no wealth of his own, he was fortunate to have patrons: a distant cousin had given him the "living" of Steventon in 1761, and an uncle, who had paid for his education, had later given him the living of Deane in 1773. The living of Steventon came with the rectory to live in and glebe lands to help support the family. At that time, a rector had no specified salary; the mixture of farm income and tithes (usually ten percent of farm production in the parish) literally provided him with his living, which he held, once appointed, for his lifetime or until he resigned it. Mr. Austen's income wasn't large, but it was enough to enable him to marry the witty and attractive Miss Cassandra Leigh in 1764 and start a family.

They lived first at Deane, and their three eldest boys were born there. They moved to Steventon in the summer of 1768, with Mrs. Austen, who was not feeling well, making the two-mile journey over the rutted lanes atop a feather bed laid over their possessions in the cart.

Mrs. Austen, who grew up in the rich scenic loveliness of the area near Henley-on-Thames, had not been impressed with the scenery of the parish when she had viewed it shortly before her marriage. The beauty of the Steventon countryside is of a quiet and pastoral kind, with narrow lanes bordered by ancient hedgerows and grassy meadows. Jane Austen's nephew, James Edward Austen-Leigh, who grew up in the parsonage after Mr. Austen retired and James Edward's father took over as priest, wrote that the country around Steventon is "certainly not a picturesque country; it presents no grand or extensive views… the hills are not bold, nor the valleys deep… Still it has its beauties. The lanes wind along in a natural curve, continually fringed with irregular borders of native turf, and lead to pleasant nooks and corners… Of this somewhat tame country, Steventon, from the fall of the ground, and the

OPPOSITE St. Nicholas Church, Steventon, Hampshire, where George Austen, Jane Austen's father, was rector 1761–1805.

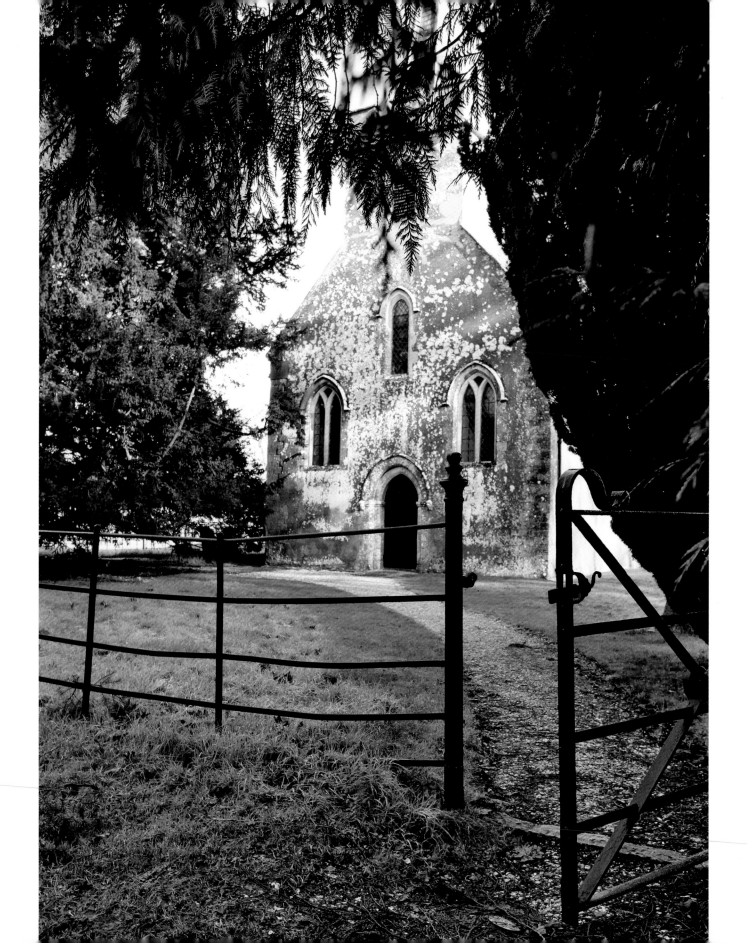

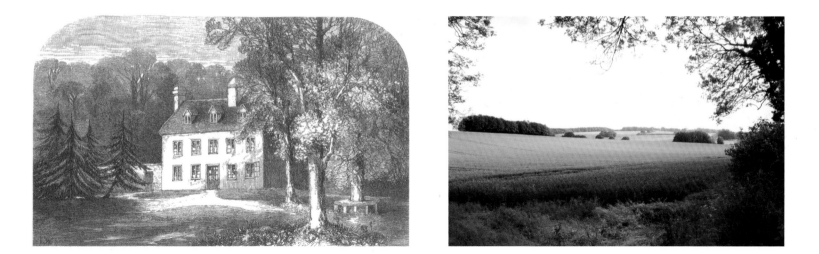

OPPOSITE The lane leading to St. Nicholas Church, where Jane Austen and her family regularly worshipped.
ABOVE LEFT Steventon Rectory, from *A Memoir of Jane Austen*, 2nd ed., 1871. ABOVE RIGHT Fields near the village of Steventon.
BELOW *Landscape with Cottages*, by James Ward, circa 1802–1827.

abundance of its timber, is certainly one of the prettiest spots." To this day the neighborhood remains quite rural in nature, with much of the surrounding countryside under cultivation or grazed.

Steventon village, which by the time Mr. Austen retired in 1801 had 20 houses and a mere 153 inhabitants, was laid out in a straggling line along the road. The Austens' parsonage stood somewhat removed from the end of the village, near the corner of Frog Lane and Church Walk, a shady track leading up the hill to Mr. Austen's church, St. Nicholas. The rectory, which dated to the late 17th century, was a spacious, square, whitewashed building with a tiled roof, casement windows, and two projecting wings at the back. Set amidst sloping meadows dotted with graceful elm trees, it faced the lane to the north, with a sweep (a semi-circular carriage drive) leading to the door. Behind the house, to the south, a walled garden rose to meet a row of spruce trees and a green terrace "of the finest turf," where perhaps the young Jane Austen, like Catherine Morland, "loved nothing so well in the world as rolling down the green slope at the back of the house." The house itself was above the average for parsonages at the time, James Edward noted, "but the rooms were finished with less elegance than would now be found in the most ordinary dwellings. No cornice marked the junction of wall and ceiling; while the beams which supported the upper floors projected into the rooms below in all their naked simplicity, covered only by a coat of paint or whitewash." The house, though old-fashioned, was a pleasant home for Jane and her siblings to grow up in. Certainly it had plenty of room. On the ground floor was an entrance parlor, where Mrs. Austen liked to sit and sew; a second parlor, used as a sitting room and as the dining room; two kitchens, one in front and one in back; and Mr. Austen's study, which overlooked the garden on the southern side of the house. Jane's niece Anna remembered the study fondly: "The lower bow-window, which looked so cheerfully into the sunny garden and up the middle grass walk bordered with strawberries, to the sundial at the end, was that of my grandfather's study, his own

ABOVE TOP Cottage in the village of Steventon.
ABOVE St. Nicholas Church.

exclusive property, safe from the bustle of all household cares." Upstairs were seven bedrooms (one of which was shared by Jane and her older sister, Cassandra) with three attics above them, space enough for the Austens and for the live-in pupils Mr. Austen took in to supplement his income.

By the time Jane was born on the wintry night of December 16, 1775, the rectory was filling up. Jane was the seventh of eight children. Her eldest brother, James (the father of James Edward Austen-Leigh, her biographer), was ten years old when she was born. After him came a new baby every year or two: George, Edward, Henry, Cassandra, Francis, then Jane, and finally Charles in 1779. Mrs. Austen nursed each baby for two or three months, and then, in a custom that seems odd and somewhat cruel today, but was common among the gentry then, the babies were weaned and sent to be cared for by a nearby village family, returning when they were a year or two old to the Austen household. Regardless of how it seems to the modern eye, it was a successful system as far as the health of the Austen children was concerned—all of them survived to adulthood, a rarity in those days. The Austens may have been a remarkably robust family, but undoubtedly the foster family they probably chose, the Littleworths, provided a wholesome life for the children with plenty of good farm food, fresh air, and exercise. Mr. and Mrs. Austen made a point of visiting their children often and the children were also brought to see them at the parsonage. The Littleworth family had close and friendly ties to the Austens for many decades, often working for them as valued servants. Nanny Littleworth, who worked as possibly a cook or dairymaid for the Austens, even filled in once in the capacity of lady's maid for Jane: "You and Edward will be amused, I think, when you know that Nanny Littlewart [a variant spelling] dresses my hair," Jane wrote to her sister. (November 25, 1798) Jane was later godmother to Nanny's eldest daughter.

One child could not remain at home. Poor little George suffered from epileptic fits, and may have been mentally disabled

ABOVE TOP *Night*, by Francis Wheatley, 1799.
ABOVE Detail, *Feeding the Ducklings*, by Thomas Rowlandson, undated.

and possibly deaf as well. The Austens arranged for him to be cared for permanently by another family, again a practice that seems cruel by modern standards, but which was considered tolerable or even kind in the 18th century. The mentally disabled and insane were often abandoned or warehoused in horrible conditions. The Austens, by placing George permanently with a foster family, were acting according to the accepted standards of the time. They paid for his care until he died at the age of 72, but he never returned to his family. It's possible that they may have visited him, although he is not mentioned in family letters. Jane wrote once of talking to a deaf man "with my fingers," which she may have learned from talking to George.

While the Austens were a close-knit and affectionate family, one gets the impression that the brothers and sisters were closer to each other than they were to their parents, as is often the case in large families, where the parents are kept busy by the demands of the large household and the children find their amusement and comfort from each other. Jane wrote of a similar family in *Northanger Abbey,* the Morlands, who had ten children: "Mrs. Morland was a very good woman, and wished to see her children everything they ought to be; but her time was so much occupied in lying-in and teaching the little ones, that her elder daughters were inevitably left to shift for themselves." Mrs. Austen would have been very busy, taking care not only of the children, but also managing the household, the garden, the poultry yard, the dairy, the extra pupils that Mr. Austen took in, and the servants. It has been estimated that over the years the Austens could have had from nine to twenty or more people living in their household at any given time, including Mr. and Mrs. Austen, those children living at home, young visiting scholars, and servants.

Like many gentlemen of the time, Mr. Austen took a personal hand in the management of his farms, assisted by his steady, middle-aged bailiff (farm manager), John Bond. The soil around Steventon was not rich; most of the acreage seems to have been woodland and pasture. Mr. Austen raised sheep, which a friend praised as "the finest that was ever ate," some pigs, and a few cows, probably for milk for Mrs. Austen's dairy. Like Mr. Austen, the area farmers raised mostly sheep and a few pigs, but also grew wheat, barley, and oats, a few acres of turnips, rapeseed, peas, and a tiny amount, 1½ acres in the whole parish, of potatoes, some of which were cultivated at the rectory. Mrs. Austen grew potatoes, which were a relatively recent import from the New World, but they were slow to be accepted in the village. There is an Austen family tradition that Mrs. Austen tried to convince a local woman to grow potatoes in her garden, but she replied, "No, no; they are very well for you gentry, but they must be terribly *costly to rear.*"

The Austens, like most country families, grew a great deal of their own food. The garden, said Jane's nephew James Edward, was "one of those old-fashioned gardens in which vegetables and flowers are combined." Her niece Anna remembered well "the square walled-in cucumber garden," with its cucumber frames, and cherry and other fruit trees trained to its walls. Mrs. Austen relished gardening, growing not only potatoes, vegetables and fruit, but also herbs and flowers, including marigolds. According to Anna, a well stood in the garden; this may be the well that is the only remnant of the parsonage left today, though this is not clear. A villager who was Nanny Littleworth's grandson, and whose father had worked for James Austen, later reported to a visitor to Steventon that the pump for the well was in the washhouse behind the house. A variety of outbuildings stood in the yard, mostly to the west of the rectory. In addition to the washhouse, there was a garden tool house, a granary, a brewhouse, and a barn, where the Austen children held theatricals. Mrs. Austen raised turkeys, chickens, ducks, and guinea fowl in her poultry yard, and Cassandra kept bees for honey and mead.

Mrs. Austen probably had some of the servants help her take care of the large kitchen garden. The Austen servants were expected to help not only in the house, but often with a variety of other tasks

ABOVE TOP "One of those old-fashioned gardens in which vegetables and flowers are combined" at Chawton House Library.
ABOVE An 18th-century-style garden frame for cucumbers and melons at Gilbert White's House, Selborne, Hampshire.

as needed, from cooking to sewing to working in the dairy. After doing without a maid for some time in 1798, Jane was pleased to report to Cassandra that a new one had been hired: "We are very much disposed to like our new maid; she knows nothing of a dairy, to be sure, which, in our family, is rather against her, but she is to be taught it all. In short, we have felt the inconvenience of being without a maid so long, that we are determined to like her, and she will find it a hard matter to displease us. As yet, she seems to cook very well, is uncommonly stout, and says she can work well at her needle." (December 1, 1798)

The Austens made a great many improvements to the rectory and its grounds, no doubt providing inspiration for the characters of the many parsons busily improving their properties in Jane Austen's novels. In *Emma*, the "old and not very good" vicarage has been "very much smartened up by the present proprietor," Mr. Elton. In *Sense and Sensibility*, Elinor and Edward "chuse papers, project shrubberies, and invent a sweep." Henry Tilney plants a shrubbery that delights Catherine Morland in *Northanger Abbey*. In *Mansfield Park*, the parsonage at Mr. Rushworth's estate is merely "a tidy looking house," but Edmund Bertram plans to move the farmyard at his own parsonage so that it will look more like a gentleman's house. Doctor and Mrs. Grant do their best to turn Mansfield Parsonage into a fashionable abode, filling Mrs. Grant's "favourite sitting-room with pretty furniture" and planting a shrubbery:

"This is pretty, very pretty," said Fanny, looking around her as they were thus sitting together one day; "every time I come into this shrubbery I am more struck with its growth and beauty. Three years ago, this was nothing but a rough hedgerow along the upper side of the field, never thought of as anything, or capable of becoming anything; and now it is converted into a walk, and it would be difficult to say whether most valuable as a convenience or an ornament... There is such a quiet simplicity in the plan of the walk! Not too much attempted!"

LEFT *The Feather'd Fair, Feeding the Feather'd Fowl*, 1783. MIDDLE *Sara Hough, Mrs. T. P. Sandby's Nursery Maid*, by Paul Sandby, circa 1805. RIGHT *Gardening: a man digging in a walled garden*, undated.

"Yes," replied Miss Crawford carelessly, "it does very well for a place of this sort. One does not think of extent here; and between ourselves, till I came to Mansfield, I had not imagined a country parson ever aspired to a shrubbery, or anything of the kind."
MANSFIELD PARK

The Austens made one improvement to Steventon Rectory of special importance to Jane and Cassandra. In 1795, when Jane was nineteen and Cassandra was 22, a bedroom above the dining room was converted into a pleasant sitting room. The Austens' account with a local house furnisher records their purchase of blue wallpaper, blue-and-white striped curtains, Scotch carpet (an inexpensive pileless carpet with a reversible pattern), and the construction of a built-in bookcase painted chocolate brown. "This room, the Dressing room, as they were pleased to call it, communicated with one of smaller size where my two Aunts slept,"

niece Anna later recalled. "I remember the common-looking carpet with its chocolate ground that covered the floor… A painted press, with shelves above for books, that stood with its back to the wall next the Bedroom, & opposite the fireplace; my Aunt Jane's Pianoforte—& above all, on a table between the windows, above which hung a looking glass, 2 Tonbridge-ware work boxes of oval shape, fitted up with ivory barrels containing reels for silk, yard measures, etc… But the charm of the room, with its scanty furniture and cheaply papered walls, must have been, for those old enough to understand it, the flow of native homebred wit, with all the fun & nonsense of a clever family who had but little intercourse with the outer world."

Jane took a keen interest in the family's plans for the grounds at Steventon Rectory. "Our Improvements have advanced very well," she wrote to Cassandra, who was visiting their brother Edward. "The Bank along the Elm Walk is sloped down for the

AT HOME WITH JANE AUSTEN

reception of Thorns & Lilacs; & it is settled that the other side of the path is to continue turf'd & be planted with Beech, Ash, and Larch." (October 26, 1800) The "Elm Walk" was a rustic shrubbery, complete with occasional seats and a maypole with a weathercock near the gate to the walk. At the eastern end of the terrace behind the garden a path, the "Church Walk," ran up the hill to the church between hedgerows, Jane's nephew James Edward reported, under whose shelter "the earliest primroses, anemones, and wild hyacinths were to be found." Many of the prized elms were lost in a great windstorm in November 1800, which Jane reported with dismay to Cassandra:

I was sitting alone in the dining-room, when an odd kind of crash startled me… I then went to the window, which I reached just in time to see the last of our two highly valued Elms descend into the Sweep!!!!! The other, which had fallen, I suppose, in the first crash, & which was the nearest to the pond, taking a more easterly direction, sunk amongst our screen of Chesnuts & firs, knocking down one spruce fir, beating off the head of another, & stripping the two corner chesnuts of several branches in its fall.—This is not all—One large Elm out of the two on the left hand side, as you enter what I call the Elm walk, was likewise blown down, the Maypole bearing the weathercock was broke in two, & what I regret more than all the rest, is that all the three Elms which grew in Hall's meadow, & gave such ornament to it, are gone; two were blown down, & the other so much injured that it cannot stand.
(NOVEMBER 9, 1800)

Up the lane from the site of the rectory is St. Nicholas, The Reverend Austen's small, picturesque church that dates to around 1200 A.D. The church still stands, not greatly altered from the days when the Austens worshiped there, except for a spire tacked onto the bell tower in Victorian times and some alterations to the interior decorations. On either side of the door are two carved medieval stone faces, one male and one female. There are three mass clocks, which act as sundials, scratched in the stone, as well as a cross scratched in the stone to the left of the door, possibly a crusader's cross. In recent years, restoration has uncovered some early features, including painting on the plaster walls. Most of the painting is thought to be Victorian, but some small areas of medieval painting have also been uncovered. There are several memorials to members of the Austen family in the church, including a brass plaque in honour of Jane Austen. Surrounding the church is the churchyard, filled with crumbling, lichen-covered headstones attesting to the many generations of Steventon villagers buried there, including James Austen and his wife Mary. The enormous yew tree to the left of the front door of the church may be nearly as old as the church itself and must already have been an impressive size when Jane and her family worshiped there. The trunk is too big around to span. In the Austens' day, the heavy key to the church was kept in a hollow of the tree, but it has since disappeared and a replacement had to be made.

The Austen family was fairly self-sufficient when it came to entertaining themselves. All agreeable, intelligent, and fond of each other, they could be excused, James Edward Austen-Leigh wrote, "if they were inclined to live somewhat too exclusively" within their family circle. The children had excellent examples in their parents. Mrs. Austen, a practical woman and an excellent housekeeper, was also intelligent and witty. Some of Jane's love of the ridiculous must have come from her mother, who appreciated absurdities and enjoyed writing humorous doggerel verse. Mr. Austen was a thoughtful and literary man whose personal library contained over 500 books. In addition to the excellent education he provided, he encouraged his children, including the girls, to read widely. The family often read aloud to each other, and Mr. Austen was particularly skilled at it, a skill Jane inherited. "She was a very sweet reader," recalled a friend later. The Reverend Mr. Collins in *Pride and Prejudice* starts back in horror when offered a novel

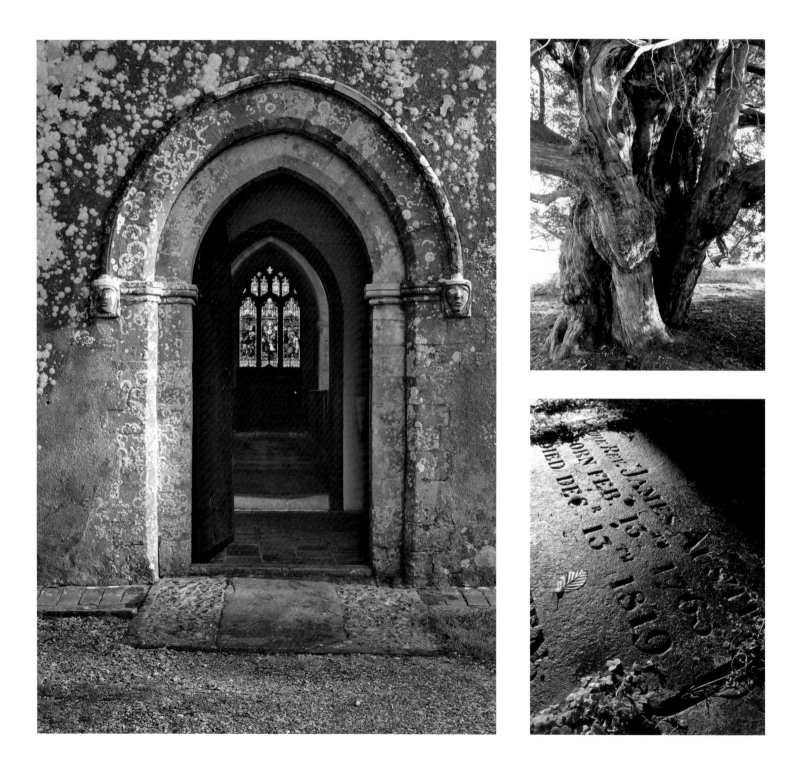

ABOVE LEFT Entrance to St. Nicholas Church. ABOVE RIGHT TOP Ancient yew tree near the entrance to St. Nicholas Church.
ABOVE RIGHT The gravestone of Jane Austen's brother James, who was curate (1801–1805) then rector of Steventon until his death in 1819.

AT HOME WITH JANE AUSTEN

ABOVE LEFT TOP Carved medieval heads mark the entrance to St. Nicholas Church.
ABOVE LEFT AND RIGHT Interior of St. Nicholas Church.

STEVENTON

ABOVE LEFT *Tales of Wonder!* by James Gillray, 1802.

to read, but "our family," Jane wrote, "are great Novel-readers, & not ashamed of being so." (18 December 1798) The Austens also enjoyed charades and putting on amateur theatricals. Jane wrote several absurd pieces when she was a teenager for the family to act.

Outside of the family, the Austens enjoyed a busy social life, mixing with the local gentry and the inhabitants of the great houses and rectories near Steventon. The Austens' "circle of society" was small, Jane's nephew wrote in his *Memoir:* "yet she found in her neighbourhood persons of good taste and cultivated minds." Among the many families who were friends with the Austens were

the Digweeds, who rented Steventon Manor, the Lefroys, who lived at Ashe Rectory, and the Lloyds, who rented Deane Rectory from the Austens for several years. The Lloyds then moved nearly fifteen miles away to Ibthorpe, but Mary and Martha Lloyd remained friends with the Austens for the rest of their lives. Mary Lloyd married James Austen after his first wife died. Jane and Cassandra were particularly close to Martha Lloyd; she eventually shared a household with them and ultimately married Francis Austen as his second wife when she was 62.

Jane and her family would often walk on their visits if the

ABOVE TOP *Tickford Park—Dinner waiting at a Neighbour's house*, by Diana Sperling, 1816.
ABOVE *Papering the saloon at Tickford Park*, by Diana Sperling, 1816.

STEVENTON

25

distance was only a mile or two. "We have been exceedingly busy ever since you went away," she wrote to Cassandra, "we have been obliged to take advantage of the very delightful weather ourselves by going to see almost all our neighbours. On Thursday we walked to Deane, yesterday to Oakley Hall and Oakley, and today to Deane again… This morning we called at the Harwoods." (October 25, 1800) Jane and Cassandra also walked regularly to the Wheatsheaf Inn, a coaching inn dating to the 18th century, to collect the family's mail and post letters. The inn, which still stands, is near North Waltham, where Popham Lane meets the Winchester Road. If Jane and Cassandra had walked only in the lanes, the walk was 2½ miles from the Rectory, or nearly three if they walked through Steventon on errands first. But if they walked cross-country like Lizzie Bennett in *Pride and Prejudice,* "crossing field after field at a quick pace, jumping over stiles and springing over puddles with impatient activity," the walk was approximately two miles. The lanes were hardly better than the paths; narrow, often mere muddy tracks with deep cart ruts, they were just as likely to cause "weary ankles [and] dirty stockings." To keep their shoes up out of the mud, Jane and Cassandra wore pattens, metal rings that slipped over the shoe. Remnants of pattens have found in the field where the rectory once stood.

Jane was particularly fond of dancing. The Austen girls often had the opportunity to attend balls at some of the local great houses and at the Basingstoke assemblies. She reported on one ball, attended when she was 23, "There were twenty Dances, & I danced them all, & without any fatigue.—I was glad to find myself capable of dancing so much & with so much satisfaction as I did… in cold weather & with few couples I fancy I could just as well dance for a week together as for half an hour.—My black Cap was openly admired by Mrs Lefroy, & secretly I imagine by every body else in the room." (December 24, 1798) Two years later she attended another assembly at Basingstoke and was pleased with

the dancing, but not as much with the men: "Charlotte & I did my hair, which I fancy looked very indifferent; nobody abused it, however, & I retired delighted with my success.—It was a pleasant Ball, & still more good than pleasant, for there were nearly 60 people, & sometimes we had 17 couple… There was a scarcity of Men in general, & a still greater scarcity of any that were good for much.—I danced nine dances out of ten, five with Stephen Terry, T. Chute & James Digweed & four with Catherine.—There was commonly a couple of ladies standing up together, but not often any so amiable as ourselves." (November 1, 1800)

Such pleasant days came to an end when Mr. Austen decided to retire to Bath in 1801. The decision came as a shock to Jane, who was greeted with the news on her return from a visit to the Lloyds' at Ibthorpe. A family tradition, which has led to a great deal of discussion and disagreement over the years, states that she was so upset that she fainted. Whether or not it was true, it is clear that Jane was not eager to trade peaceful Steventon for the noisy, smoky city of Bath. One of her characters in her spoof "Love and Freindship [sic]," written when she was a teenager, had warned against leaving the countryside: "Beware my Laura (she would often say) Beware of the insipid Vanities and idle Dissipations of the Metropolis of England; Beware of the unmeaning Luxuries of Bath and of the stinking fish of Southampton… Ah! little did I then think I was ordained so soon to quit that humble Cottage for the Deceitfull Pleasures of the World." But by January 3 of 1801 she was writing, "I get more & more reconciled to the idea… We have lived long enough in this Neighborhood."

The site of Jane Austen's birthplace is now a field where dairy cows graze peacefully, but traces of the rectory, pulled down due to flooding not long after Jane's death, could still be seen for many years after its demolition. As late as 1883 a gentleman who lived in Steventon reported that until recently "garden flowers used to bloom every season in the meadow where it formerly stood."

OPPOSITE Site of the demolished Steventon Rectory, with the new rectory, built after Jane Austen's death, in the distance.
A little triangular fence marks the spot where the Austens' well stood, near a fine, tall lime, or linden, tree planted by James Austen in 1813.

A Village Day School, 1804.

AT HOME WITH JANE AUSTEN

AWAY AT SCHOOL

*The letter which I have this moment received from you has diverted me beyond moderation.
I could die of laughter at it, as they used to say at school.*

LETTER FROM JANE AUSTEN TO HER SISTER, CASSANDRA, SEPTEMBER 1, 1796

Sometime in March of 1783, ten-year-old Cassandra Austen and her cousin, twelve-year-old Jane Cooper, the daughter of Mrs. Austen's sister, were sent to school at the Oxford home of Ann Cawley, Mr. Cooper's widowed sister. With them went little Jane Austen, just seven years old. Why the Austens sent the girls to school is unclear—Mr. Austen was a superb educator and there was no apparent need from an educational point of view. It's possible that the Austens wanted extra room at the Rectory for Mr. Austen's pupils, or perhaps they thought Cassandra, as a gentleman's daughter, would benefit by picking up a little social polish at the school, and Jane simply wouldn't be separated from her sister. Like the Musgrove sisters in *Persuasion*, the older girls at least would have been expected to acquire "all the usual stock of accomplishments," not necessarily academic ones, but social graces such as Miss Bingley lists in *Pride and Prejudice*: "A woman must have a thorough knowledge of music, singing, drawing, dancing, and the modern languages, to deserve the word; and besides all this, she must possess a certain something in her air and manner of walking, the tone of her voice, her address and expressions, or the word will be but half-deserved." A woman's accomplishments enhanced her chances that she would marry well. "Give a girl an education and introduce her properly into the world," says Mrs. Norris in *Mansfield Park*, "and ten to one but she has the means of settling well." It is unknown whether Mrs. Cawley was up to fulfilling such high expectations; certainly subsequent events would prove that she had poor judgment.

In the summer Mrs. Cawley, for unknown reasons, and without telling the girls' parents, moved with her pupils to Southampton, a port city on the south coast of Hampshire. They arrived just in time for a typhus outbreak. Typhus, often called jail fever, war fever, or camp fever, is an often-fatal bacterial disease spread by lice. As its nicknames suggest, it is associated with overcrowded, filthy conditions such as those prevailing in prisons and ships, and outbreaks in port cities were common. It is easily spread from person to person, either by the bite of the louse, or merely by contact with its feces. The symptoms of typhus are high fever, a bad cough, severe headaches, wracking muscle and joint pain, and sometimes delirium and coma, followed by death from cardiac failure. The outbreak spread rapidly through the city; Jane Cooper, Cassandra, and little Jane soon became infected and very ill. Nevertheless, Mrs. Cawley failed to notify the Coopers and the Austens. Jane Cooper was able to send a message to her

mother, who traveled hastily to Southampton with Mrs. Austen and removed the girls from Mrs. Cawley's negligent care. The girls slowly recovered, but tragically, Mrs. Cooper became infected and died the following month.

The next summer, the bereaved Mr. Cooper sent his now-motherless son and daughter to school. Edward went to Eton, and thirteen-year-old Jane to the Ladies Boarding School in Reading, an event that Jane Austen must have recollected years later when she wrote about motherless Georgiana Darcy being sent to school in *Pride and Prejudice,* and about Anne Elliot's similar experience in *Persuasion*: "Anne had gone unhappy to school, grieving for the loss of a mother whom she had dearly loved, feeling her separation from home, and suffering as a girl of fourteen, of strong sensibility and not high spirits, must suffer at such a time."

Apparently Mr. Cooper was satisfied with the school, for Jane Cooper not only continued to stay, but was joined the following summer, in 1785, by Cassandra and Jane Austen. Cassandra was twelve years old and Jane only nine. The Austens weren't sure whether Jane was old enough yet to benefit from additional schooling, but as before, Jane refused to be separated from Cassandra. "She would have been miserable without her sister," said her nephew James Edward in his *Memoir.* His sister Anna remembered Mrs. Austen saying that "it was her own doing; she *would* go with Cassandra; if Cassandra's head had been going to be cut off Jane would have her's cut off too."

The Reading Ladies Boarding School may have been the inspiration for Mrs. Goddard's "real, honest, old-fashioned Boarding school," which Harriet Smith attends in *Emma*:

Mrs. Goddard was the mistress of a School—not of a seminary, or an establishment, or any thing which professed, in long sentences of refined nonsense, to combine liberal acquirements with elegant morality, upon new principles and new systems—and where young ladies for enormous pay might be screwed out of health and

into vanity—but a real, honest, old-fashioned boarding-school, where a reasonable quantity of accomplishments were sold at a reasonable price, and where girls might be sent to be out of the way, and scramble themselves into a little education, without any danger of coming back prodigies.

The Austen sisters, like Harriet, held the special status of "parlour boarder." Mr. Austen paid £35 per girl each year, which was more than double what ordinary boarding students were charged. The extra fees brought extra privileges, among them taking tea and

AN

ACCOUNT

OF THE

JAIL FEVER,

OR

TYPHUS CARCERUM:

AS IT APPEARED AT CARLISLE IN THE YEAR 1781.

BY JOHN HEYSHAM M.D.

Principiis obsta ; sero medicina paratur, Cum mala per longas invaluere moras.
Ovid.

LONDON:

PRINTED FOR T. CADELL, J. MURRAY, R. FAULDER, AND J. MILLIKEN, BOOK-SELLER, CARLISLE. M.DCC.LXXXII.

A screen in cloth-work stood in a corner, and there were several miniatures over the lofty mantelpiece," a scene very reminiscent of Mrs. Goddard's parlor in *Emma*.

Sarah Latournelle had been born plain Esther Hackett. She had come to the school as the French language teacher (though Mrs. Sherwood claimed she "never could speak a word of French"), and took over when the earlier proprietress died, at some point deciding that "Latournelle" was a more fitting name for the owner of a fine girls' school. She was socially well connected, but not a particularly refined or educated woman, according to Mrs. Sherwood:

Mrs. Latournelle was a person of the old school, a stout woman, hardly under 70, but very active, although she had a cork leg. But how she lost its predecessor she never told. Hers was only an everyday, common mind, but a very useful one; for tea must be made, and dinners ordered, or a house would soon tumble to pieces without these very useful every day kind of people.

Jane Austen must have remembered Mrs. Latournelle fondly, for there is kindness in her description of the similar school owner in *Emma*:

[Mrs. Goddard] was a plain, motherly kind of woman, who had worked hard in her youth, and now thought herself entitled to the occasional holiday of a tea-visit; and having formerly owed much to Mr. Woodhouse's kindness, felt his particular claim on her to leave her neat parlour, hung round with fancy-work whenever she could, and win or lose a few sixpences by his fireside.

The Ladies Boarding School was located in Reading, in the Abbey Gate, a remnant of the ruined abbey there, and in a large attached two-story building with attics above. "The best part of the house was encompassed by a beautiful old-fashioned garden," Mrs. Sherwood remembered, "where the young ladies were allowed to

supper with the owner, Mrs. Latournelle, in her parlor. Most of the current knowledge of the experiences the Austen girls might have had at the school comes from the reminiscences of another student, Mary Butt, who attended the school not long after the Austens had left. Mary, who became the celebrated author Mrs. Sherwood, described the school in terms very evocative of the fictional Mrs. Goddard's school, lending weight to the probable source of Jane Austen's inspiration. She remembers Mrs. Latournelle welcoming her as a new pupil, "in a wainscotted parlour, the wainscot a little tarnished, whilst the room was hung round with chenille pieces, representing tombs and weeping willows.

OPPOSITE Title page of *An Account of the Jail Fever or Typhus Carcerum*, by John Heysham, 1782. ABOVE *Les Deux Ami (The Two Friends)*, by John Raphael Smith, 1778.

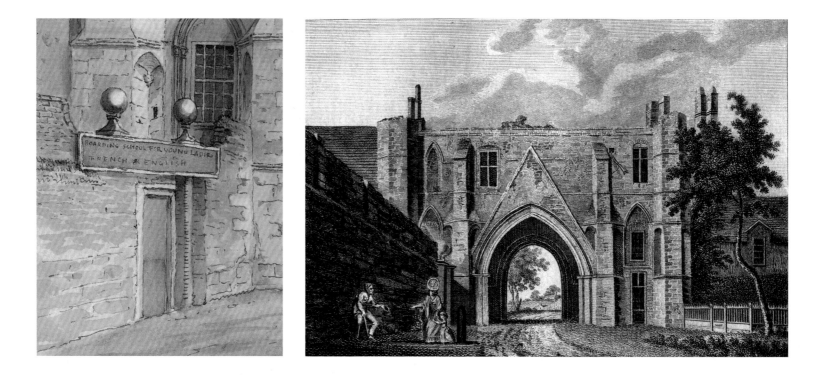

LEFT Detail, *The Gatehouse, Reading Abbey,* by Samuel Hieronymus Grimm, undated. RIGHT Reading Abbey, 1784.

wander, under tall trees, in hot summer evenings; whilst around two parts of this garden was an artificial embankment, from the top of which we looked down upon [the] magnificent ruins." Upstairs there were dormitories, each holding four to six beds, in which the students (60 or 70 girls when Mrs. Sherwood attended) slept two to a bed. Downstairs lay the main rooms, including the schoolroom, where morning prayers and lessons were held and where the students took breakfast and dinner. There was a large ballroom where the students practiced dancing and which was sometimes fitted up as a theater "with foot-lights and everything else complete" for the girls to act out plays. Mrs. Latournelle may have had some prior connection to the theater; she had a large fund of stories about actors and the behind-the-scenes life of the theater that she was fond of sharing whenever she got the chance.

It is not clear what subjects Jane and Cassandra studied at the school, nor which of their accomplishments were attributable to their formal schooling and which to the education available to them at home. In addition to French and dancing, Mrs. Sherwood mentions "music, drawing, writing, needle-work, speaking," as "every kind of accomplishment taught to girls," but doesn't stress a more academic education. As adults, Jane and Cassandra would certainly have been considered accomplished in the sense that Charles Bingley mentions in *Pride and Prejudice*: "It is amazing to me," said Bingley, "how young ladies can have patience to be so very accomplished as they all are… They all paint tables, cover screens, and net purses. I scarcely know anyone who cannot do all this, and I am sure I never heard a young lady spoken of for the first time, without being informed

that she was very accomplished." Jane and Cassandra read French fluently and some Italian, too. Cassandra drew well, and Jane played the piano and embroidered beautifully. But they were also very knowledgeable in history and literature, which was due no doubt to Mr. Austen's teaching and to his encouragement that they read widely.

By the spring of 1786, Mr. Austen's finances were in poor enough shape that he reduced Cassandra and Jane from their status as parlor boarders to regular boarders, and in December removed them from the school for good. Jane and Cassandra were left to a home education, like the Bennet sisters in *Pride and Prejudice*: "Such of us as wished to learn never wanted the means. We were always encouraged to read, and had all the masters that were necessary. Those who chose to be idle, certainly might." The Austen sisters grew up well educated and accomplished in every sense of the word; clearly they were not idle.

Dr. Syntax Visits a Boarding School for Young Ladies, by Thomas Rowlandson, 1821.

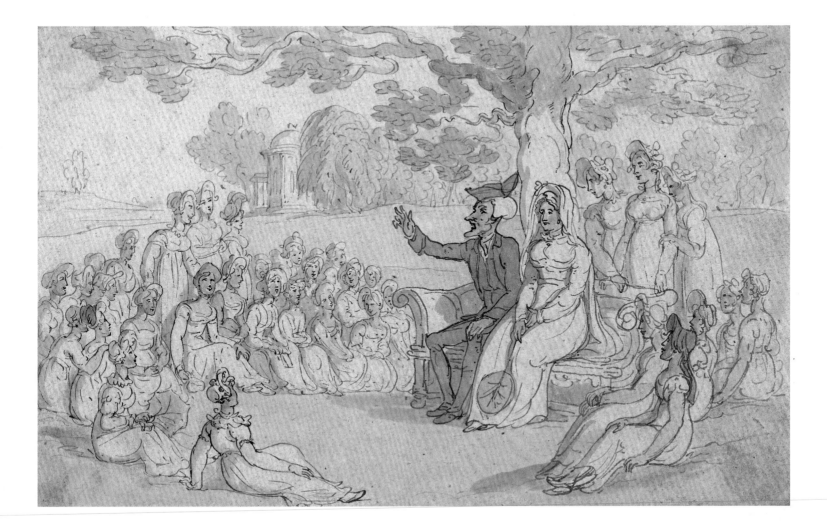

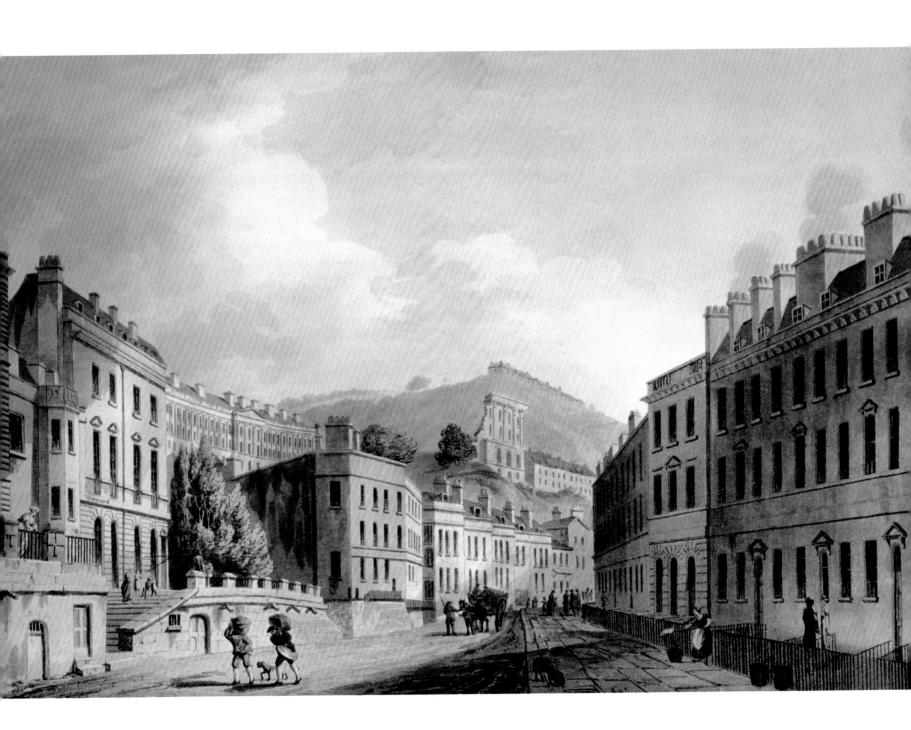

ABOVE *Axford & Paragon Buildings* from *Bath Illustrated by a Series of Views*, by I. Hill after Jean Claude Nattes, 1806.
OPPOSITE Title page of *The New Bath Guide*, by Christopher Anstey, 1807.

AT HOME WITH JANE AUSTEN

BATH

Before moving to Bath in 1801 on her father's retirement, Jane Austen had visited the fashionable spa town at least twice as a young woman. Her experiences inspired many of the scenes in *Northanger Abbey* (then called *Susan*), which she began writing following her first visit. In November 1797, Mrs. Austen, Cassandra, and 21-year-old Jane traveled to Bath to see if the famous mineral waters there would improve Mrs. Austen's health. They stayed for a month at No. 1 Paragon Buildings with Mrs. Austen's wealthy brother James Leigh-Perrot and his wife, Jane, joining the throngs of other visitors who came for their health or merely for amusement:

No place in England, in a full season, affords so brilliant a circle of polite company as Bath. The young, the old, the grave, the gay, the infirm, and the healthy, all resort to this place of amusement… The constant rambling about of the younger part of the company is very enlivening and cheerful. In the morning the rendezvous is at the Pump-Room;— from that time 'till noon in walking on the Parades, or in the different quarters of the town, visiting

the shops, etc;—thence to the Pump-Room again, and after a fresh strole, to dinner; and from dinner to the Theatre (which is celebrated for an excellent company of comedians) or the Rooms, where dancing, or the card-table, concludes the evening. —
THE NEW BATH GUIDE, OR, USEFUL POCKET COMPANION, 1799

Mr. Leigh-Perrot, like Mr. Allen in *Northanger Abbey*, visited Bath "for the benefit of a gouty constitution." For those who came to Bath for their health, there were hot baths to ease rheumatic joints and skin diseases, and at the Pump Room they could drink a glass of hot spring water with "a fine sulphureous steely taste" while listening to a small chamber orchestra. In *Northanger Abbey*, young Catherine Morland is more interested in meeting her friends there:

With more than usual eagerness did Catherine hasten to the Pump-room the next day, secure within herself of seeing Mr. Tilney there before the morning were over, and ready to meet him with a smile:— but no smile was demanded—Mr. Tilney did not

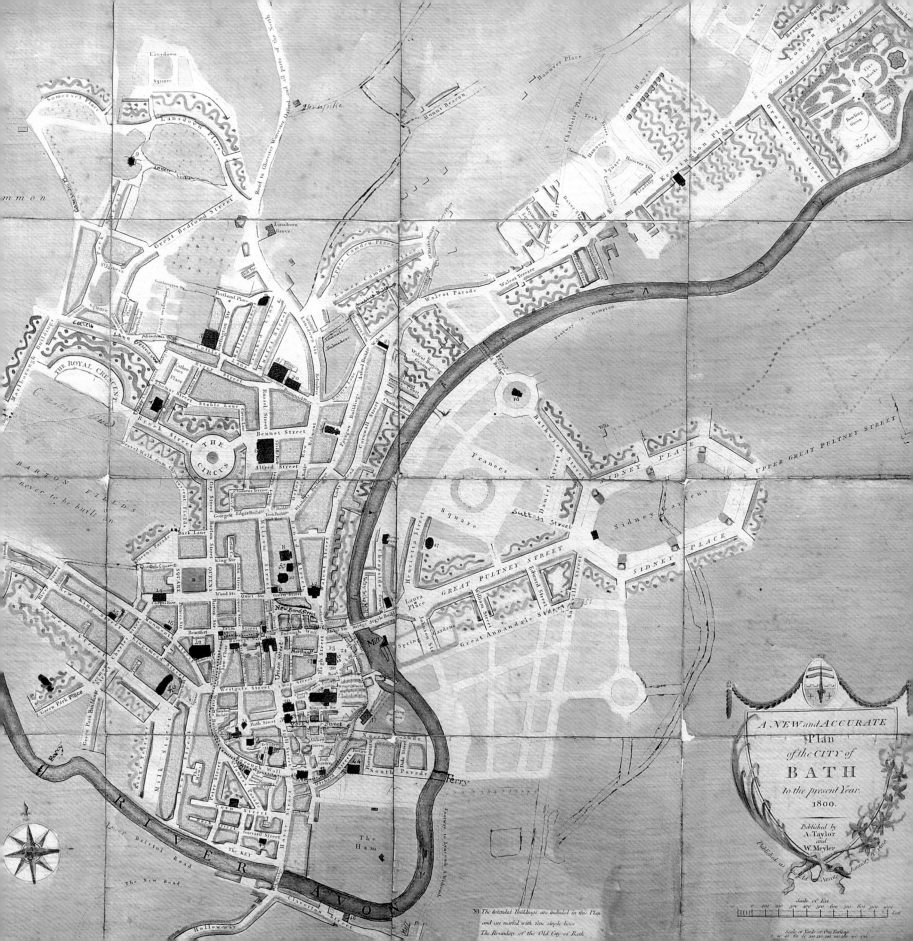

A NEW and ACCURATE
Plan
of the CITY of
BATH
to the present Year.
1800.

Published by
A. Taylor
and
W. Meyler

THE ROYAL CRESCENT

THE CIRCUS

QUEENS SQUARE

RIVER AVON

GROSVENOR PLACE

SIDNEY PLACE

GREAT PULTNEY STREET

UPPER GREAT PULTNEY STREET

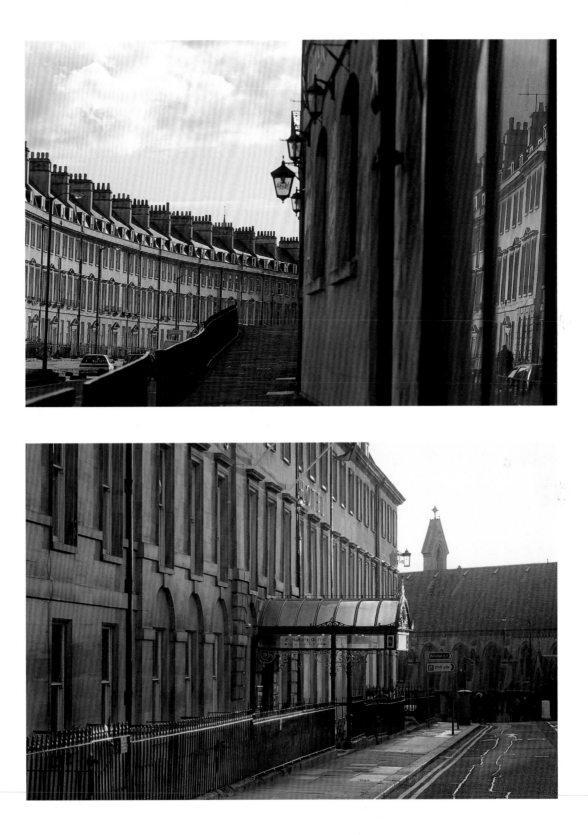

OPPOSITE *A New and Accurate Plan of the City of Bath*, 1800.
RIGHT TOP The Paragon, Bath.
RIGHT Queen Square, Bath.

BATH

appear. *Every creature in Bath, except himself, was to be seen in the room at different periods of the fashionable hours; crowds of people were every moment passing in and out, up the steps and down; people whom nobody cared about, and nobody wanted to see; and he only was absent.*

Jane finished her first draft of *Northanger Abbey* following her second trip to Bath in May 1799 with her brother Edward and his family. Edward had been prescribed a visit to Bath for what he feared were the symptoms of gout. He and his wife, Elizabeth, their two eldest children, and Mrs. Austen and Jane stayed at No. 13 Queen Square (which still stands), part of the magnificent sets of buildings designed by John Wood the Elder in his quest to beautify Bath. "Nothing can exceed, in correctness of architecture and elegance of design, the houses surrounding this area," enthused the author of *A Picturesque Guide to Bath* (1793). Immediately on arriving, Jane wrote to Cassandra, delighted with their lodgings:

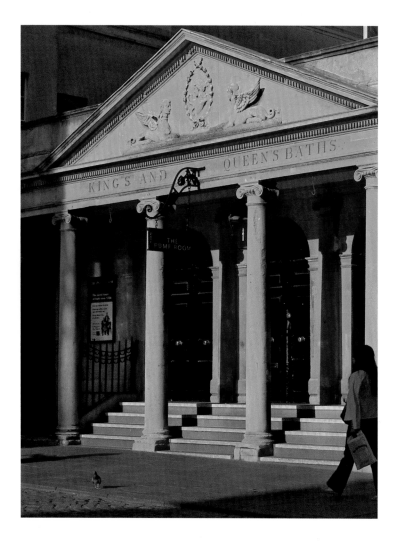

We are exceedingly pleased with the House; the rooms are quite as large as we expected, M^{rs} Bromley is a fat woman in mourning, & a little black kitten runs about the Staircase… We have two very nice sized rooms, with dirty Quilts & everything comfortable. I have the outward & larger apartment, as I ought to have; which is quite as large as our bed room at home, & my Mother's is not materially less… I like our situation very much—it is far more chearful than Paragon, & the prospect from the Drawingroom Window at which I now write, is rather picturesque, as it commands a perspective veiw of the left side of Brock Street broken by three Lombardy Poplars in the Garden of the last house in Queen's Parade.

MAY 17, 1799

LEFT TOP *Comforts of Bath: The Pump Room,* by Thomas Rowlandson, 1798.
LEFT Entrance to the Pump Room and Spa in Bath.

Jane wrote enthusiastically to her sister about the family's activities. Edward was drinking the waters, she said, and was to bathe in the warm baths, "& try Electricity on Tuesday," a radical new treatment, "but I fancy we are all unanimous in expecting no advantage from it." (June 2, 1799) They drank tea with friends, attended a play and a gala night with a concert and fireworks at Sydney gardens, and made purchases at some of the many enticing shops. "Bath is a charming place," says Mrs. Allen in *Northanger Abbey*, "there are so many good shops here." Jane had lace-trimmed cloaks made for herself and Cassandra, shopped for presents, and hunted for bargains in material and hat-trimmings:

I saw some Gauzes in a shop in Bath Street yesterday at only 4ˢ a yard, but they were not so good or so pretty as mine.—Flowers are very much worn, & Fruit is still more the thing.—Eliz[abeth] has a bunch of Strawberries, & I have seen Grapes, Cherries, Plumbs, & Apricots… We have been to the cheap Shop, & very cheap we found it, but there are only flowers made there, no fruit… I cannot help thinking that it is more natural to have flowers grow out of the head than fruit.—What do you think on that subject?

JUNE 2 & 11, 1799

But though Jane obviously enjoyed these short visits to Bath, she may have agreed with Catherine Morland's flighty friend Isabella Thorpe in *Northanger Abbey* that "though it is vastly well to be here for a few weeks, we would not live here for millions." We might see Jane Austen's opinion of her family's 1801 move to Bath in her last novel, *Persuasion,* whose gentle heroine, Anne Elliot, is forced to leave her beloved childhood home in the country for Bath. Anne's friend Lady Russell enjoys

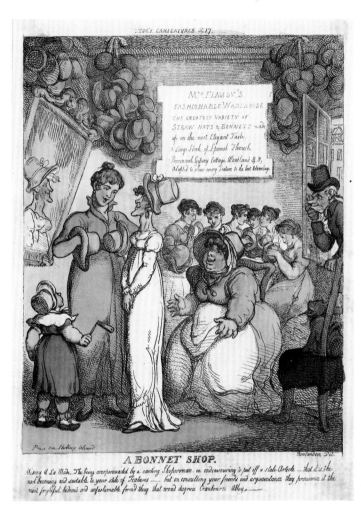

A BONNET SHOP.

RIGHT TOP *A Bonnet Shop,* by Thomas Rowlandson, 1810.
RIGHT Early 19th-century shopfront, Argyle Street, Bath.

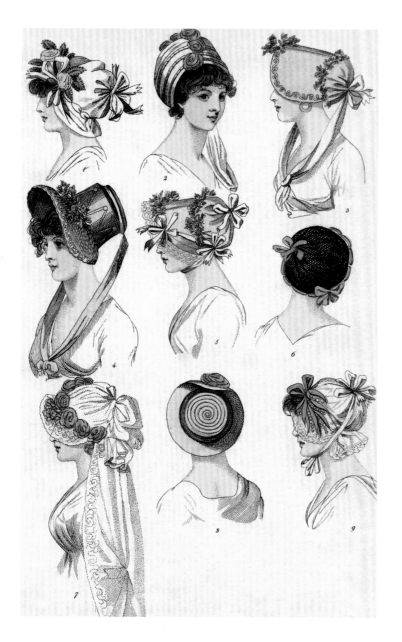

extensive buildings, smoking in rain, without any wish of seeing them better… And looked back, with fond regret, to the… seclusion of Kellynch." In later years, a great-niece wrote that Jane "loved the country and her delight in natural scenery was such that she would sometimes say she thought it must form one of the joys of heaven." Trading the pleasant countryside of Steventon, Hampshire, for the "white glare" of Bath and losing not only rural surroundings but also the country freedom "of wandering from place to place in free and luxurious solitude" (*Sense and Sensibility*) must have been a wrench for her.

Choosing where to live in Bath proved difficult for the family. Jane's letters to Cassandra in the early months of 1801 are full of the Austens' debates and discussions of different Bath neighborhoods, trying to balance affordability with desirability. Some neighborhoods were far too expensive, such as Camden Place, where in *Persuasion* the comically arrogant Sir Walter Elliot and his daughter live: "Sir Walter had taken a very good house in Camden-place, a lofty, dignified situation, such as becomes a man of consequence." Jane and Cassandra originally hoped the family would find a house near Laura Place, where in *Persuasion* the Dowager Viscountess Dalrymple, "had taken a house, for three months… and would be living in style," but feared the area would be too expensive. "I join with you in wishing for the Environs of Laura place," Jane wrote to Cassandra, "but do not venture to expect it.—My Mother hankers after the Square [Queen] dreadfully." Jane wished to be by a little greenery: "It would be very pleasant to be near Sidney Gardens!—we might go into the Labyrinth every day." (January 22, 1801) Mr. Austen seems to have been more concerned initially about price than location, but changed his mind as time went on, Jane reported. "At present the Environs of Laura-place seem to be his choice.

the bustle and even the noises of the city, "the dash of other carriages, the heavy rumble of carts and drays, the bawling of newsmen, muffin-men and milk-men, and the ceaseless clink of pattens… noises which belonged to the winter pleasures." But Anne herself "persisted in a very determined, though very silent, disinclination for Bath; caught the first dim view of the

LEFT London Head Dresses for May, from *Fashions of London and Paris*, 1800. OPPOSITE The palace front of the north side of Queen Square.

His veiws on the subject are much advanced since I came home; he grows quite ambitious, & actually requires now a comfortable & a creditable looking house." (January 14, 1801)

The debate extended to the question of how many servants they could afford. "My Mother looks forward with as much certainty as you can do, to our keeping two Maids—my father is the only one not in the secret.—We plan having a steady Cook & a young giddy Housemaid, with a sedate, middle-aged Man, who is to undertake the double office of Husband to the former & sweetheart to the latter—No Children of course, to be allowed on either side." Most of the Austens' furniture would be left behind, Jane wrote to Cassandra:

My father & mother wisely aware of the difficulty of finding in all Bath such a bed as their own, have resolved on taking it with them;—All the beds indeed that we shall want are to be removed, viz:—besides theirs, our own two, the best for a spare one, & two for servants… I do not think it will be worth while to remove any of our chests of Drawers.—We shall be able to get some of a much more commo[dious form] made of deal, & painted to look very neat; and I flatter myself that for little comforts of all kinds, our apartment will be one of the most complete things of the sort all over Bath—Bristol included… My mother bargains for having no trouble at all in furnishing our house in Bath—& I have engaged for your willingly undertaking to do it all. JANUARY 3, 1801

In May Mrs. Austen and Jane traveled to Bath to begin house-hunting in earnest, staying again with the Leigh-Perrots. They looked at Green Park Buildings, which were thought too damp, and at some houses in New King Street. "They were smaller than I expected to find them," Jane reported to Cassandra. "One in particular out of the two, was quite monstrously little;—the best of the sittingrooms not so large as the little parlour at Steventon, and the second room in every floor about capacious enough to admit a very small single bed." (May 21, 1801) Another time they looked at a house in Seymour Street, "but this house was not inviting;—the largest room downstairs, was not much more than fourteen feet square." (May 12, 1801) Compared to the spaciousness they had been accustomed to in their country house, the narrow terraced houses of Bath must have seemed cramped. Even the finest houses of the wealthy seemed small in comparison to the manor houses their occupants had left. In *Persuasion*, Anne Elliot is downcast when she thinks of the contrast between the house her father has chosen in Bath and the family's country estate:

Their house was undoubtedly the best in Camden-place; their drawing-rooms had many decided advantages over all the others which they had either seen or heard of; and the superiority was not less in the style of the fitting-up, or the taste of the furniture… Anne… must sigh, and smile, and wonder too, as Elizabeth threw open the folding-doors and walked with exultation from one drawing-room to the other, boasting of their space; at the possibility of that woman, who had been mistress of Kellynch Hall, finding extent to be proud of between two walls, perhaps thirty feet asunder.

Finally, on May 21, an attractive advertisement appeared in the *Bath Chronicle*:

The lease of No. 4 Sydney Place, 3 years and a quarter of which are unexpired at Midsummer. The situation is desirable, the Rent very low, and the Landlord is bound by Contract to paint the two first floors this summer. A premium will therefore be expected. Apply Messrs. Watson and Foreman, Cornwall Buildings, Bath.

The Austens had found their house at last. No. 4 Sydney Place was part of a terraced group of houses across the road from Sydney Gardens, near Great Pulteney Street. The house, built of the local golden-colored Bath Stone, was narrow, some twenty feet wide, with four stories and a basement. As with other terraces, the uniform front and repeated architectural details of the Sydney Place terrace of houses gave the impression of a large, almost palatial building. The location was greener and more pleasant than many in Bath, which must have pleased Jane. The front rooms in the house overlooked Sydney Gardens, and the rooms at the back of the house overlooked meadows that had not yet been developed. Behind the house itself was a long, narrow, walled garden, hidden from the street and the neighbors. It was tiny in comparison with the garden in Steventon, but it had room for a gravel or slate walk and a few flowers.

OPPOSITE Vestibule and drawing room, No. 4 Sydney Place, Bath, from *Jane Austen, Her Homes and Her Friends,* by Constance Hill, 1901. ABOVE LEFT No. 4 Sydney Place, Bath. ABOVE RIGHT Sydney Place terrace, Bath.

On the ground floor, the entry hall led to the stairs and a passage to the back of the house. To the left of the door, at the front of the house, was the dining room, also used as a sitting room, and behind it lay a smaller room, possibly used as a study for Mr. Austen. The first floor (second American) had a large drawing room with lofty ceilings that ran the width of the house, its three large windows overlooking Sydney Gardens. Wide double doors connected the room with a second sitting room at the back of the house, and could be thrown open to create one grand room. The second floor (third American) contained the family's bedrooms, one for Mr. and Mrs. Austen, one for Jane and Cassandra, and a guest room. The servants slept in the top floor, which had three bedrooms. In the basement were the kitchen and storerooms. Like most of the houses in Bath, it had piped water, which must have seemed a pleasant luxury compared to Steventon, where every bit of needed water had to be pumped from the heavy pump behind the house and then carried pail by pail inside. The typical narrow English city house amused tourist Louis Simond, author of *Journal of a Tour and Residence in Great Britain During the Years 1810 and*

1811: "These narrow houses, three or four stories high,—one for eating, one for sleeping, a third for company, a fourth under ground for the kitchen, a fifth perhaps at top for the servants,—and the agility, the ease, the quickness with which the individuals of the family run up and down, and perch on the different stories, give the idea of a cage with its sticks and birds." No. 4 Sydney Place still stands, with each floor converted into a separate, self-catering flat for tourists.

At the time the Austens moved to Bath, it was one of the largest cities in Great Britain, and one of the most attractive. "The buildings of this city are magnificent, and in a grand taste," wrote the author of *A Tour Through the South of England* (1793). "The streets are large, well paved, and clean; the market place is spacious and open; the grove, the squares, and the parades afford the most agreeable promenades." There were over 30,000 permanent residents at the turn of the century, but the population swelled from autumn through spring, averaging 8,000 visitors each week, some 40,000 visitors in total annually.

Mr. and Mrs. Austen enjoyed living in Bath, their grand-

LEFT Queen Street, Bath. RIGHT Bath Abbey, Bath.

daughter Anna wrote later. They "seemed to enjoy the cheerfulness of their Town life, and especially perhaps the rest which their advancing year entitled them to, which, even to their active natures, must have been acceptable. I have always thought that this was the short Holyday [*sic*] of their married life." Her recollection calls to mind the contented picture of Admiral and Mrs. Croft in *Persuasion*: "[Bath] suits us very well. We are always meeting with some old friend or other; the streets full of them every morning; sure to have plenty of chat; and then we get away from them all, and shut ourselves in our lodgings, and draw in our chairs, and are snug as if we were at Kellynch." Cassandra and Jane would have found their social opportunities much wider than in rural Steventon; perhaps Mr. and Mrs. Austen were thinking also of their two single daughters when they chose to move to Bath. The city had a wide variety of amusements for visitors and residents alike. In addition to the parks, the Pump Room, and the theaters, there were several circulating libraries, regularly held concerts, and two handsome assembly rooms, the Lower and Upper Rooms. Mr. and Mrs.

Leigh-Perrot took Jane to the Upper Rooms not long after she and Mrs. Austen had arrived. It was nearly the end of the social season, and rather empty for Bath, as she informed Cassandra:

I dressed myself as well as I could, & had all my finery much admired at home. By nine o'clock my Uncle, Aunt, & I entered the rooms & linked Miss Winstone on to us.—Before tea, it was rather a dull affair… for there was only one dance, danced by four couple.—Think of four couple, surrounded by about an hundred people, dancing in the upper rooms at Bath!—After tea we <u>cheered up</u>; the breaking up of private parties sent some scores more to the Ball, & tho' it was shockingly & inhumanly thin for this place, there were people enough I suppose to have made five or six very pretty Basingstoke assemblies.
MAY 12, 1801

She occupied herself at the assembly watching people and treasuring up her impressions to send to Cassandra. She spotted

AT HOME WITH JANE AUSTEN

the divorced Mary Twisleton, the former sister-in-law of one the Austens' Leigh cousins and the daughter of Lord and Lady Saye and Sele (also Leigh cousins):

I am proud to say that I have a very good eye at an Adulteress… A resemblance to M^rs Leigh was my guide. She is not so pretty as I expected… she was highly rouged, & looked rather quietly & contentedly silly than anything else.—M^rs Badcock & two young Women were of the same party, except when M^rs Badcock thought herself obliged to leave them, to run round the room after her drunken Husband.—His avoidance, & her pursuit, with the probable intoxication of both, was an amusing scene.

In *Northanger Abbey,* Jane Austen tells us that "a fine Sunday in Bath empties every house of its inhabitants, and all the world appears on such an occasion to walk about and tell their

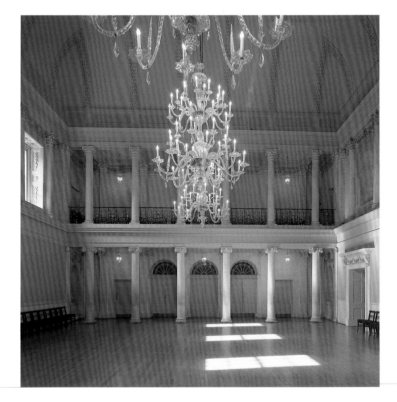

acquaintance what a charming day it is." For some, walking in Bath was a prescription for health. In *Persuasion* Admiral Croft "was ordered to walk to keep off the gout, and Mrs. Croft seemed to go shares with him in everything, and to walk for her life to do him good." For others, it was a purely social occasion. The area by the Royal Crescent, an imposing curved terrace with fine views over the city, was a fashionable place to promenade. Jane often walked there herself on Sundays, strolling and meeting friends and acquaintances. In 1801 she wrote to Cassandra: "On sunday we went to church twice, & after evening service walked a little in the Crescent fields, but found it too cold to stay long," (May 12) and in 1805: "We did not walk long in the Crescent… It was hot and not crouded enough; so we went into the field." (April 8) Her characters enjoyed walking by the Crescent as well. In *Northanger Abbey,* "As soon as divine service was over, the Thorpes and Allens eagerly joined each other; and after staying long enough in the pump-room to discover that the crowd was insupportable, and that there was not a genteel face to be seen, which everybody discovers every Sunday throughout the season, they hastened away to the Crescent, to breathe the fresh air of better company."

Jane particularly enjoyed walking in Sydney Gardens. "Yesterday was a busy day with me, or at least with my feet & my stockings," she told Cassandra. "I was walking almost all day long; I went to Sydney Gardens soon after one, & did not return till four." (April 21, 1805) In addition to pleasant, leafy walks, Sydney Gardens, known as "The Vauxhall of Bath," after the great London pleasure garden, offered riding trails, bowling greens, swings, water cascades, and a famous labyrinth whose paths, it was said, covered a half mile. *The New Bath Guide* noted that "During the summer are publick nights, with musick, fire-works, and superb illuminations." Jane, who called herself a "desperate walker," loved to walk farther afield as well. In her letters she mentions walking with friends to

LEFT The Tea Room, or Concert Room, at the Assembly Rooms, Bath.

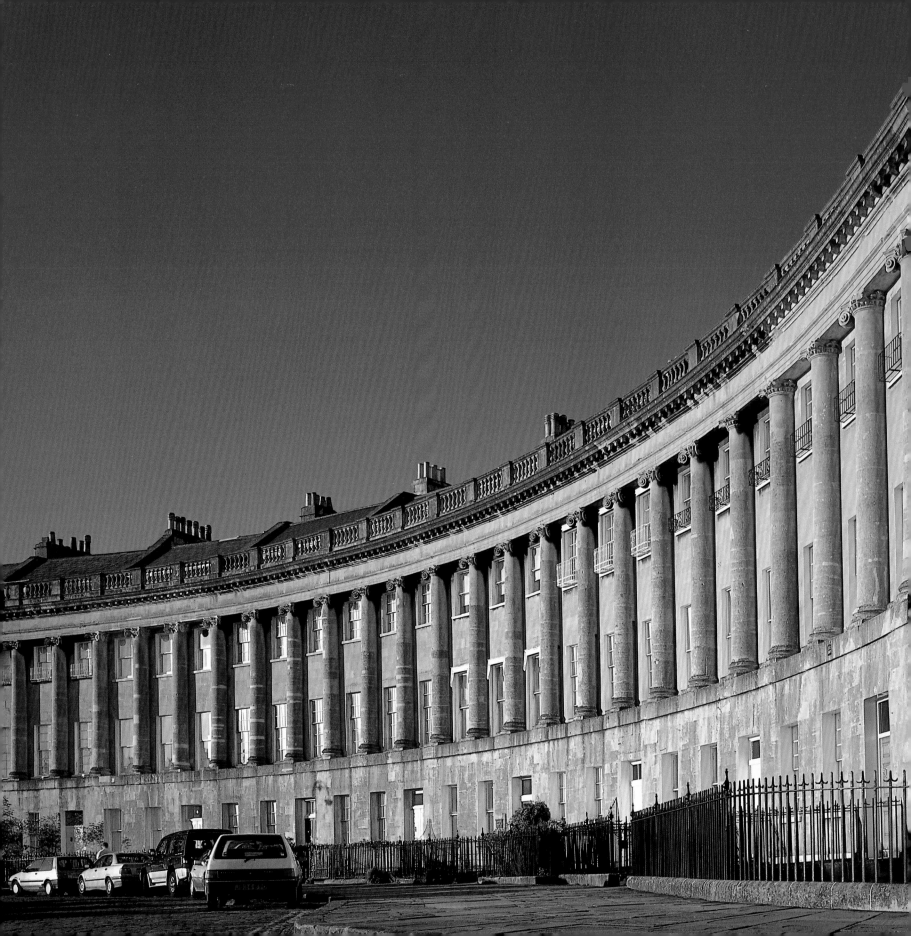

Weston, Twerton, Lyncombe, and Widcombe, among others, and surely walked to the top of Beechen Cliff as Catherine Morland did in *Northanger Abbey*. "Bath… eminently combines the advantages of town and country," wrote an American tourist in 1808. "A walk of minutes places you in the midst of cultivated fields, surrounded by an enchanting scenery, on the borders of a fine canal, or on the rich banks of the poetical Avon." Perhaps in the beautiful countryside around Bath Jane found some compensation for the rural beauties left behind in Hampshire.

The attractive countryside and towns near Bath were also popular destinations for sightseeing by carriage. In 1802, Mr. Austen bought a copy of *Excursions from Bath*, a guidebook with several suggested drives to local attractions and manor houses. The author carefully described the scenery, the architecture of the manor houses, and the artwork displayed in each. One attraction listed in the book is Blaise Castle, a folly (that is, a modern building designed to look old or ruined) built in 1766. "The traveller's eye, as he proceeds, is attracted to the left by the beautiful park of Mr. Harford's seat, called Blaze-castle. From the center of this inclosure rises a fine sugar-loaf hill, the dark wooded sides of which conceal the lower members of a Gothic castellated building, whose stately turrets appear above the shade." This pseudo-gothic "castle" appears in *Northanger Abbey* when John Thorpe tricks Catherine Morland into a drive:

opposite The Royal Crescent, Bath.
above *Road to a Fight*, from *Real Life in London*, 1821.
right Blaise Castle, Bristol.

"Blaize Castle!" cried Catherine. "What is that?"
"The finest place in England—worth going fifty miles at any time to see."
"What, is it really a castle, an old castle?"
"The oldest in the kingdom."
"But is it like what one reads of?"
"Exactly—the very same."
"But now really are there towers and long galleries?"
"By dozens."

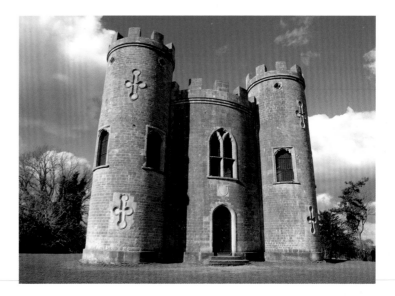

Jane Austen is sharing with the reader the joke that poor Catherine, who longs for ancient, haunted abbeys and castles, is being enticed by a silly man to see a silly modern copy of a castle. Jane herself enjoyed drives in the countryside around Bath. "I am just returned from my Airing in the very bewitching Phaeton & four," she told Cassandra. "We… had a very pleasant drive: One pleasure succeeds another rapidly." (May 27, 1801)

When the term of the lease for the Sydney Place House ran out, the Austens chose not to renew it. Mr. Austen's income was only around £600 per year; possibly he and Mrs. Austen felt the £150 per year rent had pinched their budget too much. In the autumn of 1804, after returning to Bath from their summer seaside holiday, they moved across town to Green Park Buildings, one of the properties the Austens had considered in 1801 on first arriving in Bath. Attractive terraced houses, Green Park Buildings East and West formed two arms of a triangle that encompassed an open green space, part of Kingsmead Fields leading down to the River Avon. Jane had liked the area very much during their earlier house-hunting, writing to Cassandra that she thought "nearness to Kingsmead fields would be a pleasant circumstance." (January 3, 1801) The Green Park Buildings themselves, she had said, "are very desirable in size & situation, that there is some satisfaction in spending ten minutes within them." (May 21, 1801) The location was scenic, with pleasant views across the river to Beechen Cliff, "that noble hill, whose beautiful verdure and hanging coppice render it so striking an object from almost every opening in Bath," where Jane Austen's heroine Catherine Morland walks with Henry Tilney and his sister in *Northanger Abbey*. Living close to the river could have disadvantages, though, as the area was prone to flooding. The Austens had previously looked at two houses, No. 12 and another, but had been discouraged by signs of water in the basement of one. Nevertheless, in spite of the Austens' earlier fears of what Jane had called "putrifying Houses," the Austens moved into No. 3 Green Park Buildings East in October 1804.

Possibly they saw it as a temporary stop, as they took only a six-month lease. Nothing is known about the interior of the Austens' house there, as there are no letters of Jane's surviving from the period and the house no longer exists. The east block of Green Park Buildings was destroyed in 1942 by the German Luftwaffe during the bombing campaign known as the Bath Blitz, but the west block still stands, now named just "Green Park." The house may have been similar to one of the other Green Park Buildings houses that had attracted Jane when she had viewed it earlier: "We walked all over it except into the Garrets," she had reported to Cassandra, "—the dining-room is of a comfortable size, just as large as you like to fancy it, the 2d room about 14ft. square;— The apartment over the Drawing-room pleased me particularly, because it is divided into two, the smaller one a very nice sized Dressing-room, which upon occasion might admit a bed." (May 5, 1801)

The Austens' fear that the dampness of Green Park Buildings would prove to be unhealthy may or may not have had some validity. Mr. Austen had suffered periodically over the past three years with a "feverish complaint," which Jane described as "an oppression in the head with fever, violent tremulousness, & the greatest degree of Feebleness," but had always recovered from each attack. On January 19, 1805, however, the illness returned with greater intensity. Mr. Austen seemed briefly to rally the next day, but relapsed and died on January 21. Jane wrote to her brother Frank to inform him of the melancholy news:

Our dear Father has closed his virtuous & happy life… His tenderness as a Father, who can do justice to? … [James Austen and his wife] kindly press my Mother to remove to Steventon as soon as it is all over, but I do not beleive she will leave Bath at present. We must have this house for three months longer, & here we shall probably stay till the end of that time.
JANUARY 21 & 22, 1805

Mrs. Austen, Jane, and Cassandra did indeed remain in their house at Green Park Buildings only through the remainder of their lease. With Mr. Austen's death, the income from the livings of Steventon and Deane ceased, and Mrs. Austen found her income much reduced. The interest from her own funds, combined with the interest on the £1,000 Cassandra had inherited from her fiancé, Tom Fowle, when he died, provided the Austen women with only £210 annually, just one-third of their former income. Jane had no money of her own to contribute. Fortunately Mrs. Austen's fond sons stepped forward, with Henry, Frank, and James each pledging £50 per year, and richer Edward pledging £100. This brought her income to £460 per year, which would enable her and her daughters to live in some comfort, providing they lived prudently. "She will be very comfortable," Henry wrote to Frank, "& as a smaller establishment will be as agreeable to them, as it cannot but be feasible, I really think that My Mother & Sisters will be to the full as rich as ever. They will not only suffer no personal deprivation, but will be able to pay occasional visits of health and pleasure to their friends." (January 28, 1805)

Mrs. Austen, Jane, and Cassandra moved first to furnished lodgings in 25 Gay Street. Not far from the Circus and the Royal Crescent, it was a short distance from the "comparatively quiet and

Gay Street, Bath.

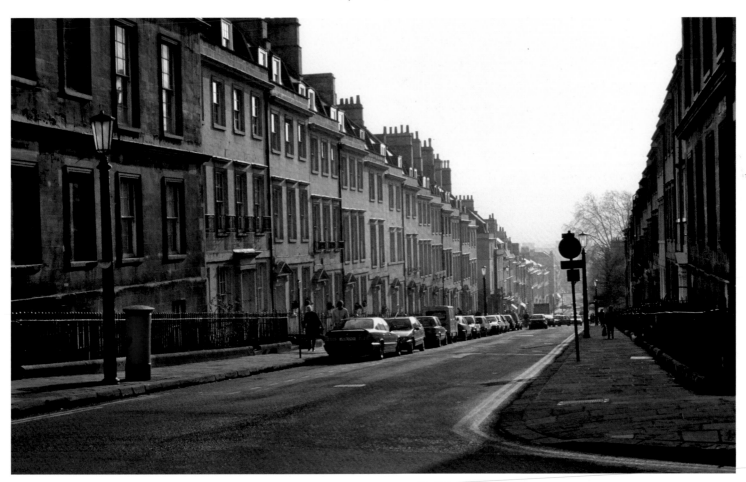

retired gravel walk," where Anne Elliot and Captain Wentworth, "exquisitely happy," walk after their reconciliation in *Persuasion*. No. 25, which still stands, currently houses a dentist's office and an apartment on the floors above. A similar house in the terrace, No. 40, is now the home of the Jane Austen Centre (see Further Information).

James Austen wrote to his brother Frank about Mrs. Austen's intentions: "Her future plans are not quite settled, but I believe her summers will be spent in the country amongst her Relations & chiefly I trust among her children—the winters she will pass in comfortable lodgings in Bath." Indeed, Mrs. Austen and her daughters spent the summer at Edward Austen's estate Godmersham in Kent, (see Stately Mansions), then traveled with Edward and his family to the seaside resort of Worthing (see By the Sea), where they joined their dear friend Martha Lloyd. Martha's mother had recently died, and the Austen women decided that she should join their household, a happy arrangement that continued more than 20 years, ending only when Martha married Frank Austen as his second wife in 1828.

On returning to Bath, the Austens took temporary lodgings at one of the houses in Trim Street, but the exact address of the house is unknown. Mrs. Austen had difficulty finding permanent lodgings, as the family now needed only a suite of rooms, not an entire house. Always a practical woman, she must have felt the need to cut back on the family's expenses, like the Elliots in *Persuasion*: "Can we retrench? Does it occur to you that there is any one article in which we can retrench?" Trim Street lies right in the middle of the older, busier part of Bath, a far cry from the Austens' earlier addresses with their pleasant views of Sydney Gardens and Beechen Cliff. Mrs. Austen did not seem happy with their location. Writing to her daughter-in-law Mary Lloyd Austen on April 10, 1806, there is a hint of her exasperation in the heading of her letter: "*Trim Street Still.*" Another possibility for housing had fallen through,

RIGHT Trim Street, Bath.

she wrote: "We are disappointed of the Lodgings in St. James's Square, a person is in treaty for the whole House, so of course he will be prefer'd to us who want only a part.—We have look'd at some others since, but don't quite like the situation—hope a few days hence we shall have more choice, as it is supposed many will go from Bath when this gay week is over."

In any event, a better plan presented itself. Captain Frank Austen had taken part in recent naval victories at St. Domingo against the French. As the captain of one of the victorious British ships, the *Canopus,* he was entitled to considerable prize money, his share of the worth of the ships captured in the action. His newfound prosperity made him feel secure enough to go ahead with his long-anticipated wedding to Mary Gibson. He and his mother and sisters decided to move to the coastal town of Southampton, Hampshire, and combine their households. Mary would have company when Frank was at sea, and both families would benefit from sharing expenses, a plan, he wrote later, "equally suited to [my] love of domestic society and the extent of [my] income which was somewhat restricted."

Mrs. Austen, Jane, Cassandra, and Martha left Bath on July 2, 1806. Jane may have enjoyed much of her sojourn in Bath, but

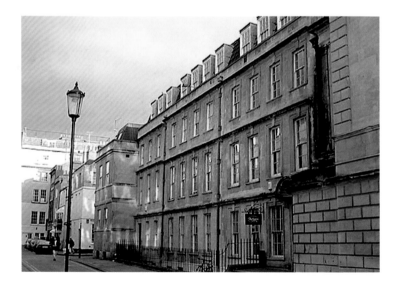

AT HOME WITH JANE AUSTEN

the stresses of the previous year, with her father's death and the family's unsettled living situation, no doubt contributed to her sense of relief at seeing the last of the city. She recalled her feelings when later she wrote to Cassandra, "It will be two years tomorrow since we left Bath… with what happy feelings of Escape!" (July 1, 1808) The Austens spent the summer traveling, first to nearby Clifton, then to Adlestrop and Stoneleigh Abbey, properties of Mrs. Austen's cousins (see Stately Mansions), and Hamstall Ridware, where nephew Edward Cooper lived. Frank and his bride, the "lovely couple," as Jane called them, honeymooned at Godmersham. They all met again at Steventon in the autumn, and moved to Southampton in October.

Francis Austen's ship HMS *Canopus,* by Thomas Dutton after Henry Andrews Luscombe, undated.

TRAVELS & TOURS

Martha has promised to return with me, & our plan is to… throw ourselves into a postchaise,
one upon the other, our heads hanging out at one door, & our feet at the opposite.

LETTER FROM JANE AUSTEN TO HER SISTER, CASSANDRA, NOVEMBER 30, 1800

Jane Austen enjoyed traveling. Her letters to her sister describing her trips have an almost jaunty note to them that showed she relished the opportunity to get out into the world and see new sights. Although travel in her day could be frustrating, exhausting, and occasionally even dangerous, she seemed to take any difficulties on her journeys in stride, filling her letters with cheerful and humorous commentary on her experiences, whether good or bad, and reporting on the roads, the weather, the inns, the food, and, above all, the scenery. Writing about her trip to Bath to house-hunt with Mrs. Austen in 1801 she told Cassandra, "Our Journey here was perfectly free from accident or Event; we changed Horses at the end of every stage, & paid at almost every Turnpike;—we had charming weather, hardly any Dust, & were exceedingly agreable, as we did not speak above once in three miles." (May 5, 1801) In 1808, after traveling with the family of her brother James she wrote, "We were rather crowded yesterday, though it does not become me to say so, as I and my boa were of the party, and it is not to be supposed but that a child of three years of age [her niece Caroline] was fidgety… The country is very beautiful. I saw as much as ever to admire in my yesterday's journey." (June 15, 1808) Her letter informing Cassandra about her journey with their brother Henry

in an open curricle (a light, two-wheeled vehicle, the equivalent of a sports car) from Chawton to London in May 1813 clearly shows the delight she took in touring and taking in the sights and scenery, and her willingness to shrug off such inconveniences as a little rain in an open carriage:

We had no rain of any consequence; the head of the Curricle was put half-up three or four times, but our share of the Showers was very trifling, though they seemed to be heavy all round us, when we were on the Hog's-back… Three hours & a qr [quarter] took us to Guildford, where we staid barely two hours, & had only just time enough for all we had to do there, that is, eating a long comfortable Breakfast, watching the Carriages, paying M^r Harrington & taking a little stroll afterwards. From some veiws which that stroll gave us, I think most highly of the situation of Guildford. We wanted all our Brothers & Sisters to be standing with us in the Bowling Green & looking towards Horsham… I was very much pleased with the Country in general; between Guildford & Ripley I thought it particularly pretty, also about Painshill & every where else; & from a M^r Spicer's Grounds at Esher which we walked into before our dinner, the veiws were beautiful. I cannot say what

Strip map showing part of the route from London to Winchester, past Chawton and Alton, Hampshire, from *Paterson's British Itinerary,* by David Paterson, 1785.

we did <u>not</u> see, but I should think there could not be a Wood or a Meadow or a Palace or a remarkable spot in England that was not spread out before us, on one side or the other… Upon the whole it was an excellent Journey & very thoroughly enjoyed by me;—the weather was delightful the greatest part of the day, Henry found it too warm & talkd of its' being close sometimes, but to my capacity it was perfection.

MAY 20, 1813

Jane's appreciation of traveling and viewing new places and beautiful scenery shows itself in her heroines, from Elizabeth Bennet in *Pride and Prejudice,* for whom "every object in the next day's journey was new and interesting" and whose spirits "were in a state of enjoyment," to Marianne Dashwood in *Sense and Sensibility,* who "sat in silence almost all the way, wrapt in her own meditations, and scarcely ever voluntarily speaking, except when any object of picturesque beauty within their view drew from her an exclamation of delight."

Jane traveled relatively often to the various corners of Southern England when she and her family went to stay with their friends and extended family or took holiday trips to the seaside, experiences that would later influence the settings of her novels and the journeys her characters made. When Jane was a girl, she and Cassandra traveled from their village of Steventon in Hampshire to school in Oxford, Southampton, and Reading, Berkshire. As the girls grew older, they began to travel farther afield with their family. The first such journey recorded was in 1788, when Mr. and Mrs. Austen took Jane and Cassandra to see their Kentish Austen cousins at the Red House in Sevenoaks. The Red House was the home of Mr. Austen's uncle Francis Austen, who had assumed responsibility for George Austen and his siblings when their father had died young. They also visited Mr. Austen's half-brother, William Walter, and his family in nearby Seal, possibly in the Grey House in Church Street. Mr. Walter's 27-year-old

ABOVE TOP Carriage Dress, from Ackermann's *Repository of Arts,* December 1816. ABOVE *A Gentleman with His Pair of Bays Harnessed to a Curricle,* by John Cordrey, 1806.

AT HOME WITH JANE AUSTEN

daughter, Philadelphia, thought that fifteen-year-old Cassandra was pretty and very like herself, but was less taken with Jane: "The youngest (Jane) is very like her brother Henry, not at all pretty & very prim, unlike a girl of twelve," she wrote to her brother, "but it is a hasty judgement wh[ich] you will scold me for… Yesterday they all spent the day with us, & the more I see of Cassandra the more I admire—Jane is whimsical & affected." One wonders what the whimsical young Jane was thinking of her in return.

Subsequent years found them traveling widely, sometimes together with their parents and sometimes separately to see friends, brothers, and some of the innumerable Austen and Leigh cousins (Mrs. Austen was born a Leigh). As young women, Jane and Cassandra returned to Southampton without their parents in December 1793 to visit their Butler-Harrison cousins, who lived in the suburb of St. Mary's. The Christmas season gaieties included an assembly ball at the Dolphin Inn, which Jane fondly remembered in later years (see Southampton). Among the friends they often stayed with were their good friends the Lloyds, who had moved from Deane near Steventon to Ibthorpe, near Hurstbourne Tarrant in Hampshire. At Kintbury, Berkshire, the Austens visited the Fowle family, whose sons had been Mr. Austen's pupils at Steventon. One of the Fowle sons, Thomas, was engaged to Cassandra for some years, but tragically died of yellow fever in 1797 before they could be married. Other family visited by the Austens included Mrs. Austen's nephew Edward Cooper at his rectory at Harpsden, Oxfordshire, where he was curate. Several times the family traveled to see Mrs. Austen's Leigh cousins at Adlestrop in Gloucestershire (see Stately Mansions) and to see her brother and his wife in Bath (see Bath).

When Jane's brother Edward was adopted by the Austens' cousins Mr. and Mrs. Thomas Knight II and moved permanently to Kent, the Austens began to visit him frequently, first at Rowling when he was a young married man, and then at Godmersham when he inherited the estate (see Stately Mansions). On their way

to and from Kent the Austens sometimes stayed with Mrs. Austen's cousins the Cookes at Great Bookham, Surrey, which is some five miles from Box Hill, the site of the ill-fated picnic in *Emma*. There is no absolute proof that Jane Austen visited Box Hill, but she is famous for advocating writing only from personal knowledge.

ABOVE TOP *The Road from London to Chichester,* by Thomas Kitchin, 1767. ABOVE *Box Hill, Surrey, with Dorking in the Distance,* by George Lambert, 1733.

It seems reasonable to assume that like the characters in *Emma*, the Cookes and the Austens organized a pleasant excursion and had "a very fine day for Box Hill" and that Jane enjoyed the same "beautiful views beneath her" as her heroine Emma. On these journeys to Kent and back, the Austens also often stopped overnight or for a day or two to stay with Jane's brother Henry in London, and Jane and Cassandra both visited Henry there at other times (see London).

After Mr. Austen retired to Bath in 1801, the Austens made several tours of the seaside in Dorset and Devon, probably visiting Sidmouth and Colyton in 1801, Dawlish and probably Teignmouth in 1802, and possibly Charmouth, Uplyme, and Pinhay in 1803. That November the Austens visited Lyme and returned again in the summer of 1804. In the 1802 tour the Austens may even have traveled as far as Tenby and Barmouth in Wales (see By the Sea).

The northern limit of Jane's journeys seems to have been a trip she and her mother and sister made in 1806 with Mrs. Austen's cousin the Reverend Thomas Leigh of Adlestrop to his newly inherited estate of Stoneleigh Abbey in Warwickshire (see Stately Mansions). They then traveled on to Jane's cousin Edward Cooper's new rectory at Hamstall Ridware in Staffordshire, finally accepting the invitation they had turned down earlier in favor of a seaside tour.

When Jane felt her health beginning to fail in 1816, she and Cassandra visited the Gloucestershire spa town of Cheltenham, made popular when George III came "for the benefit of the waters" in 1788. Jane's brother James and his wife, Mary, had visited the town for a month in 1813, recommendation enough for Jane to see whether Cheltenham's celebrated mineral waters would improve her health. She and Cassandra stayed for at least two weeks, but her condition continued to deteriorate. Her last journey was to Winchester, to seek medical care before her death there in 1817 (see Winchester). Jane seems never to have regretted not having traveled abroad, writing just a few months before she died to

her friend Alethea Bigg, "I hope your Letters from abroad are satisfactory. They would not be satisfactory to <u>me</u>, I confess, unless they breathed a strong spirit of regret for not being in England." (January 24, 1817)

Although the Austens traveled to sites that seem relatively close together today, in their era such journeys were often several-day affairs, requiring much planning, trouble, and money.

Traveling by carriage was slow. Assuming the carriage held together and the horses were good, often the best speed travelers could hope for was seven miles an hour with stops. Travel was also incredibly expensive. The Reverend Thomas Leigh recorded a journey he took in 1806 from Adlestrop to his new estate of Stoneleigh Abbey in Warwickshire, then to London, then back to Stoneleigh Abbey and Adlestrop. His travel and sundry expenses amounted to £58, more than the annual salary of £54 paid to Jane's brother Henry as curate of Chawton a decade later.

The Austens would have had several choices of transport for their travels. Well-off families might own their own carriage, as the Austens did for some of their years at Steventon (though they later found it too expensive). Travelers could use their own horses to pull their carriage, but then the horses could only travel so far before they needed to be rested, and it meant that the journey would be much slower. In *Northanger Abbey*, the heroine, Catherine Morland, is excited to travel with her friends Henry and Eleanor Tilney to their home, but is frustrated by the long delay at Petty France while General Tilney's horses are rested and fed. When Jane and her brother Henry traveled to London in his curricle, he drove his own horses and stopped frequently to allow them to rest. The approximately 50-mile journey (which now takes less than an hour and a half by automobile) thus took 12 hours start to finish. "I fancy it was about ½ past 6 when we reached this house, a 12 hours Business, & the Horses did not appear more than reasonably tired," wrote Jane. "I was very tired too, & very glad to get to bed early, but am quite well to-day." (May 20, 1813)

For quicker transport, travelers might take the first stage with their own horses, then use hired horses from a posting inn that were switched out for fresh horses at each subsequent stage, generally ten to fifteen miles apart. Using a pair of horses was common, though wealthier travelers might use four. The horses could be of varying quality, as Jane noted to Cassandra in 1798: "It wanted five minutes of twelve when we left Sittingbourne, from whence we had a famous pair of horses, which took us to Rochester in an hour and a quarter; the postboy seemed determined to show my mother that Kentish drivers were not always tedious… Our next stage was not quite so expeditiously performed; the road was heavy and our horses very indifferent." (October 24) The postboy she mentioned was a postillion, who guided the horses by riding on the left horse of the pair, rather than driving the carriage from a box. In *Northanger Abbey,* the rich General Tilney keeps "a fashionable chaise and four" (horses) and his own postillion for each pair, "handsomely liveried, rising so regularly in their stirrups," to Catherine's admiration. There is an amusing Austen family tradition about Henry Austen and a postillion that illustrates "the dry, quaint humour which was a characteristic of some of the family," his great-nephew Lord Brabourne wrote. "He is said to have been driving on one occasion with a relation in one of the rough country lanes near Steventon, when the pace at which the postchaise was advancing did not satisfy his eager temperament. Putting his head out of the window, he cried out to the postillion, "Get on, boy! get on, will you?" The "boy" turned round in his saddle, and replied: "I *do* get on, sir, where I can!" "You stupid fellow!" was the rejoinder. "Any fool can do that. I want you to get on *where you can't!*"

Hired, or hack, chaises could also be obtained from the posting inns as well as horses. These carriages generally belonged to the posting inn, so it was necessary to change into a new one at every stage. The chaises varied in quality as well as the horses, as Jane wrote to Cassandra about the 1801 trip to Bath:

"We had a very neat chaise from Devizes; it looked almost as well as a Gentleman's, at least as a very shabby Gentleman's—; in spite of this advantage however We were above three hours coming from thence to Paragon." The biggest inconvenience was the necessity of removing the luggage and other belongings from chaise to chaise at each stop, which could result in breakage and loss. "When I got into the Chaise at Devizes I discovered that your Drawing Ruler was broke in two," Jane wrote. "It is just at the Top where the crosspeice is fastened on.—I beg pardon." (May 5) When the Austens stopped for the night at Dartford on their way home from Godmersham in 1798, Jane's own valued possessions went missing, she reported to Cassandra: "After we had been here a quarter of an hour it was discovered that my writing and dressing boxes had been by accident put into a chaise which was just packing off as we came in, and were driven away towards Gravesend in their way to the West Indies. No part of my property could have been such a prize before, for in my writing-box was all my worldly wealth… Mr. Nottley [the landlord] immediately despatched a man and horse after the chaise, and in half an hour's time I had the pleasure of being as rich as ever; they were got about two or three miles off." (October 24) Her writing desk probably also contained her early manuscripts, which would have been an even greater loss. Larger pieces of luggage too big or too heavy to fit onto a postchaise had to be sent by a separate coach or wagon that was traveling to the same destination. Jane often recorded her worries about whether her trunk would arrive in time or whether its contents would be damaged. "I have some hopes of being plagued about my Trunk…" she joked in her letter to Cassandra from Bath in 1799, "for it was too heavy to go by the Coach which brought Thomas & Rebecca [the servants] from Devizes, there was reason to suppose that it might be too heavy likewise for any other Coach, & for a long time we could hear of no Waggon to convey it.—At last however, we unluckily discovered that one was just on the point of setting out for this place—but at any rate, the Trunk cannot be

here till tomorrow—so far we are safe—& who knows what may not happen to procure a farther delay." (May 17) Visiting Henry in London in 1814, she worried that she would be left short of clothing: "My Trunk did not come last night, I suppose it will this morn[in]g; if not I must borrow Stockings & buy Shoes & Gloves for my visit. I was foolish not to provide better against such a Possibility. I have great hope however that writing about it in this way, will bring the Trunk presently." (March 3)

As women, Jane and Cassandra usually had to wait to travel until their father, a brother, or a friend could take them, which could be frustrating at times for Jane, "but till I have a travelling purse of my own, I must submit to such things," she told her sister. On a second visit to Henry's in 1814, though, at the age of 38, she traveled on the stagecoach by herself from Alton near her home at Chawton to London. Stagecoach travel was much cheaper than traveling post, but often very much less comfortable. Passengers who could afford it would travel inside, which could be crowded enough, and those who could not piled on top of the coach, often making it perilously top-heavy, and hung on as best they could. Jane reported that on her journey there were initially only four inside the coach "& I was told 15 at top... in short, everybody either <u>did</u> come up by Yalden [the Alton-London

The Evening Coach, with London in the Distance, by Philippe-Jacques de Loutherbourg, 1805.

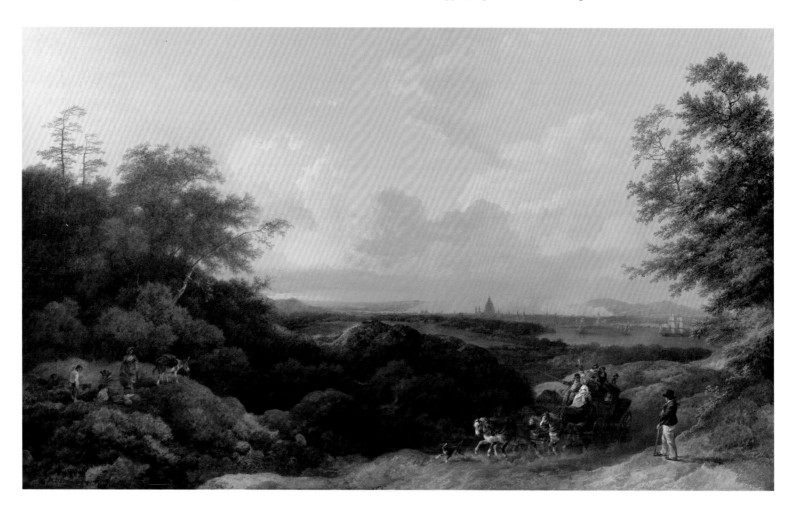

AT HOME WITH JANE AUSTEN

coach] yesterday, or wanted to come up." (August 23) Outside passengers had to endure whatever weather prevailed, and often arrived at their destination in poor weather feeling half-drowned or half-frozen. Jane's young nephews deliberately chose to ride on the outside of a stagecoach when in 1808 they traveled from Winchester to visit the Austens in Southampton. "Edward and George came to us soon after seven on Saturday, very well, but very cold, having by choice traveled on the outside, and with no great coat but what Mr. Wise, the coachman, good-naturedly spared them of his, as they sat by his side," Jane told Cassandra. "They were so much chilled when they arrived, that I was afraid they must have taken cold; but it does not seem at all the case; I never saw them looking better." (October 24) Jane's journey to London inside the stagecoach was far more comfortable. "I had a very good Journey, not crouded, two of the three taken up at Bentley being Children, the others of a reasonable size; & they were all very quiet & civil.—We were late in London, from being a great Load & from changing Coaches at Farnham, it was nearly 4 I beleive when we reached Sloane St; Henry himself met me, & as soon as my Trunk & Basket could be routed out from all the other Trunks & Baskets in the World, we were on our way to Hans Place…" Though travel inside the coach was less unpleasant, the bumping and jolting could still be exhausting, as Jane noted. "If it continues fine, John [Henry's coachman] is to drive me there by & bye, & we shall take an Airing together; & I do not mean to take any other exercise, for I feel a little tired after my long Jumble."

Carriage travel in Jane Austen's day could not only be uncomfortable but actually quite hazardous. New methods of road building and the institution of the turnpike system in the late 18th century made travel on the main roads faster and safer than it had been for previous generations. Some of the main roads were relatively smooth—Jane and Henry amused themselves on one trip to London by reading her manuscript of *Mansfield Park.* Still, travelers could and did suffer accidents, sometimes merely

inconvenient, but sometimes fatal. Jane Cooper (then Lady Williams), who had been at school with Jane and Cassandra, was killed in 1798 when her carriage overturned. Accidents were common enough that Jane could joke in one of her letters to Cassandra that perhaps they would be spared having to visit their cousins the Cookes at Great Bookham if only the Cookes would have a carriage accident: "I assure You that I dread the idea of going to Bookham as much as you can do; but I am not without hopes that something may happen to prevent it… They talk of going to Bath too in the Spring, & perhaps they maybe overturned in their way down, & all laid up for the summer." (January 8, 1799) In *Sanditon,* the novel she was working on the year of her death, Jane used the dramatic occasion of a carriage accident to start the story and throw the heroine, Charlotte Heywood, into contact with the Parker family, who invite her back to the seaside village of Sanditon with them. The Parkers, "being induced by business to quit the high road and attempt a very rough lane, were overturned in toiling up its long ascent, half rock, half sand. The accident

ABOVE Detail, *Rural Sports, Cat in a Bowl. No. 1,* by Thomas Rowlandson, 1811.

happened just beyond the only gentleman's house near the lane," where the road had "become worse than before" and "no wheels but cart wheels could safely proceed. The severity of the fall was broken by their slow pace and the narrowness of the lane."

Though much less common than in previous generations, highwaymen still occasionally presented a danger when carriages traveled by night or on lonely roads. Jane's cousin Eliza once claimed that she had nearly been robbed by a highwayman while riding in her carriage near London. Closer to home, a highwayman, "a stout lusty man about 35 years of age" with a "pale sodden complexion" terrorized the neighborhood of Overton, near the Austens' village of Steventon, in the summer of 1793. He committed a series of robberies that ended only when the offer of a large reward for his capture and conviction apparently caused him to flee the area. He stopped the carriage of the Austens' neighbor Mrs. Bramston of Oakley Hall and a friend of hers one evening in June and robbed them of eleven or twelve guineas. A month later he robbed and beat the servant of Mrs. Lefroy, the good friend of seventeen-year-old Jane. And a week after that he attacked again. Three ladies "travelling in their own carriage," the *Reading Mercury* reported, "were stopped in the vicinity of Popham-lane, by a man in a smock frock, with a handkerchief or crape over his face, and armed with pistols, who robbed them of nine guineas, their gold watches, and ear-rings from their ears, value together about 100£. The villain came out of Popham wood, and tied his horse to a gate, whilst he committed the robbery." The presence of such a dangerous man in the area must have been a source of fear and consternation to the neighborhood, terrifying but also no doubt very exciting and interesting to the young Jane and Cassandra. In *Emma*, Jane recounted the alarm felt with far less justification by the residents of Highbury when gypsies camp nearby and frighten Harriet Smith:

Within half an hour it was known all over Highbury. It was the very event to engage those who talk most, the young and the low; and all the youth and servants in the place were soon in the happiness of frightful news. The last night's ball seemed lost in the gipsies. Poor Mr. Woodhouse trembled as he sat, and, as Emma had foreseen, would scarcely be satisfied without their promising never to go beyond the shrubbery again.

Wale *delin* J. *Pollard sculp.*

Wᵐ PAGE *leaving his Phæton, while he* ROBS *a Gentleman, near Putney.*

RIGHT *William Page robbing a gentleman near Putney, 1795.*

For the vast majority of travelers, though, their greatest worries were merely whether their carriages would hold together on rough roads, just how fatigued they would be when they reached their destination, and whether or not the inns they stayed at had good beds and food. Travel often left passengers feeling weary from "sitting ten or twelve hours on a stretch, (or rather with no stretch at all) doubled up in a dancing box of about two feet and a half square," said the author of *The Miseries of Human Life* (1806). Carriage makers tried their best to ease the bone-rattling experience of bounding on wooden wheels over uneven roads by fitting their carriages with specially designed springs to blunt the jolting and with straps to limit the sway of the carriage body, but even well-made carriages rocked and bounced to the point that riding in a carriage and trying to keep one's seat was considered a type of exercise. Mrs. Austen, unlike Jane, was not a good traveler and seems to have suffered from motion sickness. Far from being beneficial to her as exercise, the swaying and bouncing of the carriage left her weak and ill, sometimes for days. An important part of Jane's communications to Cassandra whenever Jane traveled with her mother was reporting on how Mrs. Austen and her digestion had fared during the journey. "She was very little fatigued on her arrival at this place, has been refreshed by a comfortable dinner, and now seems quite stout," Jane wrote to Cassandra from Dartford on the first evening of their journey from Godmersham to Steventon in 1798. "My mother took some of her bitters at Ospringe, and some more at Rochester, and she ate some bread several times." (October 24) Bitters were recommended, said the author of *Domestic Medicine* (1794), "when digestion is bad or the stomach relaxed and weak." But two more days of travel took their toll, as Jane wrote in her next letter:

I cannot send you quite so triumphant an account of our last day's Journey as of the first & second. Soon after I had finished my letter from Staines, my Mother began to suffer from the exercise &

fatigue of travelling so far, & she was a good deal indisposed from that particular kind of evacuation which has generally preceded her Illnesses—. She had not a very good night at Staines, & felt a heat in her throat as we traveled yesterday morning, which seemed to foretell more Bile—. She bore her Journey however much better than I had expected, & at Basingstoke where we stopped more than half an hour, received much comfort from a Mess of Broth, & the sight of [the surgeon] Mr. Lyford, who recommended her to take 12 drops of Laudanum [liquid opium] when she went to Bed, as a Composer, which she accordingly did.

OCTOBER 27, 1798

The physician who wrote *Domestic Medicine* also cautioned travelers to be extremely wary of the beds when they stopped at an inn. "Nothing is more to be dreaded by travellers than damp beds," he wrote. "When a traveller, cold and wet, arrives at an inn [and] be put into a cold room, and laid in a damp bed… the worst consequences will ensue. Travellers should avoid inns which are noted for damp beds, as they would a house infected with the plague, as no man however robust, is proof against the danger arising from them." *The European Magazine and London Review* (1790) published a helpful hint to "prevent the dreadful effects of sleeping in a damp bed." It suggested that a clean glass could be put upside down into the bed "immediately as the warming-pan is taken out" and the glass examined for steam. Jane's friend Mrs. Lefroy, ever a fond and anxious mother, gave her son Christopher Edward the same advice in 1803: "If the glass remains perfectly clear, the bed is dry; you know the tumbler is to be put between the sheets, & the cloathes over it at the foot of the bed."

The Austens seem to have had good luck with the inns they chose. In 1798, their inn at Dartford, the "Bull and George," sounds cosy enough, as Jane wrote to Cassandra: "We have got apartments up two pair of stairs, as we could not be otherwise accommodated with a sitting-room and bed-chambers on the same

ARRIVAL OF THE STAGE COACH

Publd. May 29. 1816, by R. Pollard, Holloway, near London

ABOVE *Arrival of the Stage Coach,* by James Pollard, 1816. OPPOSITE *Interior of an Inn,* by Nicholas Pocock, circa 1815.

AT HOME WITH JANE AUSTEN

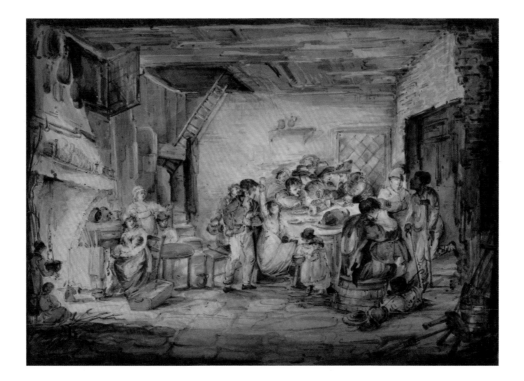

floor, which we wished to be. We have one double-bedded and one single-bedded room; in the former my mother and I are to sleep. I shall leave you to guess who is to occupy the other. We sate down to dinner a little after five, and had some beef-steaks and a boiled fowl, but no oyster sauce… My father is now reading the 'Midnight Bell', which he has got from the library, and mother sitting by the fire." (October 24) And on the trip to Bath in 1799, she reported to Cassandra that she was pleased with the rooms and the food at the inn: "At Devizes we had comfortable rooms, & a good dinner to which we sat down about 5; amongst other things we had Asparagus & a Lobster which made me wish for you, & some cheesecakes on which the children [her niece Fanny and nephew Edward] made so delightful a supper as to endear the Town of Devizes to them for a long time." (May 17) Like her heroine Catherine in *Northanger Abbey*, Jane's travel experiences were for the most part pleasant and without alarming incident:

Under these unpromising auspices, the parting took place, and the journey began. It was performed with suitable quietness and uneventful safety. Neither robbers nor tempests befriended them, nor one lucky overturn to introduce them to the hero. Nothing more alarming occurred than a fear, on Mrs. Allen's side, of having once left her clogs behind her at an inn, and that fortunately proved to be groundless.

NORTHANGER ABBEY

AT HOME WITH JANE AUSTEN

STATELY MANSIONS

The eye was instantly caught by Pemberley House, situated on the opposite side of a valley… It was a large, handsome, stone building, standing well on rising ground, and backed by a ridge of high woody hills;—and in front, a stream of some natural importance was swelled into greater, but without any artificial appearance… Elizabeth was delighted. She had never seen a place for which nature had done more, or where natural beauty had been so little counteracted by an awkward taste. They were all of them warm in their admiration; and at that moment she felt, that to be mistress of Pemberley might be something!

PRIDE AND PREJUDICE

As the daughter of a country rector who had eight children to provide for, Jane Austen did not often experience luxury growing up. Mr. Austen's parsonage in the country village of Steventon was a plain, spacious house, appropriate to the parish and the time, but life in the big Austen family could hardly be called luxurious. Jane had many opportunities, however, to experience more opulent surroundings when visiting the manor houses of the Austens' more affluent relatives and neighbors. Jane and her family traveled frequently to visit relatives and often stayed for weeks, experiences that must have provided her with excellent inspiration for the houses of the characters in her novels.

GODMERSHAM PARK

One of the Austen children, Edward, the third-eldest son, did become wealthy. He had the extraordinary good luck to catch the attention of Mr. Austen's distant cousin Thomas Knight II and his wife, Catherine, when they visited the Austen family while on their honeymoon. They invited young Edward to travel with them

and were so pleased with him that they began to invite him to stay with them now and then. When it became clear after some years that they would remain childless, the Knights began to mark Edward out as the eventual heir, as Jane's niece Anna recollected: "By degrees however, it came to be understood in the family that Edward was selected from amongst themselves as the adopted son and Heir of Mr. Knight; and in further course of time he was taken more entire possession of, & sent to study in some German university." Early in 1786 he set off on the traditional Grand Tour of Europe, visiting Rome, Switzerland, and Dresden, then returning about two years later to live permanently with the Knights at their estate of Godmersham Park in Kent, where Mr. Knight taught him the intricacies of estate management. Late in 1791 he married a neighbor of the Knights, Elizabeth Bridges, the daughter of Sir Brook Bridges of Goodnestone Park. The Bridges provided them with a small country house, Rowling, near Goodnestone, and the young couple's first four children were born there. Later that year, when Thomas Knight died, his will confirmed Edward as his

eventual heir. Mrs. Knight inherited a life interest in his estates and continued to live at Godmersham, but in 1798 she moved to Canterbury and turned over the estates to Edward and his family, reserving to herself an income of £2,000 from Godmersham. Jane and Cassandra visited their brother and his family at Rowling in 1794 and Jane returned in 1796. While there, Jane enjoyed the elegant social life Edward's family led in Kent, writing to Cassandra, "We were at a Ball on Saturday I assure you. We dined at Goodnestone & in the Evening danced two Country Dances & the Boulangeries.—I opened the Ball with Edw[ar]d Bridges… We supped there, & walked home at night under the shade of two Umbrellas." (September 5, 1796) Ten days later, she was still in the heart of the social whirl: "We have been very gay since I wrote last; dining at Nackington, returning by Moonlight, and everything quite in Stile… At Nackington we met Lady Sondes' picture over the Mantlepeice in the Dining room… Miss Fletcher and I were very thick, but I am the thinnest of the two… We dine to day at Goodneston…" (September 15, 1796)

When Edward moved into Godmersham in 1798, Mr. and Mrs. Austen, Jane, and Cassandra came to stay with Edward's family in August, the first recorded visit made by the Austen family to Godmersham, though there may have been earlier occasions. In future years, Jane and Cassandra made frequent visits to Godmersham, often for months at a time, sometimes together and sometimes alone. The sisters, who were always very close, no doubt found it difficult to be apart, but they compensated by writing chatty letters to each other frequently. Indeed, most of the known existing letters that Jane Austen wrote are from the times they were separated.

Godmersham Park, an elegant Palladian mansion built of red brick, is sometimes mentioned as one of the many possible estates that inspired Mr. Darcy's estate of Pemberley in Jane's novel *Pride and Prejudice*. It is sited some eight miles southwest of Canterbury among the beautiful wooded hills and gentle downs of the River

Stour valley. Surrounded by a large park and extensive pleasure grounds, it could also have been an inspiration for Mansfield Park, the Bertrams' estate in the novel of the same name. Mary Crawford, worldly and ambitious, is impressed enough with Mansfield Park to contemplate marriage with the heir, Tom:

Miss Crawford soon felt, that he and his situation might do. She looked about her with due consideration, and found almost everything in his favour, a park, a real park five miles round, a spacious modern-built house, so well placed and well screened as to deserve to be in any collection of engravings of gentlemen's seats in the kingdom, and wanting only to be completely new furnished…

Godmersham was often featured in such collections of "engravings of gentlemen's seats." The mansion had a taller central portion containing the grand entrance hall and was flanked by two lower wings. It was nearly always depicted in the engravings with the River Stour curling picturesquely in front of the long, low house, a wooded hill rising behind, and horses, cattle, or deer grazing placidly in the foreground. At the back of the house grew the gardens and shrubberies of the pleasure grounds, sloping up toward the hill shown in the engravings to a handsome summerhouse and a planted wood called "Bentigh." "The family always walked through it on their way to church," wrote Edward Knight's grandson, Lord Brabourne, "leaving the shrubberies by a little door in the wall, at the end of the private grounds, which brought them out just opposite the church." In the front of the house, across the River Stour and up another hill, grew the wood the family called "Temple Plantations," named after another little summerhouse in the form of a temple there. Jane enjoyed strolling all over Godmersham Park, writing to Cassandra, "Yesterday passed quite a la Godmersham: the gentlemen rode about Edward's farm, and returned in time to saunter along Bentigh with us; and after dinner we visited the Temple Plantations… James and Mary

are much struck with the beauty of the place." (June 16, 1808)

The house has had its interior considerably altered since the days when Jane Austen visited there and certain rooms she mentions are not always identifiable. One of the wings had a large and comfortable library, no longer in existence, where Edward's family and guests would sometimes gather, take tea, and even breakfast, and where Jane liked to write, her niece Marianne recalled:

I remember that when Aunt Jane came to us at Godmersham she used to bring the manuscript of whatever novel she was writing with her, and would shut herself up with my elder sisters in one of the bedrooms to read them aloud. I and the younger ones used to hear peals of laughter through the door, and thought it very hard that we should be shut out from what was so delightful. I also remember how Aunt Jane would sit quietly working beside the fire in the library, saying nothing for a good while, and then would suddenly burst out laughing, jump up and run across the room to a table where pens and paper were lying, write something down, and then come back to the fire and go on quietly working as before.

Judging by her letters to Cassandra, Jane very much relished the luxuries afforded by a large estate and a large income. She wrote to Cassandra from Godmersham not only about the family's activities and visitors, but also about how much she enjoyed the elegant food and drink served there, contrasting the wine the Austens made at home with Edward's imported wine: "The Orange Wine will want our Care soon.—But in the meantime for Elegance & Ease & Luxury—The Hattons' & Milles' dine here today—& I shall eat Ice & drink French wine, & be above Vulgar Economy." (July 1, 1808)

Godmersham Park is in private ownership and is open only by special arrangement. Remnants of the original gardens and shrubberies still exist, as do the two summerhouses.

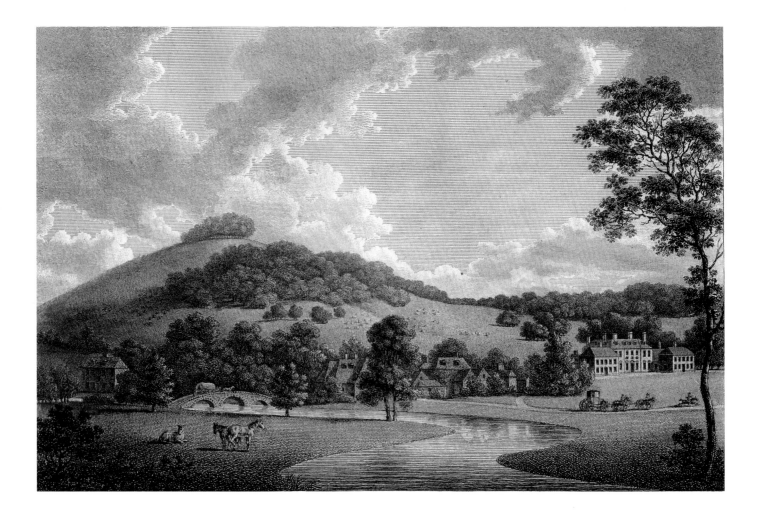

CHAWTON HOUSE

The second estate inherited by Edward from Thomas Knight was Chawton, near Alton in Hampshire. The Knight family bought the estate in 1551, and replaced the medieval manor house with the warm red brick house that stands on the site today. Much of the original house, which was begun around 1583 and worked on through the mid 1660s, still exists and has been extensively restored after becoming dilapidated in the late 20th century. Some of the house looks as it did when Jane Austen visited there, though in the late 19th century Montagu Knight made some changes, including adding a great deal of new paneling, in imitation of the original paneling, to various rooms. The ground floor contains the entry hall, the dining room, and the paneled Great Hall, which retains its original paneling. Upstairs, in addition to former bedrooms, are the rooms now known as the Tapestry Gallery, the Great Gallery, the Oak Room, and the Library, which dates to the mid-Victorian period. The kitchen, part of the Elizabethan servants' wing, was built in 1592, and contains a work table and a dresser from the 18th century, as well as a kitchen range from the early Victorian period. "This is a fine large old house," wrote Jane's niece Fanny in 1807,

"We all five walked together into the Kitchen Garden & along the Gosport Road, & they drank tea with us." (June 14, 1814) Fanny faithfully noted the daily visiting in her diary, with "We drank tea at the Cottage" and "The Cottage dined here" being frequent entries.

Chawton House is now home to the Chawton House Library, a center dedicated to the study of the works and lives of women writers who wrote before 1830. The restored rooms are used for research, education, and conferences. Tours of the house are available on certain days of the week, and self-guided garden tours are available on weekdays. Many features of the gardens and pleasure grounds at Chawton House today look nearly the same as they did in Jane Austen's day, including a lime (linden) avenue; a wilderness walk, like the "prettyish kind of a little wilderness" Lady Catherine de Bourgh notices at the Bennets' estate in *Pride and Prejudice*; and a ha-ha, a sunken fence that preserves views of the grounds, like the one at Mr. Rushworth's estate in *Mansfield Park*. A late Regency walled kitchen garden, which Edward planted not long after Jane's death, is gradually being restored.

When Mrs. Knight died in 1812, Edward came into full possession of his inheritance of Godmersham Park, the Chawton House estate, and other property in Hampshire, including Steventon, and in obedience with the terms of his cousin's will changed his name from Austen to Knight. His daughter Fanny was not happy about the change, writing in her diary, "we are all therefore *Knights* instead of dear old *Austens*. How I hate it!!!!!!" Jane took a more prosaic attitude, writing to Martha Lloyd, "We have reason to suppose the change of name has taken place… I must learn to make a better K." (November 29, 1812)

". . . & here are such a number of old irregular passages &c &c that it is very entertaining to explore them, & often when I think myself miles away from one part of the house I find a passage or entrance close to it . . ."

Edward's extensive property, which included much of the village of Chawton, enabled him to do a substantial favor for his widowed mother and his sisters. He offered them the house now known as Chawton Cottage, and in July 1809 Mrs. Austen, Jane, Cassandra, and Martha Lloyd left Southampton and moved to Chawton for good (see Chawton). Edward's main residence remained at Godmersham, but he and his family often stayed at Chawton House, when it was not being let out, for months at a time in summers or when Godmersham was being painted. There was much visiting back and forth between the "Great House" and "The Cottage." The two families often walked together in the pleasant grounds of Chawton House, and regularly met to dine

ABOVE *Dynes Hall*, by Diana Sperling, no date.

ABOVE LEFT Chawton House, by Mellichamp, circa 1740. ABOVE RIGHT Chawton House and Church, unknown artist, 1899.
BELOW *The Spoiled Child, Scene 1,* by Lewis Vaslet, circa 1802.

AT HOME WITH JANE AUSTEN

ABOVE LEFT The Wilderness Walk at Chawton House Library. ABOVE RIGHT *The Gardener's Offering*, by Thomas Rowlandson, circa 1803–1805.

ADLESTROP

Mrs. Austen, who had been born into the rather aristocratic Leigh family, kept close ties with her cousins over the years. Her cousin the Reverend Thomas Leigh lived at Adlestrop rectory (now called Adlestrop House) and his nephew James at Adlestrop House (now called Adlestrop Park) nearby. Jane Austen visited the Leighs at Adlestrop at least three times, in 1794, 1799, and 1806. Adlestrop is a picturesque village in the Cotswolds, near Stow-on-the-Wold, Gloucestershire. The Reverend Leigh (whom Jane called respectable, clever, and agreeable), seemed to have had a soft spot for Mrs. Austen's children, often tipping them little presents of money whenever he saw them. In 1802 he had the famed landscape designer Humphry Repton carry out improvements to the Adlestrop estate. He opened up the back of the rectory and moved the entrance, reminiscent of Henry Crawford's plans for Edmund Bertram's parsonage in *Mansfield Park*. He enclosed the village green and developed his garden in the best picturesque style. Humphry Repton, in his *Observations on the Theory and Practice of Landscape Gardening* (1803), described the changes at Adlestrop,

including "a lively stream of water… led through a flower garden, where its progress down the hill is occasionally obstructed by ledges of rock… in full view both of the mansion and the parsonage, to each of which it makes a delightful, because a natural, feature in the landscape." Repton charged five guineas a day to provide such delightful visions to his clients, a fact that Jane Austen must have learned during her 1806 visit, and used in *Mansfield Park*. Mr. Rushworth wants to improve his property to look as well as his friend Smith's, but doesn't know where to begin: "'I must try to do something with it,' said Mr. Rushworth, 'but I do not know what. I hope I shall have some good friend to help me… as [Repton] has done so well by Smith, I think I had better have him at once. His terms are five guineas a day.' 'Well, and if they were *ten*,' cried Mrs. Norris, 'I am sure you need not regard it.'"

STONELEIGH ABBEY

Coincidently, it was right around the time of the Austens' 1806 visit to Thomas Leigh that he inherited the great estate of Stoneleigh Abbey from a distant cousin who had died unmarried. At the end

of the Austens' visit, the Reverend Leigh invited them and the rest of his houseguests to travel to Warwickshire with him to view his inheritance. The Abbey, established in 1154, became a private home in 1535 when Henry VIII dissolved the monasteries of England, selling them off or granting them outright, much like the history of the fictional Northanger Abbey in Jane Austen's novel of the same name. The Leigh family purchased Stoneleigh in 1561, and it remained in Leigh hands until 1996, when ownership passed to a charitable trust. Stoneleigh is a large, handsome house, with some sections, including the gatehouse, dating to medieval times, and some to the 17th century. In the 1720s the 3rd Lord Leigh, inspired by his Grand Tour of the continent, added an impressive new extension, the Great West Wing.

Mrs. Austen wrote to her daughter-in-law about her favorable impressions of Stoneleigh:

Here we all found ourselves on Tuesday… at a late hour, in a Noble large Parlour hung round with family Pictures—everything is very Grand & very fine & very Large—The house is larger than I could have supposed—we can now find our way about it, I mean the best part, as to the offices (which were the old Abby [sic] Mr. Leigh almost dispairs [sic] of ever finding his way about them… I expected to find everything about the place very fine & all that, but I had no idea of its being so beautiful, I had pictured to myself long Avenues, dark rookeries, & dismal Yew Trees, but here are no such melancholy things. The Avon runs near the house amidst green meadows bounded by large and beautiful woods, full of delightful walks. At nine in the morning we say our prayers in a handsome chapel… I will now give you some idea of the inside of this vast house, first premising that there are 45 windows in front, (which is quite strait with a flat Roof) 15 in a row—you go up a considerable flight of steps (some offices are under the house) into a large Hall, on the right hand, the dining parlour, within that the Breakfast room, where we generally sit, and reason good, tis the only room (except the Chapel) that looks towards the River,—on the left hand the Hall is the best drawing room, within that a smaller, these rooms are rather gloomy, Brown wainscoat & dark Crimson furniture, so we never use them but to walk thro' them to the old picture Gallery; Behind the smaller drawing Room is the State Bed chamber with a high dark crimson Velvet Bed, an <u>alarming</u> apartment just fit for an Heroine, the old Gallery opens into it—behind the Hall & Parlour, a passage all across the house containing 3 staircases & two small back Parlours—there are 26 Bed Chambers in the new part of the house, & a great many (some very good ones) in the Old… The garden contains 5 acres and a half. The ponds supply excellent fish, the park excellent venison; there is also great plenty of pigeons, rabbits, & all sort of poultry, a delightful dairy where is made butter, good Warwickshire cheese & cream ditto.

LETTER FROM MRS. AUSTEN TO MARY LLOYD AUSTEN, AUGUST 13, 1806

Clearly, Mrs. Austen had the same sort of imagination as her daughter Jane, thinking of the sort of atmosphere an abbey *ought* to have: "dismal Yew Trees" and a state bedchamber that would have pleasantly alarmed Catherine Morland in *Northanger Abbey*. Stoneleigh Abbey, ancient and impressive, may have served as a model for some of the great estates in Jane Austen's works. There is some evidence that she copied at least one feature. The chapel at Stoneleigh matches the description of the chapel at Sotherton Court in *Mansfield Park* very closely: a "spacious, oblong room, fitted up for the purpose of devotion" with "crimson velvet cushions appearing over the ledge of the family gallery above."

In 1809, Thomas Leigh again employed Humphry Repton, this time to improve Stoneleigh Abbey. Repton designed one of his famous Red Books, showing the "before" and "after" of his vision for Stoneleigh, but not all of his proposals were implemented. One of the important changes made was to move

AT HOME WITH JANE AUSTEN

Sam, Ireland delt.

Stonely Abbey, Warwickshire.

Stoneleigh Abbey, 1795.

the course of the River Avon closer to the house, creating a lake with an island. The view from the pleasant, sunny breakfast room where Mrs. Austen, Jane, and Cassandra sat is therefore somewhat different today from what they saw in 1806. The changes improved an already beautiful landscape, drawing notice to Stoneleigh as a worthwhile stop for tourists:

Stoneleigh Abbey, with its beautiful gardens, noble bridge, romantic deer park, splendid apartments, spacious chapel, &c, &c. is most delightfully situated… surrounded by towering and spreading woods, and having all the concomitants of water, rock and meadow, that are generally considered necessary to the perfection of landscape, and a ride hither, whether he be fortunate

enough to gain access to the interior of the magnificent mansion or not, will well repay the attention of the visitor.
— THE VISITOR'S NEW GUIDE TO THE SPA OF LEAMINGTON PRIORS, AND ITS VICINITY, 1818

The breakfast room itself was completely remodeled and redecorated as a bedroom for a visit from Queen Victoria in 1858. The room has been preserved since and is now known as "Queen Victoria's Bedroom." Most of Stoneleigh Abbey has been converted into private flats. The large staterooms, including the chapel with its crimson cushions, are open for tours on certain days from late spring through early autumn (with a Jane Austen tour on some of those days) and for events. Work is underway to restore the Reptonian landscape.

As young women, Jane and Cassandra visited many of the estates near Steventon for dinners, balls, and other occasions. One, Manydown Park, near Basingstoke, was a special favorite. Jane and Cassandra were good friends with the younger daughters of the house, Elizabeth, Catherine, and Alethea Bigg and their brother

ABOVE LEFT Tom Lefroy as a young man.
ABOVE RIGHT Harris Bigg-Wither as a young man.

Harris Bigg-Wither. Over the years the girls made numerous visits to Manydown and enjoyed the social events hosted there, including a ball where Jane flirted with the love of her teenage life, Tom Lefroy:

We had an exceeding good ball last night… Mr. H. began with Elizabeth, and afterwards danced with her again; but they do not know how to be particular. I flatter myself, however, that they will profit by the three successive lessons which I have given them. You scold me so much in the nice long letter which I have this moment received from you, that I am almost afraid to tell you how my Irish friend and I behaved. Imagine to yourself everything most profligate and shocking in the way of dancing and sitting down together. I can expose myself, however, only once more, because he leaves the country soon after next Friday… He is a very gentlemanlike, good-looking, pleasant young man, I assure you. But as to our having ever met, except at the three last balls, I cannot say much; for he is so excessively laughed at about me at Ashe, that he is ashamed of coming to Steventon, and ran away when we called on Mrs. Lefroy a few days ago… I danced twice with Warren last night, and once with Mr. Charles Watkins, and, to my inexpressible astonishment, I entirely escaped John Lyford. I was forced to fight hard for it, however. We had a very good supper, and the greenhouse was illuminated in a very elegant manner.
— LETTER FROM JANE AUSTEN TO CASSANDRA, JANUARY 9, 1796

In 1802, though, Jane experienced a completely different sort of romantic embarrassment at Manydown. On November 25 Jane and Cassandra arrived at the house, intending to visit Alethea and Catherine Bigg for two or three weeks. All went well at first, but on the evening of December 2 Harris Bigg-Wither proposed to Jane—and she accepted him. Overnight she must have panicked at the prospect, for by the morning she told him she had changed her

ABOVE *Elegant Company Dancing,* by Thomas Rowlandson, undated.

mind. She and Cassandra packed up and left the house in a flurry, arriving back at their brother James's house at Steventon with a demand that he drive them back to Bath at once. On the surface, it had looked like a good match. Harris would have inherited a nice property eventually, and he was the brother of Jane's dear friends. He was, however, some years younger than Jane, and "was very plain in person—awkward, & even uncouth in manner—nothing but his size to recommend him," according to Jane's niece Caroline. At nearly 27 years old, Jane may have felt, in what her niece Catherine called "a momentary fit of self-delusion," that the position Harris offered had too many advantages to pass up, but then couldn't face being married to the man himself. Like her heroines, Jane had high standards. As Emma says in the novel of the same name, "My being charming, Harriet, is not quite enough to induce me to marry; I must find other people charming—one other person at least… I must see somebody very superior to any one I have seen yet, to be tempted."

SOUTHAMPTON

We hear that we are envied our House by many people, & that the Garden is the best in the Town.

LETTER FROM JANE AUSTEN TO HER SISTER, CASSANDRA, FEBRUARY 21, 1807

Jane Austen had traveled to Southampton, a scenic port town on the south coast of England, at least twice before she moved there: first in the summer of 1783, when little seven-year-old Jane, her sister, Cassandra, and their cousin had moved to the town with their schoolmistress, and once in 1793, when she and Cassandra, then eighteen and twenty years old, had visited a cousin for the Christmas holidays and had very much enjoyed dancing at an assembly at the Dolphin Inn. But now, in the autumn of 1806, Mrs. Austen, Jane, Cassandra, their friend Martha Lloyd, and their brother Captain Francis Austen and his wife, Mary, were moving to Southampton for an indefinite stay. The two families planned to combine their households, saving on expenses and providing young Mary Gibson Austen, who was expecting her first child, with companionship when Frank went to sea. Southampton, near enough to Portsmouth and its Navy Dockyards to be convenient for Frank, had a reputation as a healthful and attractive resort. It was sited on the inlet known as Southampton Water in the county of Hampshire, on a gravelly peninsula between the Rivers Test and Itchen, looking out over the New Forest. "The lovely situation of Southampton, the elegance of its buildings, the amenity of its environs, and the various other attractions which it possesses,

in a very high degree, will always render it a place of fashionable residence… equally adapted for health, pleasure, and commerce," said the author of *A Guide to All the Watering and Sea-Bathing Places* (1813). "The air is soft and mild, and sufficiently impregnated with saline particles to render it agreeable, and even salutary." And, the young Austen girls' previous experiences to the contrary, it claimed that "no situation can be finer than Southampton, for the health and education of youth."

On first arriving in Southampton on October 10, the Austens moved into lodgings and began to look for a more permanent house. "The lodging houses for company… here, are in general very commodious, and many of them elegant," reported the author of *A Journey into Cornwall* (1799). The Austens soon settled in to a quiet, at-home life, reading in the evenings, helping Mary prepare the expected baby's layette, and receiving occasional visitors. There is no record of the location of the lodgings, but they were comfortable enough for the Austens to feel they could invite guests to stay. When Martha Lloyd and Cassandra left for extended Christmas visits to relatives, James Austen (the eldest Austen son) and his wife, Mary Lloyd Austen (Martha's sister), and their little girl Caroline arrived for a New Year's visit. Cassandra normally

Southampton, Hampshire, early 19th century.

SOUTHAMPTON

managed the household, directing the servants and ordering the dinners, but with Cassandra away Jane took charge of the family's housekeeping, a task not entirely to her taste. Compounding her difficulties, their usual cook, Jenny, was away, and Molly, who filled in, produced dinners that occasionally bordered on the disastrous. "Captain Foote… dined with us on Friday," Jane wrote to Cassandra, "and I fear will not soon venture again, for the strength of our dinner was a boiled leg of mutton, underdone even for James; and Captain Foote has a particular dislike to underdone mutton; but he was so good-humoured and pleasant that I did not much mind his being starved." Jenny had still not returned by the week following the unfortunate dinner, Jane reported. "We… can only suppose that she must be detained by illness in somebody or other… I am glad I did not know beforehand that she was to be absent during the whole or almost the whole of our friends being with us, for though the inconvenience has not been nothing, I should have feared still more. Our dinners have certainly suffered not a little by having only Molly's head and Molly's hands to conduct them; she fries better than she did, but not like Jenny." She couldn't help looking forward to having the house clear of guests. "When you receive this, our guests will be all gone or going, and I shall be left to the comfortable disposal of my time, to ease of mind from the torments of rice puddings and apple dumplings, and probably to regret that I did not take more pains to please them all." (January 7–8, 1807)

The Austens found their quiet life beginning to give way to a social one more quickly than they liked. "Our acquaintance increase too fast," Jane reported to Cassandra:

[Frank] was recognized lately by Admiral Bertie, and a few days since arrived the Admiral and his daughter Catherine to wait upon us. There was nothing to like or dislike in either. To the Berties are to be added the Lances, with whose cards we have been endowed, and whose visit Frank and I returned yesterday… We found only

ABOVE TOP *Southampton, the Watergate and Globe Inn,* by Thomas Rowlandson, undated. ABOVE *A Girl Peeling Vegetables,* by Joshua Cristall, circa 1810–1815. OPPOSITE Southampton, from *Hampshire, or the County of Southampton, including the Isle of Wight,* by Thomas Milne, 1791.

AT HOME WITH JANE AUSTEN

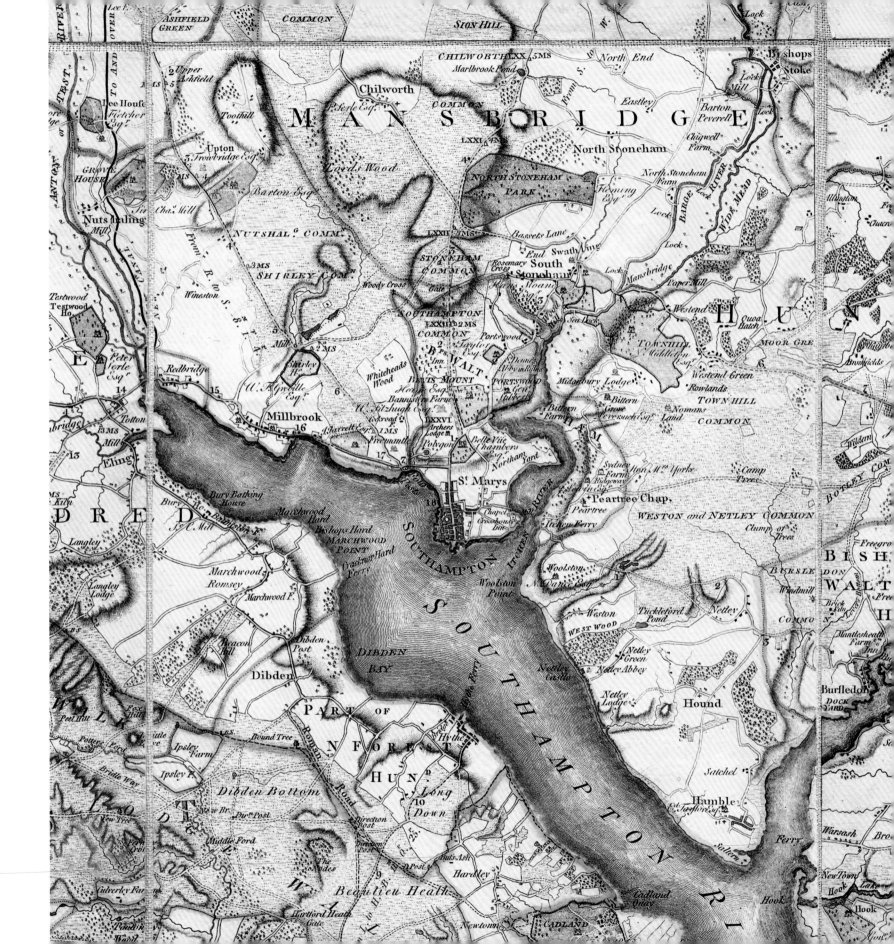

Mrs. Lance at home, and whether she boasts any offspring besides a grand pianoforte did not appear. She was civil and chatty enough, and offered to introduce us to some acquaintance in Southampton, which we gratefully declined. I suppose they must be acting by the orders of Mr. Lance of Netherton in this civility, as there seems no other reason for their coming near us. They will not come often, I dare say. They live in a handsome style and are rich, and she seemed to like to be rich, and we gave her to understand that we were far from being so; she will soon feel therefore that we are not worth her acquaintance.

JANUARY 8, 1807

It took the Austens some time to find a house not only to their taste, but also affordable and large enough for their household. By February, however, Mrs. Austen and Frank, combining their incomes and expenses, were able to find "a commodious old-fashioned house in a corner of Castle Square" to rent, their nephew James Edward Austen-Leigh later recalled in his *Memoir.* Mrs. Austen had felt at ease about the proposed expenditure, reflecting with satisfaction, Jane reported to Cassandra, on "the comfortable state of her own finances." Frank's plan of combining households looked as though it would work out well for both families as long as they were prudent in their spending. "Frank too has been settling his accounts and making calculations, and each party feels quite equal to our present expenses; but much increase of house-rent would not do for either. Frank limits himself, I believe, to four hundred a year." (January 7–8, 1807)

The Austens' house at 3 Castle Square and Castle Square itself lay elevated above the town on the site of a medieval castle on a small hill within the old city walls, many of which still stood in the Austens' day. At that time the water came right to the foot of the walls at high tide, as the author of *A Walk Through Southampton* (1805) noted: "The height of the wall from its foot is here twenty eight feet… The tide washes the whole of this wall, quite to the

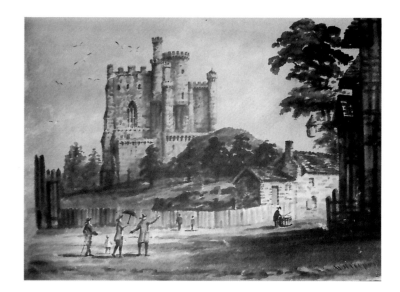

north-west corner… and the ground within is almost level with its top the whole way; so that it forms a most beautiful terrace to the gardens which belong to the houses in the High-street and Castle-square, and run quite to the wall, commanding an enchanting

ABOVE TOP Title page and frontispiece of *The Art of Cookery Made Plain and Easy,* by Hannah Glasse, circa 1777. ABOVE The Marquis of Lansdowne's mock-Gothic castle in Southampton, 1805.

AT HOME WITH JANE AUSTEN

view of the bay, from the town to the village of Milbrook, and the river beyond it quite to Redbridge." Indeed, the garden and the view were some of the best features of the house, James Edward remembered. "My grandmother's house had a pleasant garden, bounded on one side by the old city walls; the top of this wall was sufficiently wide to afford a pleasant walk, with an extensive view, easily accessible to ladies by steps." The Austens began to make improvements to the house and property prior to moving in. It must have been especially pleasing, after the narrow confines of their town gardens in Bath, to plan their extensive new garden, which was large enough to grow not only flowers, but fruit and flowering shrubs as well. Jane wrote to Cassandra, pleased with the prospect: "Our Garden is putting in order, by a Man who bears a remarkably good Character, has a very fine complexion, & asks something less than the first. The Shrubs which border the gravel walk he says are only sweetbriar & roses, & the latter of an indifferent sort;—we mean to get a few of a better kind therefore, & at my own particular desire he procures us some Syringas. I could not do without a Syringa, for the sake of Cowper's line. We talk also of a Laburnum. The Border under the Terrace Wall, is clearing away to receive Currants & Gooseberry Bushes, & a spot is found very proper for Raspberries." (February 8, 1807) The syringa she speaks of is not a lilac, but *Philadelphus*, or mock orange, and appears with laburnum in William Cowper's poem *The Task*:

> … *These naked shoots,*
> *Barren as lances, among which the wind*
> *Makes wintry music, sighing as it goes,*
> *Shall put their graceful foliage on again,*
> … *Laburnum, rich*
> *In streaming gold; syringa, ivory pure…*

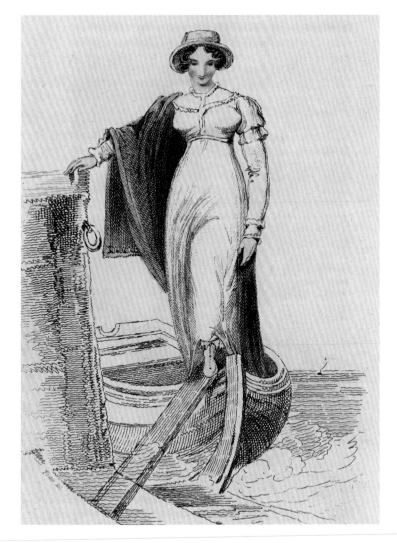

LEFT TOP *High Street, Southampton,* from Ackermann's *Repository of Arts,* 1812. LEFT Morning Dress for October 1812.

Preparations continued for the improvement of the interior of the house, too, with the Austens making many new purchases for their new home. Cassandra, still at their brother Edward's estate Godmersham, was missing out, Jane told her. "Frank & Mary cannot at all approve of your not being at home in time to help them in their finishing purchases, & desire me to say that, if you are not, they will be as spiteful as possible & choose everything in the stile most likely to vex you, Knives that will not cut, glasses that will not hold, a sofa without a seat, & a Book-case without shelves." (February 8, 1807) She asked Cassandra to bring back flower seeds from Godmersham for the garden, "particularly Mignonette seed." (February 20, 1807) Together with the servants and a workwoman, Mrs. Day, who was called in to assist, the Austens had much sewing to do before they could move in: the bedding and hangings for all the beds of the family and much more, Jane wrote. "The Garret-beds are made, & ours will be finished to day. I had hoped it wd [would] be finished on Saturday, but neither M^rs Hall [a maidservant] nor Jenny were able to give help enough for that; & I have as yet done very little & Mary nothing at all. This week we shall do more, & I shd [should] like to have all the 5 Beds completed by the end of it.—There will then be the Window-Curtains, sofa-cover, & a carpet to be altered." (February 9, 1807) Frank Austen proved himself handy as well, not only cutting out some of the linen for his expected baby's layette, but assisting with the decorating. "Frank has got a very bad Cough, for an Austen," Jane reported to Cassandra, "but it does not disable him from making very nice fringe for the Drawingroom-Curtains." (February 21, 1807)

Captain Austen's facility with handicrafts (he once made a turned wood butterchurn for a niece) and his eagerness to use his skills to improve his rented house must surely have inspired the cozy scene in *Persuasion*, where Anne Elliot visits Captain Harville's family and sees "all the ingenious contrivances and nice arrangements of Captain Harville, to turn the actual space

to the best account, to supply the deficiencies of lodging-house furniture, and defend the windows and doors against the winter storms to be expected… the picture of repose and domestic happiness it presented, made it to her a something more, or less, than gratification… a mind of usefulness and ingenuity seemed to furnish him with constant employment within. He drew, he varnished, he carpentered, he glued; he made toys for the children; he fashioned new netting-needles and pins with improvements; and if everything else was done, sat down to his large fishing-net at one corner of the room."

Living in Castle Square meant the Austens frequently saw one of the amusing sights of the city: their landlord, the notoriously eccentric Marquis of Lansdowne. The Marquis had purchased many of the houses on the square and had demolished some of them to build himself a miniature fantasy gothic castle on the ruins of the medieval castle that stood there formerly. The new castle filled much of the square, "too large for the space in which it stood,

ABOVE Detail, *The Sailor's Journal*, 1805.

though too small to accord well with its castellated style," recalled nephew James Edward. Visiting the house as a young boy he was enchanted by the sights he saw from the Austens' house over the square:

The Marchioness had a light phaeton, drawn by six, and sometimes by eight little ponies, each pair decreasing in size, and becoming lighter in colour, through all the grades of dark brown, light brown, bay, and chestnut, as it was placed farther away from the carriage. The two leading pairs were managed by two boyish postillions, the two pairs nearest to the carriage were driven in hand. It was a delight to me to look down from the window and see this fairy equipage put together; for the premises of this castle were so contracted that the whole process went on in the little space that remained of the open square.

The Marquis himself, noted tourist Louis Simond in *Journal of a Tour and Residence in Great Britain During the Years 1810 and 1811*, was a very tall, thin man who favored "riding on a long lean horse, and had following him a very little page, called his dwarf, mounted on a diminutive pony. The knight, the dwarf, and the castle, seemed made for each other. He must, in the main, have been a good sort of man, as the people about here, although they laugh at the castle and castle-builder, all speak well of him, and are hardly willing to admit that he was mad; but then, as I have observed before, the qualifications required for acknowledged insanity, are by no means easily attained in England, where a greater latitude is granted for whims, fancies, and eccentricities, than in other countries."

Jane Austen must certainly have been among those who were amused by the Mad Marquis. Writing to Cassandra as the Austens put their new house in order that the "alterations and improvements within doors, too, advance very properly, and the offices will be made very convenient indeed," she noted an encounter with a member of the Marquis's staff: "Our Dressing-Table is constructing on the spot, out of a large Kitchen Table belonging to the House, for doing which we have the permission of Mr Husket Lord Lansdown's Painter,—domestic Painter I sh[oul]d call him, for he lives in the Castle— Domestic Chaplains have given way to this more necessary office, & I suppose whenever the Walls want no touching up, he is employed about my Lady's face." (February 8, 1807)

Finally, in March the house was ready. Mrs. Day was called "to clean the new House & air the Bedding," and the Austens moved in around March 9 or 10. Not long afterward, Frank Austen was appointed to command HMS *St. Albans*, which meant convoy duty to South Africa, the East Indies, and China. He missed the birth of his baby, Mary Jane, while preparing and stocking his ship for the extended voyage, but once the ship was ready he had a month at home before setting sail at the end of June.

That summer, the Austens traveled to meet Edward and his family at Edward's other estate, Chawton. Then we have no more letters from Jane until over a year later, in the summer of 1808 when she wrote to Cassandra from Godmersham (see Stately Mansions). The next letters from Southampton start in October of that year, when Jane and Cassandra have switched places: Jane was back in Castle Square, and Cassandra was at Godmersham, helping her sister-in-law Elizabeth prepare for the birth of her 11th child. Jane's initial letters were full of the usual chatty news, telling of presents of game received at the Castle Square house from the Chawton estate, and the sorts of parties they had attended and hosted. Jane included her amusing observations on the people she met, including the "civil and silly" Miss Maitlands: "I have got a Husband for each of the Miss Maitlands;—Col [Colonel] Powlett & his Brother have taken Argyle's inner House, & the consequence is so natural that I have no ingenuity in planning it. If the Brother sh[oul]d luckily be a little sillier than the Colonel, what a treasure for Eliza." (October 1, 1808)

Tragically, news arrived from Godmersham of Elizabeth's sudden death following what had appeared initially to be a good recovery from childbirth. Jane wrote, through Cassandra, of her deepest sympathy and sorrow for and his family: "We have felt, we do feel for you all—as you will not need to be told—for you, for Fanny, for Henry, for Lady Bridges, & for dearest Edward, whose loss & whose sufferings seem to make those of every other person nothing.—God be praised! that you can say what you do of him—that he has a religious Mind to bear him up, & a Disposition that will gradually lead him to comfort… May the Almighty sustain you all—& keep you my dearest Cassandra well—but for the present I dare say you are equal to everything." (October 13, 1808)

Edward's oldest boys, Edward and George, were at school at Winchester. James and Mary Lloyd Austen picked them up from school and kept them for some days. They then went to stay with their Grandmother Austen and Aunt Jane at Castle Square, where Jane did her best to entertain and soothe them. "They behave extremely well in every respect," she told Cassandra, "showing quite as much feeling as one wishes to see, and on every occasion speaking of their father with the liveliest affection. His letter was read over by each of them yesterday, and with many tears; George sobbed aloud, Edward's tears do not flow so easily; but as far as I can judge they are both very properly impressed by what has happened." Jane entered into their feelings with ready sympathy. She made sure they had proper mourning clothes, which both boys wished to have: "I find that black pantaloons are considered by them as necessary, and of course one would not have them made uncomfortable by the want of what is usual on such occasions." She played games with them and went for walks: "We do not want amusement; bilbocatch [cup and ball], at which George is indefatigable, spillikins [jackstraws or pick-up sticks], paper ships, riddles, conundrums, and cards, with watching the flow and ebb of the river, and now and then a stroll out, keep us well employed… While I write now, George is most industriously making and naming paper ships, at which he afterwards shoots with horsechestnuts brought from Steventon on purpose; and Edward equally intent over the "Lake of Killarney," twisting himself about in one of our great chairs." (October 24, 1808) She even took them on "a little water party… from the Itchen Ferry up to Northam, where we landed, looked into the 74 [ship], and walked home" (October 25, 1808) and planned to take them to Netley Abbey. Altogether, it is obvious that Jane was a loving and devoted aunt, and it is clear that her love was returned.

Edward Austen proposed a new idea to Mrs. Austen, that she should accept a house on one of his estates and move there with Jane, Cassandra, and Martha. Perhaps, shocked and saddened by his wife's death, he felt that he would like to have his mother and his sisters closer to him. The more Mrs. Austen thought about the idea the more she liked it, and she began to ask about its features, inquiring particularly into the number of bedchambers and its garden (see Chawton). Jane began to make her plans, too. One of her few indulgences at Southampton had been the rental of a pianoforte for her own use, and she would have one at Chawton as well, she told Cassandra: "Yes, yes, we will have a Pianoforte, as good a one as can be got for 30 Guineas—& I will practise country dances, that we may have some amusement for our nephews & neices, when we have the pleasure of their company." (December 28, 1808)

The Austens continued to live at Southampton that winter and spring. Their social engagements increased and Jane intended to enjoy them as much as possible, she noted to Cassandra. "A larger circle of acquaintance, & an increase of amusement is quite in character with our approaching removal.—Yes—I mean to go to as many Balls as possible, that I may have a good bargain. Every body is very much concerned at our going away, & every body is acquainted with Chawton & speaks of it as a remarkably pretty village, & everybody knows the House we describe—but nobody fixes on the right." A recent ball at the Dolphin Inn had entertained her, she wrote:

Our Ball was rather more amusing than I expected, Martha liked it very much, & I did not gape till the last quarter of an hour.—It was past nine before we were sent for, & not twelve when we returned.—The room was tolerably full, & there were perhaps thirty couple of Dancers;—the melancholy part was to see so many dozen young Women standing by without partners, & each of them with two ugly naked shoulders! It was the same room in which we danced fifteen years ago! I thought it all over—& in spite of the shame of being so much older [she was now nearly 33], felt with Thankfulness that I was quite as happy now as then.—We paid an additional shilling for our Tea, which we took as we chose in an adjoining & very comfortable room… You will not expect to hear that I was asked to dance—but I was—by the Gentleman whom we met that Sunday with Capt[ai]n D'auvergne. We have always kept up a Bowing acquaintance since, &, being pleased with his black eyes, I spoke to him at the Ball, which brought on me this civility; but I do not know his name,—& he seems so little at home in the English Language, that I beleive his black eyes may be the best of him.

DECEMBER 9, 1808

There are no letters after January 30, but we know from family sources that Mrs. Austen, Jane, and Cassandra left Southampton in May, and traveled to Godmersham to stay with Edward and his family until the cottage at Chawton could be made ready for them. They arrived at what would be their final home in July 1809.

Dolphin Hotel, Southampton.

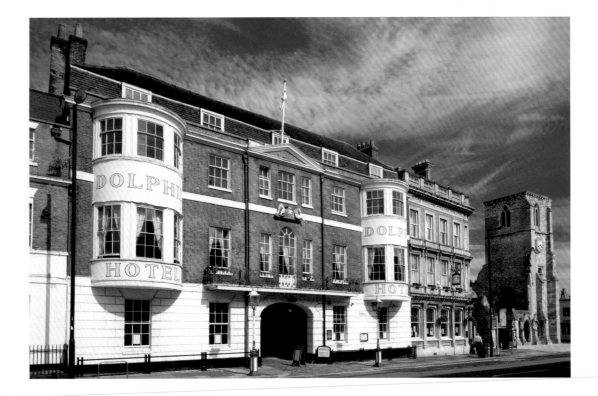

The Cobb, Lyme Regis, Dorset.

AT HOME WITH JANE AUSTEN

BY THE SEA

They went to the sands, to watch the flowing of the tide, which a fine south-easterly breeze
was bringing in with all the grandeur which so flat a shore admitted. They praised the morning;
gloried in the sea; sympathized in the delight of the fresh-feeling breeze—and were silent.

PERSUASION

The Austens frequently visited family and friends for their holidays, but they sometimes preferred to visit a seaside resort. "Edward Cooper is so kind as to want us all to come to Hamstall this summer, instead of going to the sea," wrote Jane, "but we are not so kind as to mean to do it. The summer after, if you please, Mr. Cooper, but for the present we greatly prefer the sea to all our relations." (January 25, 1801) Following the popular custom that *A Guide to All the Watering and Seabathing Places* (1803) called "the rage, to make annual excursions to the coast," the Austens made several extended tours to the shores of Devon, Dorset, Sussex, Kent, and Wales, generally in the summer or autumn, and usually staying for a few weeks. There they strolled along the shore, attended the local dances, took in the healthful air, and bathed in the sea. And there, according to family tradition, Jane Austen may have fallen in love. Years later, Jane's niece Caroline recalled as best she could the story Jane's sister, Cassandra, had once told her. On the Devon coast, possibly at Dawlish or Sidmouth, while on holiday with her family, Jane met a young man with such "charm of person, mind, and manners" that Cassandra thought him actually worthy of Jane. "I never heard Aunt Cass. speak of anyone else with such admiration—she had no doubt that a mutual attachment was in progress between him and her sister," wrote Caroline. Tragically, the love that started so promisingly turned to sorrow when the holiday ended and the Austens returned to Bath. "They parted— but he made it plain that he should seek them out again— & shortly afterwards he died!"

Jane's visits to the seashore inspired several scenes and many mentions of seaside resorts in her novels. Lydia Bennet goes to Brighton with scandalous consequences in *Pride and Prejudice.* "The young people were all wild to see Lyme" in *Persuasion.* Her unfinished novel *Sanditon* is named after the fictional coastal resort town where the action takes place. And in *Emma,* Frank Churchill and Jane Fairfax fall in love at Weymouth, and Emma and Mr. Knightley can think of no finer place to honeymoon than a two-week "tour to the seaside." It is clear from Jane's evocative images of the seaside in her novels how much she loved it, but none are so fully expressed as her descriptions of Lyme Regis and its beautiful surrounding countryside in *Persuasion.* "A very strange stranger it must be," she says, "who does not see charms in the immediate environs of Lyme, to make him wish to know it better." Indeed, her lyrical descriptions of Lyme Regis and the area's beauties are the only occasions in her novels when she describes scenery in such great detail:

The scenes in its neighbourhood, Charmouth, with its high grounds and extensive sweeps of country, and still more its sweet retired bay, backed by dark cliffs, where fragments of low rock among the sands make it the happiest spot for watching the flow of the tide, for sitting in unwearied contemplation;—the woody varieties of the cheerful village of Up Lyme, and, above all, Pinny, with its green chasms between romantic rocks, where the scattered forest trees and orchards of luxuriant growth declare that many a generation must have passed away since the first partial falling of the cliff prepared the ground for such a state, where a scene so wonderful and so lovely is exhibited, as may more than equal any of the resembling scenes of the far-famed Isle of Wight: these places must be visited, and visited again, to make the worth of Lyme understood.

PERSUASION

Set in the midst of these natural beauties, Lyme Regis, a quaint seaside village known as "The Pearl of Dorset," lies on the western border of Dorset County some 150 miles west of London. The Austens stayed at Lyme Regis at least twice. The first visit seems to have been in November of 1803, just the month her characters in *Persuasion* visit, and when Jane Austen was, like her heroine Anne Elliot, 27 years old. The second visit was made in the late summer and early autumn of 1804. Lyme Regis, "frequented principally," the guidebook said, "by persons in the middle class of life," would have provided the Austens "lodgings and boarding… not merely reasonable, [but] even cheap." Arriving, the Austens would have descended "the long hill into Lyme, and entering upon the still steeper street of the town itself," as her characters did, then driven down "the principal street almost hurrying into the water" to their lodgings. The most probable location of the Austens' lodging was Pyne House, located at No. 10 Broad Street. Pyne House still stands and, fittingly, still provides tourist accommodations.

In 1804 Jane's brother Henry and his wife Eliza, the fashionable former Countess de Feuillide, accompanied the Austens to Lyme Regis. When Henry, Eliza, and Cassandra moved on to visit Weymouth, Jane and Mr. and Mrs. Austen stayed at Lyme Regis, but moved into a smaller set of lodgings, possibly at Hiscott's boarding house on Broad Street. The newer front third of the building, now the site of the Three Cups Hotel, was built in 1807, after the Austens' visit, but the rear of the building dates to Jane's time at Lyme. Part of Hiscott's boarding house is now the Sea Tree House, providing self-catering apartments that promise tourists views of the Cobb where "Louisa Musgrove took a tumble." We can imagine the pleasure Jane felt looking out from the window of her lodgings, as Charlotte does in *Sanditon*, finding "amusement enough in standing at her ample Venetian window & looking over the… waving Linen, & tops of Houses, to the Sea, dancing & sparkling in Sunshine & Freshness."

The first object that draws the eye at Lyme Regis is the Cobb, a stone breakwater that has stood, in one form or another, since at least the 14th century, providing a safe harbor for boats and some protection for the town itself. In *Persuasion*, Anne Elliot, Captain Wentworth, and their companions are tempted to walk there immediately after they arrive.

After securing accommodations, and ordering a dinner at one of the inns, the next thing to be done was unquestionably to walk directly down to the sea. They were come too late in the year for any amusement or variety which Lyme, as a public place, might offer; the rooms were shut up, the lodgers almost all gone, scarcely any family but of the residents left… The walk to the Cobb, skirting round the pleasant little bay, which in the season is animated with

OPPOSITE TOP The Square, Lyme Regis, circa 1840. The hotel on the left is the Three Cups Hotel.
OPPOSITE BOTTOM LEFT Part of the original Pyne House, 10a Broad Street, Lyme Regis. OPPOSITE BOTTOM RIGHT View of Lyme Regis from the east, 1796.

AT HOME WITH JANE AUSTEN

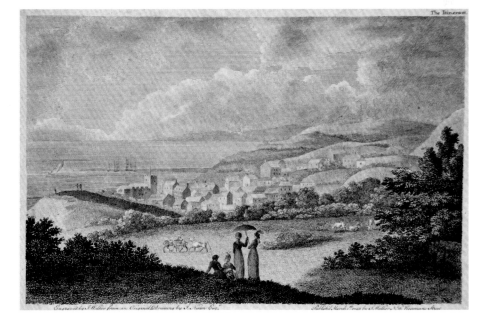

BY THE SEA

bathing machines and company, the Cobb itself, its old wonders and new improvements, with the very beautiful line of cliffs stretching out to the east of the town, are what the stranger's eye will seek… The party from Uppercross passing down by the now deserted and melancholy looking rooms, and still descending, soon found themselves on the sea shore, and lingering only, as all must linger and gaze on a first return to the sea, who ever deserve to look on it at all, proceeded towards the Cobb…

PERSUASION

There later the impetuous Louisa Musgrove jumps from the steep steps leading down from the top of the Cobb, missing Captain Wentworth's arms, and suffering a life-threatening blow to her head. The steps are often assumed to be the perilous, roughly hewn projections known as "Granny's Teeth," but are in fact more likely, according to the Lyme Regis Museum, to be the set of steps (still precarious) farther along "the high part of the new Cobb" mentioned in *Persuasion*.

Jane enjoyed walking about Lyme Regis herself. She reported one such outing to Cassandra, commenting with her usual wry humor on her companion and her family: "I called yesterday morning… on Miss Armstrong," Jane wrote to Cassandra. "Like other young Ladies she is considerably genteeler than her Parents; M^rs Armstrong sat darning a pr [pair] of Stockings the whole of my visit—. But I do not mention this at home, lest a warning should act as an example.—We afterwards walked together for an hour on the Cobb; she is very conversable in a common way; I do not perceive Wit or Genius—but she has Sense & some degree of Taste, & her manners are very engaging. She seems to like people rather too easily." (September 14, 1804) Jane and her family also explored the beautiful locales she highlighted in *Persuasion*. Henry fondly remembered their excursions, Jane reported to Cassandra the next year: "He talks of the Rambles we took together last Summer with pleasing affection." (April 11, 1805)

During the Austens' visit to Lyme Regis in November 1803 they may have encountered the same relatively empty town that Jane's characters in *Persuasion* did, having arrived too late in the season for any of the usual social activities. But the Austens' 1804 holiday took place in August and September, when the social season was in full swing. The Austens attended dances at the small assembly room, which also had a billiard table, and a card room where Mrs. Austen played the card game Commerce. "The situation for this edifice is happily chosen," said the guidebook, "as it commands a charming marine view… and the interior is compact and well arranged." Jane wrote to Cassandra about their activities:

The Ball last night was pleasant, but not full for Thursday. My Father staid very contentedly till half past nine—we went a little after eight—& then walked home with James & a Lanthorn… My Mother & I staid about an hour later. Nobody asked me the two first dances—the two next I danced with M^r Crawford—& had I chosen to stay longer might have danced with M^r Granville, M^rs Granville's son —whom my dear friend Miss Armstrong offered to introduce to me—or with a new, odd looking Man who had been eyeing me for some time, & at last without any introduction asked me if I meant to dance again.—I think he must be Irish by his ease, & because I imagine him to belong to the Hon^{ble} Barnwalls, who are the son & son's wife of an Irish Viscount— bold, queerlooking people, just fit to be Quality at Lyme.

SEPTEMBER 14, 1804

Dances and other entertainments at Lyme Regis ended early in the evening, a healthful practice for a seaside resort, the guidebook said. What could be worse, it asked, than for "those who have perspired for the greater part of the night in crowded

OPPOSITE View from Emmetts Hill looking west over Chapman's Pool, Purbeck, Dorset.

BY THE SEA

and unwholesomely-heated rooms, to expose their bodies, relaxed and feverish, as they cannot fail to be, the next morning, to the shock of an abrupt immersion into the sea?" Sea bathing, a popular practice, was thought to heal disease and have other therapeutic value. In *Sanditon,* the local resort promoter, Mr. Parker, declares that "the Sea air & Sea Bathing together were nearly infallible, one or the other of them being a match for every Disorder, of the Stomach, the Lungs or the Blood; They were anti-spasmodic, anti-pulmonary, anti-septic, anti-bilious & anti-rheumatic. Nobody could catch cold by the Sea; Nobody wanted Appetite by the Sea, Nobody wanted Spirits, Nobody wanted Strength." A person wishing to bathe was wheeled into the sea in a bathing machine, a little hut on wheels that provided a place to change and privacy on entering the water. Assistants, sometimes called dippers, helped the bathers down the steps of the machine and assisted them with swimming, or just dunked or "dipped" them as many times in the water as a physician had prescribed.

Jane bathed in the sea several times, in spite of having had a slight fever, writing to Cassandra, "I continue quite well, in proof of which I have bathed again this morning. It was absolutely necessary that I should have the little fever & indisposition, which I had;—it has been all the fashion this week in Lyme." She greatly enjoyed sea-bathing, and had rather overindulged, she wrote: "The Bathing was so delightful this morning & Molly [the maidservant] so pressing with me to enjoy myself that I believe I staid in rather too long, as since the middle of the day I have felt unreasonably tired. I shall be more careful another time, & shall not bathe tomorrow, as I had before intended." (September 14, 1804)

In addition to their extended stays at Lyme Regis, the Austens made several other holiday excursions to the seaside. In the summer of 1801 they probably traveled to the South Devon coast, including Sidmouth and Colyton. In 1802 Lieutenant Charles Austen, home during the temporary lull in the Napoleonic Wars, appears to have accompanied the Austens to Dawlish and Teignmouth in Devon and possibly to Tenby and Barmouth in Wales as well. Devon provided Jane with inspiration for some of the locales in *Sense and Sensibility*, when the Dashwood women move to Barton Cottage in Devon. Their cottage is not, much to the foolish Robert Ferrars' disbelief, located near Dawlish: "It seemed rather surprising to him that anybody could live in Devonshire, without living near

Dawlish." Dawlish appears to exert a fascinating pull on him. He and Lucy Steele end up spending their honeymoon there, which place, Lucy says, he has a "great curiosity to see." An 1802 guidebook, *The Beauties of England and Wales*, said that "Dawlish was formerly an inconsiderable fishing cove, but has now become a watering-place of considerable reputation, and appears in a state of progressive improvement." The attempts by the inhabitants to raise Dawlish to a place of fashionable resort may have come to Jane's mind when she later described the up-and-coming resort of Sanditon:

The Village contained little more than Cottages, but the Spirit of the day had been caught… & two or three of the best of them were smartened up with a white Curtain & "Lodgings to let"… [Near] the brow of a steep, but not very lofty Cliff [was]… one short row of smart-looking Houses, called the Terrace, with a broad walk in front, aspiring to be the Mall of the Place. In this row were the best Milliner's shop & the Library—a little detached from it, the Hotel & Billiard Room—Here began the Descent to the Beach, & to the Bathing Machines—& this was therefore the favourite spot for Beauty & Fashion.

Jane herself seems to have been unimpressed with the amenities offered at Dawlish, writing to her niece twelve years later that the library had been "pitiful & wretched." (August 10, 1814)

Following Mr. Austen's death in 1805, Mrs. Austen and her daughters stayed some weeks in the summer with Edward's family at Godmersham, and then they all, including Martha Lloyd, met at Worthing in September. *The Traveller's Guide: or, English Itinerary* for 1805 said that Worthing was "much frequented… by people of fashion for bathing, on account of the fine sands." It noted that "in a short space of time a few miserable fishing huts and smuggler's

LEFT *Side Way or any Way*, by Thomas Rowlandson, 1790.
RIGHT *Venus's Bathing (Margate)*, *A Fashionable Dip*, by Thomas Rowlandson, 1790.

AT HOME WITH JANE AUSTEN

dens have been exchanged for buildings, sufficiently extensive and elegant to accommodate the first families in the kingdom; so that [nearby] Broadwater looks contemptible when contrasted with [its] growing splendor." It seems very probable that Worthing provided Jane with considerable inspiration for her own fictional seaside resort, Sanditon. The parallels between Worthing and Sanditon (in Jane Austen's unfinished novel of the same name) are striking, with many of the locations and amenities of Worthing having an equivalent in Sanditon, including a promoter, Edward Ogle, who strongly brings Jane's character Mr. Parker to mind. The Austens stayed at Stanford's Cottage, which had beautiful views of the sea from its bow windows. Set back from the south side of Warwick Street, the house still stands and is now occupied by a restaurant. The Austens seemed to have enjoyed themselves at Worthing. Young Fanny Austen noted some of their activities in her diary: "I went with G[rand]Mama [Austen] in the morning to buy fish on the beach & afterwards with Mama & Miss Sharpe [the governess] to Bathe where I had a most delicious dip… We dined at 4 & went to a Raffle in the evening, where Aunt Jane won & it amounted to 17s." They all attended church, probably at St. Mary's, Broadwater, and Fanny noted that her aunt Cassandra had bathed at "the warm bath," no doubt Wicks's Baths, the only public baths in Worthing at the time. Mrs. Austen, her daughters, and Martha remained some weeks longer at Worthing after Edward's family returned to Godmersham, possibly through December. The visit to Worthing seems to have been Jane's last family holiday at the seaside, but as her novels suggest, the sea obviously continued to hold a special place in her heart and imagination.

OPPOSITE TOP Worthing seafront, early 19th century. The building on the right is Wicks's Baths, patronized by Cassandra Austen.
OPPOSITE Worthing, 1804, near the Austens' lodgings at Stanford's Cottage. On the left is the Colonnade Library, and on the right is the house of Edward Ogle, perhaps the inspiration for Mr. Parker in *Sanditon*.
RIGHT TOP Part of the coast of Devon, showing Sidmouth, Dawlish, and Teignmouth, where the Austens visited in 1801 and 1802.
RIGHT Afternoon Promenade Dress, from *La Belle Assemblee*, June 1813.

CHAWTON

*It is not in Human Nature to imagine what a nice walk we have round the Orchard.
—The row of Beech look very well indeed, & so does the young Quickset hedge in the
Garden.—I hear today that an Apricot has been detected on one of the Trees.*

LETTER FROM JANE AUSTEN AT CHAWTON COTTAGE, TO HER SISTER, CASSANDRA, MAY 31, 1811

In the summer of 1809, Jane Austen arrived at Chawton Cottage, her final home, and the home most associated with her career as an author. There she would revise her first three works, *Sense and Sensibility*, *Pride and Prejudice*, and *Northanger Abbey* for publication, and there she would write entirely *Mansfield Park*, *Emma*, and *Persuasion*. In returning to Hampshire, Jane was coming home. Her nephew wrote, "Chawton may be called the *second*, as well as the *last* home of Jane Austen; for during the temporary residences… at Bath and Southampton she was only a sojourner in a strange land; but here she found a real home amongst her own people."

The Cottage stands in the charming village of Chawton, near Alton, in a particularly beautiful and tranquil part of Hampshire. The village, relatively unchanged from the days when Jane's acquaintances in Southampton called it "remarkably pretty," is a picturesque collection of brick and half-timbered houses, some with roofs of thatch and classically lovely English cottage gardens. Chawton Cottage itself, which dates to the 17th century (some interior parts to the 16th century), is thought originally to have been a farmhouse and, for a few years in the latter half of the 18th century, an alehouse or inn. The Cottage is a rambling and commodious two-story structure, L-shaped and built of warm red brick, located at the fork of the old Winchester and Gosport Roads. In the Austens' day a large, shallow pond and a grassy area stood in the fork, but the pond has since been drained. A delightful contemporary watercolor, probably by Jane's niece Anna, shows the Cottage, its brick whitewashed or stuccoed and its roof of red tile, set in a pleasant country village scene. An old woman with a marketing basket and cane picks her way carefully along, a horse pulls a covered wagon in the distance, geese swim in the pond, and two women in similar dresses and bonnets, perhaps Jane and Cassandra, walk along the road with their parasols as a little black dog runs next to them.

On July 7, the day Jane, Cassandra, and Mrs. Austen arrived, the house and garden must have looked particularly welcoming. Edward, who escorted them to their new home on his Chawton estate, was taking significant pains and spending a considerable amount of money improving the house, formerly the house of his estate steward, into "a comfortable residence" for his mother and sisters. Mrs. Austen had been looking forward to the move for months, planning busily and anxious for information about the house. "There are six Bedchambers at Chawton," Jane had written

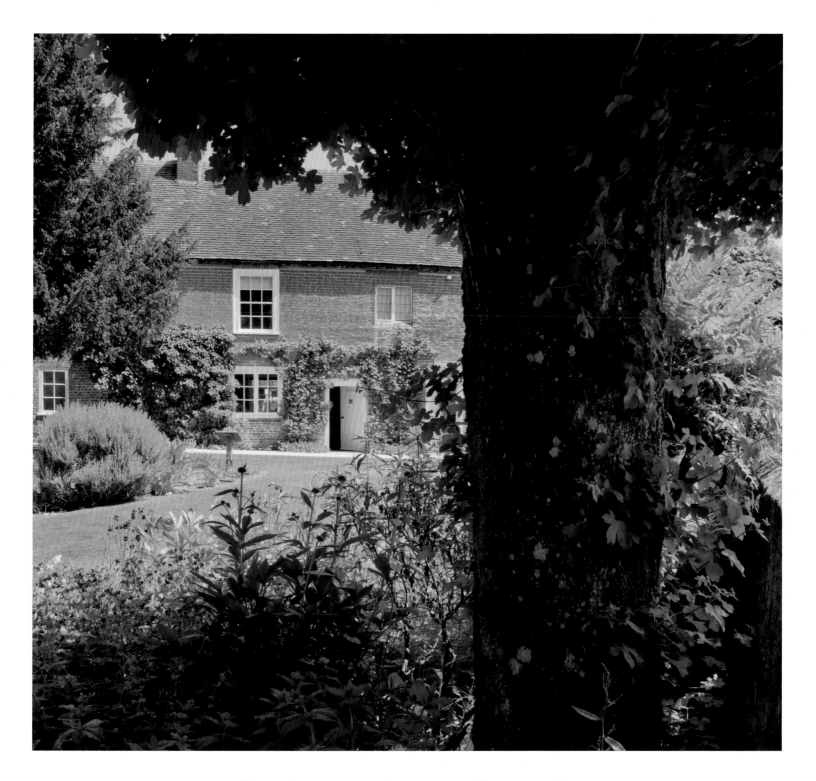

Chawton Cottage, Jane Austen's House Museum, Chawton, Hampshire.

CHAWTON

Chawton Cottage, by Anna Austen, circa early 19th century.

to Cassandra from Southampton, "Henry wrote to my Mother the other day, & luckily mentioned the number—which is just what we wanted to be assured of. He speaks also of Garrets for Storeplaces, one of which she immediately planned fitting up for Edward's Manservant [during visits]—& now perhaps it must be for our own—for she is already quite reconciled to our keeping one. The difficulty of doing without one, had been thought of before.—His name shall be Robert, if you please." (November 20, 1808) Edward set his laborers to all sorts of improvements, clearing a waste pool, "cleaving wood for Mrs. Austen," improving the outdoor plumbing (such as the well), adding more bedchambers

over the kitchen at the back, and bricking up the window of the drawing room, which overlooked the busy coach road to Winchester running close to the front of the house, to give the Austen women more privacy. On the side of the room the workmen added another window, with modern gothic-style arched trim, that looked over only the garden. "Everything indoors and *out* was well kept," recalled Jane's niece Caroline, who often visited at the Cottage. "The house was well furnished, and it was altogether a comfortable and ladylike establishment, tho' I believe the means which supported it, were but small. The house was quite as good as the generality of Parsonage houses then—and much in

Chawton Cottage, circa 1911.

the same old style—the ceilings low and roughly finished—*some* bedrooms very small—*none* very large but in number sufficient to accommodate the inmates, and several guests."

Altogether, Chawton Cottage sounds very similar to Barton Cottage, the house the Dashwood women in *Sense and Sensibility* move into after Mr. Dashwood dies: "comfortable and compact." Although Barton Cottage is small in comparison to the mansion they had left, "with the size and furniture of the house Mrs. Dashwood was upon the whole well satisfied." Regardless of the size or style of the rooms, the Austens were pleased with Chawton Cottage and its improvements. Living at Chawton brought other

advantages: Henry Austen had a branch of his bank in the nearby village of Alton (at 10 and later 34 High Street), and Frank and Mary Austen had taken Rose Cottage (31 Lenten Street, now two properties), where Mary, now expecting her second child, would stay when Frank was at sea. Not long after the Austen women's arrival, Jane reported on the contented state of affairs at the Cottage in a letter to Frank, away on a two year voyage to China:

As for ourselves, we're very well,
As unaffected prose will tell.
Cassandra's pen will give our state

The many comforts that await
Our Chawton home—how much we find
Already in it to our mind,
And how convinced that when complete,
It will all other Houses beat,
That ever have been made or mended,
With rooms concise or rooms distended.

LETTER FROM JANE AUSTEN TO FRANCIS AUSTEN, JULY 26, 1809

The Chawton Cottage grounds were transformed into a pleasant place for Jane, Cassandra, Mrs. Austen, and their friend Martha Lloyd, who continued to live with them, to walk and enjoy the outdoors. Several smaller enclosures were thrown together to enlarge the grounds and hedges were planted to screen the road. A shrubbery border with gravel paths "very gay with Pinks & Sweet Williams, in addition to the Columbines already in bloom," as Jane wrote (May 29, 1811), was added to circle the property, and again her favorite syringa (mock orange) bushes were planted. There was an orchard, fruit trees trained to the walls, and "a good kitchen garden." The ever-practical Mrs. Austen had been worried in the winter before their arrival that the garden might be left bare by the current tenant and had tried to arrange to have it planted for the season. "She hopes you will not omit begging M^rs Seward to get the Garden cropped for us," Jane wrote to Cassandra, who was helping to arrange matters, "supposing she leaves the House too early, to make the Garden any object to herself." (January 30, 1809) Whether or not Mrs. Seward fulfilled the request, Mrs. Austen apparently found the quality of the existing garden not up to her standards, for in November three of Edward's laborers worked trenching her garden, that is, loosening the soil and probably manuring it. Mrs. Austen, who would turn 70 years old that autumn, turned over the day-to-day management of the household to Cassandra, but kept herself busy, her granddaughter Anna's daughter later wrote:

She found plenty of occupation for herself in gardening and needlework. The former was, with her, no idle pastime, no mere cutting of roses and tying up of flowers. She dug up her own potatoes, and I have no doubt she planted them, for the kitchen garden was as much her delight as the flower borders, and I have heard my mother say that when at work, she wore a green round frock like a day-labourer's.

Mrs. Austen relished working vigorously in the garden, growing potatoes, peas, gooseberries, tomatoes, currants, and strawberries among the crops in the kitchen garden. She felt that working outdoors improved her health, writing in one of her humorous verses, "My flesh is much warmer, my blood freer flows / When I work in the garden with rakes and with hoes." Cassandra enjoyed gardening, too, collecting flower seeds and cuttings from friends and family for the flower borders and shrubbery, and growing them with varying success, as Jane reported to her when she was away: "Some of the Flower seeds are coming up very well—but your Mignionette makes a wretched appearance.—Miss Benn has been equally unlucky as to hers; She has seed from 4 different people, & none of it comes up." (May 29, 1811) Cassandra also tried to grow mulberry trees, without much success, Jane again informed her by letter: "I will not say that your Mulberry trees are dead, but I am afraid that they are not alive." (May 31, 1811) As they had at Steventon, the Austens kept bees in the garden, providing the Cottage with honey and home-brewed mead, "a most refreshing and enlivening drink, little inferior, when properly made, to champaigne," according to the *Encyclopaedia of Gardening* (1822). Mead was a staple in the Austen household. "I long to know something of the Mead," Jane wrote to Cassandra (March 6, 1814), and another time: "We hear now that there is to be no Honey this year. Bad news for us.—We must husband our present stock of Mead; & I am sorry to perceive that our 20 Gal: is very nearly out.—I cannot comprehend how the 14 Gal: cd [could] last so long." (September 9, 1816)

THE HONEY-BEE.

"What well appointed commonwealths! where each
Adds to the stock of happiness for all;
Wisdom's own forums! where professors teach
Eloquent lessons in their vaulted hall!
Galleries of art! and schools of industry!
Stores of rich fragrance! Orchestras of song!
What marvellous seats of hidden alchymy!
How oft when wandering far and erring long,
Man might learn truth and virtue from the BEE!"—*Bowring.*

Of Mead, and Wines to be made with Honey.

Mead, or *Hydromel,* is a ſtrong luſcious wine, made with honey and water; the goodneſs and ſtrength of which entirely depends on a due *mixture* and *fermentation.* When properly made, it is ſtronger than moſt other wines, and will ſoon intoxicate. Though it is a liquor at preſent not in great repute, yet it ſoon may become ſo by a little attention in making it. In order to obtain this deſireable end, and to make this cheap and wholeſome liquor pleaſing to the taſte, has induced me to attempt ſeveral experiments, which have employed my attention for ſeveral years. How far my inquiries have ſucceeded, will be found by the ſubſequent plain, eaſy, and ſimple methods.

ABOVE TOP *Picking Mulberries,* by Thomas Rowlandson, undated. ABOVE LEFT Beehives at Chawton House Library.
ABOVE MIDDLE *The Honey-Bee,* from *The Honey-Bee; Its Natural History, Physiology and Management* by Edward Bevan, 1827.
ABOVE RIGHT "Of Mead," from *The Experienced Bee-Keeper,* by Bryan J'Anson Bromwich, 1783.

AT HOME WITH JANE AUSTEN

OPPOSITE AND ABOVE Views of Chawton Cottage from the garden.

CHAWTON

The Austen women were able to raise much of what they ate, including chickens and turkeys: "The Chicken are all alive, & fit for the Table—but we save them for something grand," (May 29, 1811) Jane reported to Cassandra. Some things were purchased, such as ducks from a nearby farm. "We shall have pease soon," she wrote. "I mean to have them with a couple of Ducks from Wood Barn & Maria Middleton towards the end of next week." (May 31, 1811) A week later she could report, "We began Pease on Sunday… Yesterday I had the agreable surprise of finding several scarlet strawberries quite ripe;—had you been at home, this would have been a pleasure lost. There are more Gooseberries & fewer Currants than I thought at first.—We must buy currants for our Wine." (June 6, 1811) Friends and family provided other edibles— pork and hams from Jane's brother James at Steventon, and game and dairy from Chawton House.

Behind the Cottage was a large court with a well and several outbuildings, including a bakehouse and stabling for Mrs. Austen's donkeys, housing for the donkey cart that Edward provided for her use, and storage for hay and corn for the donkeys. The Austens kept dogs as well. In later years, a Chawton villager recalled that in the years after Jane's death, Cassandra's dog, "a nice dog, his name was 'Link'… always went with her manservant, William Littleworth, to Chawton House for milk, and carried it home in his mouth." The Austens usually employed one manservant, drawn from the young men of the village, who was in charge of such outdoor tasks. There was Thomas Carter, and after him young Browning, who had a way with those around him: "Browning goes on extremely well," wrote Jane. "My mother is exceedingly pleased.—The Dogs seem just as happy with him as with Thomas;—Cook & Betsey I imagine a great deal happier." (February 9, 1813) The manservant was also expected to wait at table, for which Browning needed a bit of training, Jane said. "He had lost some of his knowledge of waiting, & is I think rather slow; but he is not noisy & not at all above being taught." (February 4, 1813) He was succeeded

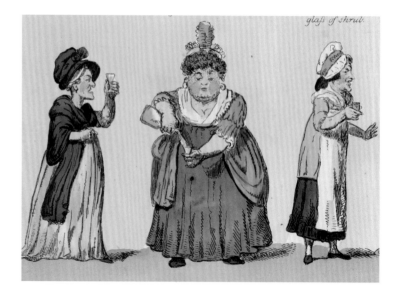

by William Littleworth (a cousin of the Steventon Littleworths), described by Jane as "a goodlooking Lad, civil & quiet, & seeming likely to do" (July 9, 1816), who worked for the Austens for as long as they lived in the Cottage.

The interior of the Cottage was unpretentious, but comfortable. "A good sized entrance, and two parlours called dining and drawing room, made the length of the house," wrote Caroline. Up the narrow wooden stairs were the bedrooms, including bedrooms in the garrets for the servants. Cellars under the house provided storage for the Austens' stock of homemade wine, homebrewed spruce beer, and mead. In the back of the house lay the kitchen and the other "offices," that is, the working areas of the house that the servants used. Now that Mrs. Austen had retired to her garden and needlework, Cassandra ran the household, with assistance from Martha, and occasionally from Jane when Cassandra was away. In *Pride and Prejudice,* Mrs. Bennet, who is "very well able to keep a good cook," is offended by Mr. Collins's suggestion that the Bennet daughters might have done some of

ABOVE Detail, *Apologies for Tippling*, by Isaac Cruikshank, 1798.
OPPOSITE Martha Lloyd's household book.

the cooking, and assures him that they "had nothing to do in the kitchen." The Austens usually kept a cook and a housemaid to do most of the cooking and housework, but they would have been actively involved in the planning and supervision of meal preparation and other household chores. Martha Lloyd kept a household book for years, collecting favorite recipes and remedies given to her by friends and relatives. Mrs. Austen contributed a recipe for a pudding written, in typical Mrs. Austen fashion, in the form of an amusing rhyme: "The proportion you'll guess / May be made more or less / To the size that each family chuses / … And these lines but obey / Nor can anyone say / That this pudding's with-out rhyme or reason." Martha recorded a recipe for orange wine, perhaps the recipe Jane had requested from her friend Alethea Bigg of Manydown: "We remember some excellent orange Wine at Manydown, made from Seville oranges, entirely or chiefly—& should be very much obliged to you for the receipt, if you can command it within a few weeks." (January 24, 1817) The Austens' cook, usually called by them just "Cook" (which makes it difficult to sort out which one was which), worked for a mere £8 a year, probably plus housing and food, and the maidservant would no doubt have been paid somewhat less. Admittedly, these were country village wages, but it shows that the Austens expected only

OPPOSITE Mrs. Austen's bedroom, now the Austen Family Room, at Chawton Cottage. ABOVE LEFT The Drawing Room at Chawton Cottage. ABOVE RIGHT The Vestibule at Chawton Cottage, with the Dining Room behind. Edward Austen Knight's portrait hangs over the fireplace.

basic, reasonably competent cooking. A fine cook such as those working for Mrs. Bennet and or the rector's wife, Mrs. Grant, in *Mansfield Park*, producing large, elaborate dinners, could possibly have commanded up to £25 a year. Mrs. Grant, to the stingy Mrs. Norris's annoyance, gives her cook

as high wages as they did at Mansfield Park, and was scarcely ever seen in her offices. Mrs. Norris could not speak with any temper of such grievances, nor of the quantity of butter and eggs that were regularly consumed in the house. Nobody loved plenty and

hospitality more than herself; nobody more hated pitiful doings; the Parsonage, she believed, had never been wanting in comforts of any sort, had never borne a bad character in her time, but this was a way of going on that she could not understand. A fine lady in a country parsonage was quite out of place.

The Austens and Martha seem to have preferred plain fare such as neck of mutton, goose, ham, puddings, and pies, which must have made Cook's job much easier, especially since the Austens' kitchen was small and simple, quite unlike rich General

Chawton Cottage kitchen circa 1940s, prior to restoration.

AT HOME WITH JANE AUSTEN

Tilney's kitchen in *Northanger Abbey*, where "every modern invention to facilitate the labour of the cooks had been adopted within this, their spacious theatre." When the architect for the Jane Austen's House Museum investigated behind a modern fireplace in the Austens' former kitchen (used as a sitting room at the time and now restored), the original brick inglenook fireplace with flanking wooden seats lay revealed. An iron bar for hanging cooking pots was still positioned above the center of the hearth, and it was noticed that the brickwork had been worn down where a wrought iron grate had long stood beneath. To the left of the fireplace was the original stove, used for cooking more delicate dishes over charcoal. Suddenly we can picture Cook working away over the fire, roasting joints of meat, boiling puddings, and making pies. Still, the success of even such simple meals depended on her skills. "I continue to like our old Cook quite as well as ever—& but that I am afraid to write in her praise, I could say that she seems just the Servant for us," Jane wrote to Cassandra. "Her Cookery is at least tolerable;—her pastry is the only deficiency." (May 31, 1811) Two years later Cook was perhaps suffering from rheumatism, as Jane sympathetically noted: "Poor Cook is likely to be tried by a wet Season now; but she has not begun lamenting much yet." (February 9, 1813) But some two years after that, the Austens were happy in the acquisition of a cook with pastry skills, Jane wrote: "I am very glad the new Cook begins so well. Good apple pies are a considerable part of our domestic happiness." (October 17, 1815) The Austens had various maidservants over the years, among them Betsy, who had been pleased with Browning, and Sally, about whom Jane wrote to her niece Caroline: "Cook & Sally seem very properly pleased by your remembrance, & desire their Duty & Thanks. Sally has got a new red Cloak, which adds much to her happiness, in other respects she is unaltered, as civil & well meaning & talkative as ever." (January 23, 1817)

Jane and Cassandra shared a bedroom, as they always had, probably the first room on the left at the top of the current staircase, looking out over the back courtyard. The room, with wide plank floors, exposed beams, and a simple fireplace, is small, and must barely have had room for the two beds they slept in and a chair or two. There are cupboards on either side of the fireplace for storage; the one on the left has shelves for a washbasin and other toiletry articles, reminiscent of the closet shelves suggested by Lady Catherine de Bourgh for Mr. Collins's "humble abode" in *Pride and Prejudice*. No doubt Jane and Cassandra valued companionship over roominess, preferring to be able to talk privately together in the evenings after retiring. When their niece Anna sent them an installment of her fledgling novel, Jane responded, "I hope you do not depend on having your book back again immediately… for it has not been possible yet to have any public reading. I have read it to your Aunt Cassandra however—in our own room at night, while we undressed—and with a great deal of pleasure. We like the first chapter extremely—with only a little doubt whether Ly [Lady] Helena is not almost too foolish." (September 28, 1814) Mrs. Austen and Martha Lloyd each had her own bedroom, and there were extra bedrooms for guests, "a spare room for a friend," as Mrs. Norris says in *Mansfield Park*, for when friends and Mrs. Austen's sons and their families visited the Cottage.

Downstairs, the dining room and the drawing room were the center of most of the family's activities. Jane began her day with music, practicing on the square piano in the drawing room before breakfast, "when she could have the room to herself," recalled Caroline.

"She played very pretty tunes, *I* thought—and I liked to stand by her and listen to them… Much that she played from was manuscript, copied out by herself—and so neatly and correctly, that it was as easy to read as print." She would not play in company, Caroline said, but she played for her family, as her nephew James Edward recalled: "In the evening she would sometimes sing, to her own accompaniment, some simple old

ABOVE Replica tent bed in Jane and Cassandra Austen's bedroom,
of the style ordered by the Austens when they lived at Steventon.
OPPOSITE Jane and Cassandra Austen's bedroom, Chawton Cottage.

AT HOME WITH JANE AUSTEN

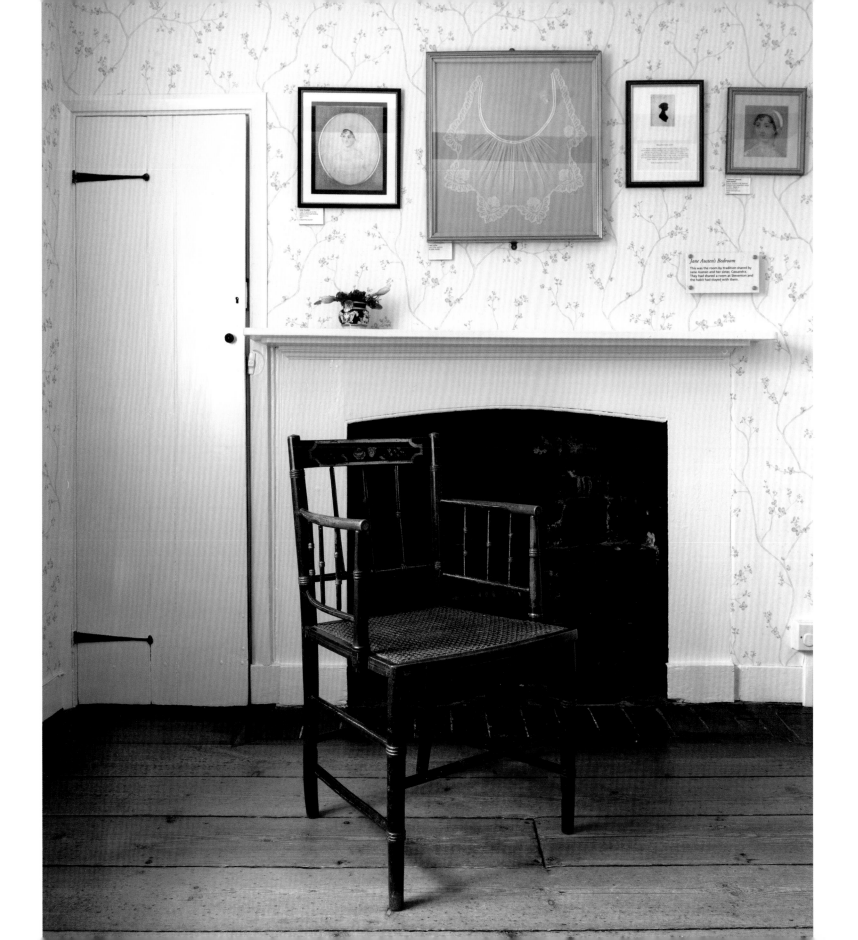

OPPOSITE Dining Room at Chawton Cottage. ABOVE LEFT 1810 Clementi square piano, similar to the piano Jane Austen would have played, at Chawton Cottage. ABOVE RIGHT The Clementi piano in the Drawing Room at Chawton Cottage.

songs, the words and airs of which, now never heard, still linger in my memory." Many of the songs she transcribed were poignant ballads, such as "Robin Adair," which Jane Fairfax plays in *Emma*, and "The Soldier's Adieu," which she altered to "The Sailor's Adieu," no doubt in honor of her brothers Frank and Charles at sea. Other songs must have appealed to her sense of humor, such as the popular comic stage tune, "The Joys of the Country":

Let Bucks and let bloods to praise London agree
Oh the joys of the country my Jewel for me
Where sweet is the flow'r that the May bush adorns
And how charming to gather it but for the thorns…
Oh the mountains and vallies and bushes
The Pigs and the screech owls and Thrushes
Let Bucks and let bloods to praise London agree
Oh the joys of the country my Jewel for me.

When the cupboard was finally opened, it contained a tea caddy, a pleasant reminder of the Austens' custom of storing their own tea there. Breakfast in the Austens' day would have been a light meal of tea and toast, muffins, or rolls. Cook would have already made the bread and sliced it, and Betsy or Sally would have laid the fire, probably in the dining room in the iron hob grate (which is the original) and filled the tea kettle with water from the well. Jane's responsibility, then, would have been to measure out the expensive tea and make it as the family liked it, and to toast the bread over the fire on a toasting fork or a hearth toaster, a rack that held the bread firmly in place. The family would possibly have eaten their meal on a set of special breakfast dishes. Martha Lloyd gave a Wedgwood breakfast set to Mrs. Austen, though this may have been a dejeuner set intended for one person. Mrs. Austen, who had a tender stomach, preferred her toast dry, but Jane, Cassandra, and Martha would have had butter from Chawton House, honey from their own beehives, and raspberry jam made at the Cottage. The dining room window looked directly onto the busy road, making the interior of the room highly visible to those passing, as Edward's adopted mother, the kindly Mrs. Knight, reported not long after the Austens had moved into the Cottage: "I heard of the Chawton Party looking very comfortable at Breakfast, from a gentleman who was traveling by their door in a Post-chaise about ten days ago. Your account of the whole family gives me the sincerest Pleasure, and I beg you will assure them all how much I feel interested in their happiness." Mrs. Austen didn't seem to mind the lack of privacy, said Caroline:

There my grandmother often sat for an hour or two in the morning, with her work or her writing—cheered by its sunny aspect and by the stirring scene it afforded her. I believe the close vicinity of the road was really no more an evil to her than it was to her grandchildren. Collyer's daily coach with six horses was a sight to see! and most delightful was it to a child to have the

After Jane finished her music practice, "at 9 o'clock she made breakfast—*that* was *her* part of the household work," Caroline remembered. "The tea and sugar stores were under *her* charge—*and* the wine—Aunt Cassandra did all the rest." The tea and sugar were locked in the cupboard to the left of the fireplace in the dining room. When the Cottage was originally purchased and restoration was underway, the keys to that cupboard could not at first be found.

ABOVE TOP Wedgwood jasper dejeuner set, circa 1790.
ABOVE Tea caddy decorated with paper filigree, circa 1790–1810.

awful stillness of night so frequently broken by the noise of passing carriages, which seemed sometimes, even to shake the bed.

Jane derived amusement from the scenes as well, especially the stream of boys passing to and from Winchester College, as she wrote to James Edward: "We saw a countless number of Postchaises full of Boys pass by yesterday morn[in]g—full of future Heroes, Legislators, Fools, & Vilains." (July 9, 1816)

"I don't believe Aunt Jane observed any particular method in parcelling out her day," Caroline wrote, "but I think she generally sat in the drawing room till luncheon: when visitors were there, chiefly at work—She was fond of work—and she was a great adept at overcast and satin stitch." "Work," that is, sewing, whether decorative or useful, was a constant occupation for women in the Austens' day. Jane and Cassandra had some of their clothing made, but they also often made alterations and changed the decorations on their dresses and bonnets, adding and subtracting ribbons and flounces as fashions changed. Jane did a great deal of practical sewing, such as making up items for the poor, and making shirts for Edward while visiting Godmersham, as Fanny Price does for her brother Sam in *Mansfield Park.* She enjoyed embroidery, often making gifts for her friends and family, some of which have been preserved. Mrs. Austen seems to have taken particular delight in handicrafts, making doll clothes for her granddaughters, knitting gloves and garters as gifts to various family members, and sewing "petticoats, Pockets & dressing Gowns" and shoes for her granddaughter Anna's trousseau. She also made a handsome quilt, now on display at the Cottage, with her daughters' help. Jane wrote to remind Cassandra to keep an eye out for suitable material: "Have you remembered to collect peices for the Patchwork?—We are now at a stand still." (May 31, 1811)

Jane must necessarily have spent much of her time writing. Caroline remembered that "her desk lived in the drawing room. I often saw her writing letters on it, and I believe she wrote much

of her Novels in the same way—sitting with her family, when they were quite alone." James Edward agreed, looking back to his visits to the Cottage. "There must have been many precious hours of silence during which the pen was busy at the little mahogany writing-desk, while Fanny Price, or Emma Woodhouse, or Anne Elliott was growing into beauty and interest. I have no doubt that I, and my sisters and cousins, in our visits to Chawton, frequently disturbed this mystic process, without having any idea of the

ABOVE Quilt in the English medallion pattern, made by Mrs. Austen, Jane, and Cassandra.

mischief that we were doing; certainly we never should have guessed it by any signs of impatience or irritability in the writer." The dining room at Chawton Cottage today contains the most important piece of furniture associated with Jane Austen: the small round tripod table where she wrote her novels. There she placed her little brass-inlaid mahogany writing desk and produced the books that are as vibrant today as the day she penned them. "Most of the work must have been done in the general sitting-room, subject to all kinds of casual interruptions" James Edward wrote, because "she had no separate study to retire to." Nevertheless, Jane managed to keep her writing secret, known only to her most immediate family: "She wrote upon small sheets of paper which could easily be put away, or covered with a piece of blotting paper. There was, between the front door and the offices, a swing door which creaked when it was opened; but she objected to having this little inconvenience remedied, because it gave her notice when anyone was coming." Jane's table was later given to the faithful William Littleworth as part of the furnishings for his cottage across the road. Edward Austen Knight's descendants repurchased it many years later, and it now stands in its rightful home at the Cottage.

Far from being disturbed by the visits of her nieces and nephews, Jane seems to have relished being a beloved aunt. "I have always maintained the importance of Aunts as much as possible," she wrote to Caroline when she in turn became an aunt. "We did not think of her as being clever, still less as being famous; but we valued her as one always kind, sympathising, and amusing," said James Edward, and Caroline agreed: "My visits to Chawton were frequent… and Aunt Jane was the great charm… Her charm to children was great sweetness of manner—she seemed to love you, and you loved her naturally in return… *Every*thing she could make amusing to a child." She played games with the children—round games and card games, spillikins (jackstraws or pick-up sticks) and bilbocatch (cup and ball), at which she excelled. She played dress-up and house with Caroline, Mary Jane, and Cassy when they visited, letting them choose from her wardrobe and being "the entertaining visitor in our make believe house." She told them "the most delightful stories chiefly of Fairyland, and her Fairies had all characters of their own—The tale was invented, I am sure, at the moment, and was sometimes continued for 2 or 3 days, if occasion served." When her nieces and nephews were away, she wrote affectionate, humorous letters to them, sometimes in code. She entered into all their concerns, from young Caroline's lost pet: "Only think of your lost Dormouse being brought back to you!—I was quite astonished," to teenaged Anna's and Fanny's love lives: "And now, my dear Fanny, having written so much on one side of the question, I shall turn round & entreat you not to commit yourself farther, & not to think of accepting him unless you really do like him. Anything is to be preferred or endured rather than marrying without affection." (January 23, 1817 & November 18, 1814)

As the nieces and nephews grew older, some of them were able to spend several weeks with their grandmother and aunts. As always for the Austens, reading aloud to each other formed a valuable part of their entertainment, and the visiting youngsters

LEFT Jane Austen's portable writing desk. OPPOSITE The small table where Jane Austen composed and revised her novels at Chawton Cottage.

CHAWTON

found it particularly amusing when Aunt Jane was involved. Caroline said that Jane "was considered to read aloud remarkably well… *once* I knew her take up a volume of Evelina and read a few pages of Mr. Smith and the Brangtons and I thought it was like a play." Anna recalled the fun she had reading with her aunts:

It was my great amusement during one summer visit at Chawton to procure Novels from a circulating Library at Alton, & after running them over to relate the stories to Aunt Jane. I may say it was her amusement also, as she sat busily stitching away at a work of charity, in which I fear that I took myself no more useful part. Greatly we both enjoyed it, one piece of absurdity leading to another, till Aunt Cassan[dr]a fatigued with her own share of laughter wd [would] exclaim "How can you both be so foolish?" & beg us to leave off.

In addition to reading entertaining novels, the Austen women kept up with news and important nonfiction works by subscribing to the local Alton Book Society for at least some of the years they lived at the Cottage. The society, housed in the printer and stationer's shop (now 30 High Street) in Alton, provided its members a sort of circulating library in exchange for the subscription fee of £1 5s. Each of the members was allowed to order a certain number of "what Books he thinks proper." Novels not being allowed, the books were for the most part of the "improving" variety, ranging from history and biography to travel guides and moral essays; there was also a good selection of periodicals. Jane wrote to Cassandra about the books she and her mother were currently reading:

We quite run over with Books. She has got John Carr's Travels in Spain from Miss B. & I am reading a Society-Octavo, an Essay on the Military Police & Institutions of the British Empire, by Capt. Pasley of the Engineers, a book which I protested against at first, but which upon trial I find delightfully written & highly

entertaining. I am as much in love with the Author as I ever was with Clarkson or Buchanan, or even the two Mr Smiths of the city. The first soldier I ever sighed for; but he does write with extraordinary force & spirit.
JANUARY 24, 1813

Unlike the Austens, not every member of the Society actually read the books, as Jane noted pointedly. "I have disposed of Mrs Grant['s Letters] for the 2d fortnight to Mrs Digweed;—it can make no difference to her, which of the 26 fortnights in the Year, the 3 vols lay in her House." (February 9, 1813)

Sometimes more exciting reading material appeared at the Cottage when Jane's books were returned fresh from the printer. When *Pride and Prejudice* arrived, Miss Benn, a poor, middle-aged neighbor, was visiting for dinner and tea. They read the book aloud without telling her who the author was, Jane told Cassandra:

*I want to tell you that I have got my own darling Child from London… Miss Benn dined with us on the very day of the Books coming, & and in the even[in]g we set fairly at it & read half the 1st vol. to her… & I beleive it passed with her unsuspected.—She was amused, poor soul! that she cd [could] not help, you know, with two such people to lead the way; but she really does seem to admire Elizabeth. I must confess that I think her as delightful a creature as ever appeared in print, & how I shall be able to tolerate those who do not like **her** at least, I do not know.*
JANUARY 29, 1813

The Austens confined their socializing, for the most part, to such quiet occasions, Caroline said. After sitting and working in the morning, Jane and Cassandra generally took a walk: "Sometimes they went to Alton for shopping—Often, one or the other of them, to the Great House—as it was then called—when a brother was inhabiting it, to make a visit—or if the house were

standing empty they liked to stroll about the grounds—sometimes to Chawton Park—a noble beech wood, just within a walk—but sometimes, but that was rarely, to call on a neighbor—They had no carriage, and their visitings did not extend far… they were upon *friendly* but rather *distant* terms with all." The Prowtings family were among the neighbors that Jane did enjoy visiting. Chawton villagers often used to see Jane climb the stile at the bottom of the Austens' garden and cross the field to visit her friends the three Misses Prowting. Occasionally Jane did feel herself obliged to accept an invitation to a party:

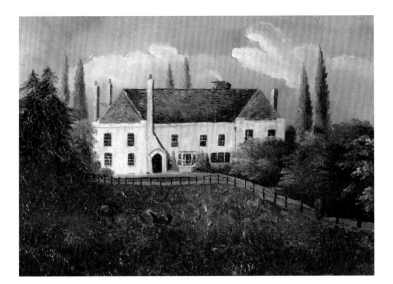

> *Our party on Wednesday [at the Reverend Papillon's house] was not unagreable, tho' as usual we wanted a better Master of the House, one less anxious & fidgety, & more conversible… We were Eleven altogether… As soon as a Whist party was formed & a round Table threatened, I made my Mother an excuse, & came away; leaving just as many for* their *round Table, as there were at Mrs. Grant's [in Mansfield Park].—I wish they might be as agreable a set.—It was past 10 when I got home, so I was not ashamed of my dutiful Delicacy.*

JANUARY 24, 1813

The fidgety Mr. Papillon was the bachelor rector of Chawton, who became a running joke in the Austen family after Mrs. Knight suggested that he might be a good marriage prospect for Jane: "I am very much obliged to Mrs Knight for such a proof of the interest she takes in me—& she may depend upon it, that I <u>will</u> marry Mr Papillon, whatever may be his reluctance or my own—I owe her much more than such a trifling sacrifice." (December 9, 1808)

The Austens regularly attended the Reverend Papillon's Sunday morning services at St. Nicholas church, just up the road next to Chawton House. Only the chancel of the current building would be recognizable to Jane Austen today, as the church was rebuilt after being heavily damaged by fire in 1871. Two of Frank

and Mary Austen's children were christened at the church, and Henry Austen was made curate of Chawton in 1817, the year Jane died. Henry had been ordained following his failure at banking (see London). Jane admired his sermons, joking to her nephew James Edward, "Uncle Henry writes very superior Sermons.—You & I must try to get hold of one or two, & put them into our Novels…

ABOVE TOP Prowtings, Chawton, unknown artist, undated.
ABOVE St. Nicholas Church and Chawton House Library, Chawton.

and we could make our Heroine read it aloud of a Sunday evening…" (December 16, 1816)

Jane's days at the Cottage began to draw to a close as her health started break down in early 1816. "I believe Aunt Jane's health began to fail some time before we knew she was really ill," Caroline wrote, remembering that Jane "used often to lie down after dinner." Mrs. Austen, now in her late 70s, used the only sofa in the drawing room when she was tired:

Aunt Jane laid upon 3 chairs which she arranged for herself—I think she had a pillow, but it never looked comfortable—She called it her sofa, and even when the other was unoccupied, she never took it… I worried her into telling me the reason of her choice—which was, that if she ever used the sofa, Grandmama would be leaving it for her, and would not lie down, as she did now, whenever she felt inclined.

Her precise ailment is unknown, but many theories have been put forward, including Hodgkin's lymphoma, cancer, recurrent typhus, tuberculosis, and even arsenic poisoning. The most common theory, based on her symptoms, is that she suffered from Addison's Disease, a disease of the adrenal glands, which at that time was fatal. The disease is often made worse by stress, and indeed her symptoms of occasional back pain and extreme weakness waxed and waned for some months, made worse after emotional stress or a shock such as Henry Austen's bank failure, followed by gradual periods of recovery, as Jane acknowledged to Cassandra:

Thank you, my Back has given me scarcely any pain for many days.—I have an idea that agitation does it as much harm as fatigue, & that I was ill at the time of your going, from the very circumstance of your going.—I am nursing myself up now into as beautiful a state as I can, because I hear that Dr White means to call on me before he leaves the Country.
SEPTEMBER 8, 1816

In spite of her fatigue, Jane continued to write cheerful letters to family and friends, and began a new novel, her last work, on January 27, 1817. She could still laugh at her own situation: in

LEFT The window in Jane Austen's Bedroom overlooks the courtyard at Chawton Cottage. OPPOSITE The upstairs landing at Chawton Cottage.

she felt better and she even ventured out for the gentle exercise of a donkey ride, she told Caroline on March 26: "I have taken one ride on the Donkey & like it very much—& you must try to get me quiet, mild days, that I may be able to go out pretty constantly.— A great deal of Wind does not suit me, as I have still a tendency to Rheumatism.—[In] short I am a poor Honey at present. I will be better when you can come & see us." In early April, Caroline and Anna, who was now married, called on Jane:

> She was keeping her room but said she would see us, and we went up to her—She was in her dressing gown and was sitting quite like an invalide in an arm chair—but she got up, and kindly greeted us—and then pointing to seats which had been arranged for us by the fire, she said, "There's a chair for the married lady, and a little stool for you, Caroline."—It is strange, but those trifling words are the last of her's that I can remember… She was not equal to the exertion of talking to us, and our visit to the sick room was a very short one—Aunt Cassandra soon taking us away—I do not suppose we stayed a quarter of an hour; and I never saw Aunt Jane again.

Beginning in mid-April Jane was confined to her bed for several weeks. Mr. Curtis, the Alton apothecary, was unable to cope with her condition and Mr. Lyford, a surgeon from Winchester, was called in. Jane was worried enough that she made her will on April 27, but Mr. Lyford's treatments gradually provided her some relief. She wrote to her good friend Anne Sharp, a former governess at Godmersham, on May 22: "I am going to Winchester… for some weeks to see what Mr Lyford can do farther towards re-establishing me in tolerable health… My dearest Cassandra with me I need hardly say—And as this is only two days off you will be convinced that I am now really a very genteel, portable sort of Invalid."

On May 24 Jane and Cassandra traveled the sixteen miles to Winchester, Jane's last journey, in James and Mary Austen's coach, accompanied by Henry Austen and Edward's son, William.

Sanditon she places the heroine at a seaside health resort among a trio of comical hypochondriacs. She wrote to Fanny on February 20, "I am almost entirely cured of my rheumatism; just a little pain in my knee now & then, to make me remember what it was, & keep on flannel.—Aunt Cassandra nursed me so beautifully!" She soon began to feel weak again, though, suffering from a feverish attack attended by facial discoloration in March, and writing her last sentence of *Sanditon* on March 18. There were still periods when

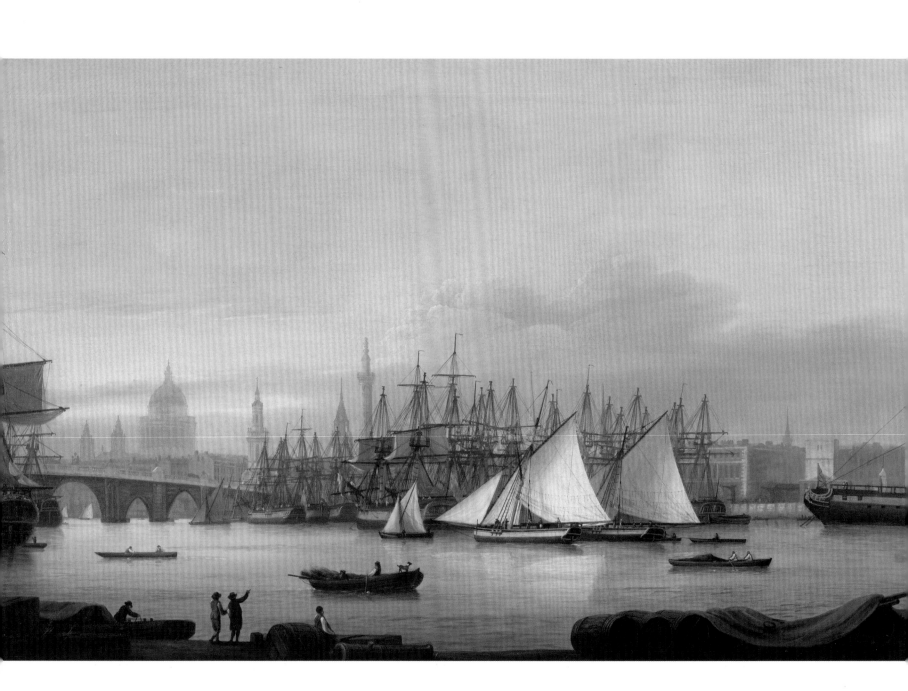

The Port of London, by Thomas Luny, 1798.

AT HOME WITH JANE AUSTEN

LONDON

"It is very right that you should go to town; I would have every young woman of your condition in life, acquainted with the manners and amusements of London."

MRS. DASHWOOD IN SENSE AND SENSIBILITY

Jane Austen first visited London in 1788 when she was only twelve years old. On the way back to Hampshire from visiting her great-uncle Francis Austen in Kent, Jane, her parents, and fifteen-year-old Cassandra stopped in London to break their journey. They dined with Mr. Austen's sister, Mrs. Hancock, and her daughter, Eliza de Feuillide, but presumably stayed in a hotel. They may have taken the time to show the girls a little bit of the city and "the Amusements so various and pleasing in London," as Jane called them in her youthful story "Lesley Castle." Many of the characters in her juvenilia pieces, which she began writing about this time, yearn to go to London. In one of her later stories, "Catherine: Or the Bower," Catherine's (Kitty) aunt and guardian looks "upon London as the hot house of vice where virtue had long been banished from society and wickedness of every description was daily gaining ground," and refuses to let Kitty go there. "Kitty… was the last girl in the world to be trusted in London, as she would be totally unable to withstand temptation." When Jane and her brothers Edward and Frank next visited London on the way to Kent in 1796, Jane knew that Cassandra would appreciate the joke, writing to her, "Here I am once more in this Scene of Dissipation & vice, and I begin already to find my Morals corrupted." Jane, then 20 years old, and Edward and Frank, 28 and 22 respectively, enjoyed a London entertainment highly popular with young people. "We are to be at Astley's to night, which I am glad of," Jane wrote. (August 23) Astley's Amphitheatre, near Westminster Bridge, featured displays of daring horsemanship and grand spectacles especially suited to entertaining the young. It makes an appearance in *Emma*, where John Knightley's young sons and Harriet Smith and Robert Martin "were all extremely amused." The young Austens stayed in Cork Street, possibly at a hotel, or possibly with Benjamin Langlois, an uncle of their Lefroy neighbors.

On Jane's future visits to London she stayed with her brother Henry, who had set up as an banker and an army agent in London in 1801. Henry had married his widowed cousin Eliza de Feuillide in 1797, and the couple lived at a series of fashionable London houses, all but one of which still stands. Henry's first house was 24 Upper Berkeley Street (now a hotel), but though Cassandra stayed with Henry and Eliza in 1801, there does not seem to be any record of Jane visiting Henry in London until mid-May 1808. At that time the couple were living at 16 Michael's Place (now

Geo. Jones del.

ARENA *of* ASTLEY's AMPHITHEATRE, *SURREY ROAD*.

Wise sculp.

ABOVE Detail, *The Arena of Astley's Amphitheatre, Surrey Road*, 1815. OPPOSITE Hans Place and Sloane Street area,
from *Plan of the Cities of London and Westminster the Borough of Southwark and Parts Adjoining*, by Richard Horwood, 1795.

AT HOME WITH JANE AUSTEN

placed her characters' houses accordingly. Her richer characters such as the Bingleys in *Pride and Prejudice*, the Rushworths in *Mansfield Park*, and the John Dashwoods, the Palmers, and Mrs. Jennings in *Sense and Sensibility*, live to the west and northwest of the city. But Elizabeth Bennet's uncle and aunt Gardiner, who live "within view of his own warehouses" in the commercial eastern side of London, are in a much less fashionable area, making it unlikely that Mr. Bingley will visit there, as Elizabeth knows: "Mr. Darcy would no more suffer [Mr. Bingley] to call on Jane in such a part of London! My dear aunt, how could you think of it? Mr. Darcy may perhaps have *heard* of such a place as Gracechurch Street, but he would hardly think a month's ablution enough to cleanse him from its impurities, were he once to enter it."

Beginning in 1811, Jane made repeated trips to London to take care of the practical business of getting her novels published, staying with Henry, who acted as her agent. In 1809 Henry and Eliza, increasingly affluent as Henry's business prospered, had moved to 64 Sloane Street, an elegant house near Hans Place. They and their house were looked after by Eliza's French servants, Madame Bigeon, the housekeeper, and her daughter Madame Perigord. Henry and Eliza included Jane in their social activities, which Jane for the most part seems to have enjoyed, especially the smaller gatherings with special friends. "We drank tea again yesterday with the Tilsons, & met the Smiths," she wrote to Cassandra. "I find all these little parties very pleasant." (April 18, 1811) Henry and Eliza Austen also held a large musical soirée with professional musicians, including a harpist and three glee singers, similar to the scene in *Sense and Sensibility*, where Elinor and Marianne Dashwood attend a musical party that "like other musical parties, comprehended a great many people who had real taste for the performance, and a great many more who had none at all; and the performers themselves were, as usual, in their own estimation, and that of their immediate friends, the first private performers in England." The event was a success, Jane reported:

redeveloped), in the western suburban village of Brompton. Jane stayed with them a month, taking in the sights, including seeing "the ladies go to Court on the 4th." The Austens, like most of the gentry of London, chose to live to the northwest and west of the city proper. The prevailing winds blew east toward the city, leaving the elegant terraces and squares to the west relatively free of city soot and fumes. Development of the areas where the Austens lived was new enough that many of the houses were surrounded by fields and farms. The district was famous for its nurseries and other commercial gardens that supplied the great markets of London. *Walks Through London* (1817) said that the area had "the appearance of a continual garden, with extensive nurseries of trees of various kinds; while the sides of the roads being enlivened by meadows and genteel residences of every description, the whole forms a picture of ease and happiness highly gratifying." Jane evidently took notes during her visits about the fashionable addresses of London and

Our party went off extremely well. There were many solicitudes, alarms & vexations, beforehand of course, but at last everything was quite right. The rooms were dressed up with flowers &c, and looked very pretty… At ½ past 7 arrived the Musicians in two Hackney coaches, & by 8 the lordly Company began to appear… The Draw[in]g room being soon hotter than we liked, we placed ourselves in the connecting Passage, which was comparatively cool & gave us all the advantage of the Music at a pleasant distance, as well as that of the first veiw of every new comer.—I was quite surrounded by acquaintance, especially Gentlemen… Including everybody we were 66—which was considerably more than Eliza had expected, & quite enough to fill the Back Draw[in]g room & leave a few to be scattered about in the other, & in the passage.— The Music was extremely good… All the Performers gave great satisfaction by doing what they were paid for, & giving themselves no airs… The house was not clear till after 12.
APRIL 25, 1811

In her next letter she gave Cassandra more details, including her pleasure at being praised by an acquaintance attending the party: "My head dress was a Bugle band like the border to my gown, & a flower of M^rs Tilson's.—I depended upon hearing something of the Even[in]g from M^r W[yndham] K[natchbull]—& am very well satisfied with his notice of me. 'A pleasing looking young woman';—that must do;—one cannot pretend to anything better now—thankful to have it continued a few years longer!" (April 30, 1811) 64 Sloane Street still stands, encased in newer Victorian facing and with an additional storey added, but looking at the rear of the house, the shape of the octagonal back drawing room where the musicians played can still be seen.

Jane made the most of her trips to London, taking advantage of the opportunity to see the sights, attend the theater, and shop. During one visit to Henry, she went to the Liverpool Museum and the British Gallery. "I had some amusement at each," she wrote to Cassandra, "tho' my preference for Men & Women, always inclines

LEFT *The Interior of the British Institution Gallery,* by John Scarlett Davis, 1829.
RIGHT *New Covent Garden Theatre,* by John Bluck and Thomas Rowlandson, 1810.

AT HOME WITH JANE AUSTEN

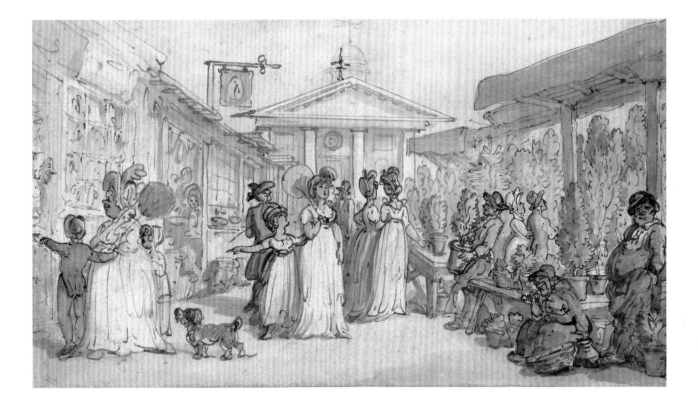

me to attend more to the company than the sight." (April 18, 1811) She spent many hours shopping and fulfilling commissions, including tea from Twinings and dishes from Wedgwood for her family. She seemed to enjoy hunting for bargains and having new clothes and bonnets made up for herself and Cassandra. "I am sorry to tell you that I am getting very extravagant & spending all my Money; & what is worse for <u>you</u>, I have been spending yours too," she told Cassandra. "I was very well satisfied with my purchases, my Bugle Trimming at 2/4d & 3 pr [pair] silk Stock[in]gs for a little less than 12./S a pr [pair]… Mrs. Burton has made me a very pretty little Bonnet—& now nothing can satisfy me but I must have a straw hat, of the riding hat shape… I am really very shocking; but it will not be dear at a Guinea.—Our Pelisses are 17/S each." (April 18, 1811)

In spite of all her activities and busy life in London, Jane remained focused on the most important thing: her work. "No indeed, I am never too busy to think of S&S [*Sense and Sensibility*]," she wrote to Cassandra. "I can no more forget it, than a mother can forget her sucking child… I have had two sheets to correct, but the last only brings us to W.s first appearance… I have scarcely a hope of its being out in June.—Henry does not neglect it; he <u>has</u> hurried the Printer, & says he will see him again today." (April 25, 1811) Eliza became ill in 1813, and Jane returned that April to stay with her until Eliza's death following her "long & dreadful Illness." Jane returned yet again in May to help Henry settle Eliza's affairs.

The newly widowed Henry moved in June to 10 Henrietta Street, above his banking offices in the Covent Garden area. The faithful Mme Bigeon and Mme Perigord lived out, but continued

LEFT TOP City of Westminster Green Plaque at 10 Henrietta Street, one of Henry Austen's London houses.

LEFT Door of 10 Henrietta Street.

ABOVE The entrance to Twinings in London looks much as it did when the Austens bought their tea there.

OPPOSITE LEFT *Tugging at a Eye-Tooth,* by George Cruikshank, 1821.

OPPOSITE RIGHT *Drury Lane Theatre,* by Thomas Rowlandson, from *The Microcosm of London,* 1808.

to care for Henry. Jane stayed there a few days with Edward and his family as they all traveled from Chawton to Godmersham and was pleased with Henry's new quarters, writing to Cassandra, "This house looks very nice. It seems like Sloane S^t moved here." (September 15, 1813) Writing to Frank, she said, "N° 10 is made very comfortable with Cleaning, & Painting & the Sloane S^t-furniture. The front room upstairs is an excellent Dining & common sitting parlour—& the smaller one behind will sufficiently answer his purpose as a Draw[in]g room.—He has no intention of giving large parties of any kind." (September 25, 1813) While at Henrietta Street, Jane and the others experienced the usual whirlwind round of shopping, theater-going, as well as the unpleasant chore of taking Edward's girls to the dentist. The dentist cleaned and filed their teeth, "putting in gold & talking gravely," Jane reported. "Poor Marianne had two taken out after all… we heard… two sharp hasty Screams… I would not have had him look at mine for a shilling a tooth & double it.—It was a disagreable hour." (September 16, 1813) She returned in March, probably to superintend the publication of *Mansfield Park.* Her letters to Cassandra are full of details of their busy London life. We see her reading

The Corsair (Lord Byron's newest work) and attending the theater several times, including seeing the famous Edmund Kean in *Shylock*: "We were quite satisfied with Kean. I cannot imagine better acting, but the part was too short, & excepting him & Miss Smith, & <u>she</u> did not quite answer my expectation, the parts were ill filled & the Play heavy." (March 6, 1814) A few days later the pace had begun to tire her out, she wrote: "Well, we went to the Play again last night, & as we were out [a] great part of the morning too, shopping & seeing the Indian Jugglers, I am very glad to be quiet now till dressing time. We are to dine at the Tilsons & tomorrow at M^r Spencers." (March 9, 1814) 10 Henrietta Street still stands, but the ground floor has been converted to retail space, and the interior altered substantially.

That summer Henry moved into his final London home at 23 Hans Place, on an open, airy garden square just west of his old house in Sloane Street. Behind the house there was a pleasant garden, complete with greenhouse. "It is a delightful Place—more than answers my expectation," Jane reported to Cassandra. "Having got rid of my unreasonable ideas, I find more space & comfort in the rooms than I had supposed." Henry's study was on the garden side

AT HOME WITH JANE AUSTEN

of the house, which Jane very much appreciated during her visits. "The garden is quite a love," she wrote to Cassandra. "I live in his room downstairs, it is particularly pleasant, from opening upon the garden. I go & refresh myself every now & then, and then come back to Solitary Coolness." (August 23, 1814) She returned briefly in the autumn to discuss a second edition of *Mansfield Park*, and again in the autumn of 1815, her last visit to London, to discuss the sale of *Emma* to a new publisher, John Murray. "M^r Murray's Letter is come," she wrote Cassandra, "he is a Rogue of course,

but a civil one. He offers £450- but wants to have the Copyright of MP. & S&S included. It will end in my publishing for myself I daresay.—He sends more praise however than I expected. It is an amusing Letter." (October 17, 1815)

Meanwhile, Henry had fallen ill with a "bilious attack with fever." Charles Haden, a local apothecary and surgeon, treated him with calomel, a harsh, mercury-based laxative, and bled him copiously for three successive days. Perhaps not surprisingly, Henry's condition worsened rapidly, and for some time Jane feared for his life. He gradually improved, however, and Jane stayed in London until December 16, caring for him and correcting the proof sheets for *Emma*. "It was during this stay in London," her niece Caroline later wrote, "that a little gleam of Court favor shone upon her." It appears that a physician, called in on Henry's case, was also a physician to the Prince Regent and had informed the prince of Jane's presence in London. The prince admired her novels, he said, and kept a set of her books in each of his royal residences. Such prominent attention and notice did not necessarily please Jane. Like her previous novels, *Emma* was to be published anonymously. The title page of her first novel, *Sense and Sensibility*, had read "By a Lady," and those of her subsequent books had read merely "by the author of "Sense and Sensibility," or "by the author of "Pride and Prejudice," &c. &c." But in spite of all her precautions, and to her annoyance, Jane had found herself gradually becoming known as an author. The secret had been slowly leaking out, thanks to Henry, loving but overenthusiastic, who acted not only as her literary agent but also as her self-appointed publicist. She had written to Frank in amused exasperation when she heard that Henry had given away the secret, yet again: "*Henry* heard P&P [*Pride & Prejudice*] warmly praised in Scotland, by *Lady Rob[er]t*

OPPOSITE TOP LEFT Rear of Henry and Eliza Austen's house at 64 Sloane Street, showing the octagonal room where their musical evening party was held. OPPOSITE BOTTOM LEFT English Heritage Blue Plaque at Henry Austen's house at 23 Hans Place. OPPOSITE RIGHT Central garden square of Hans Place. LEFT Georgian houses in Hans Place.

Kerr & another Lady; and what does he do in the warmth of his Brotherly vanity & Love, but immediately tell them who wrote it!—A Thing once set going in that way—one knows how it spreads!—and he, dear Creature, has set it going so much more than once… I am trying to harden myself." (September 25, 1813) To be lionized as a famous author was far from her wish, yet it seemed as though visiting Henry in London continually brought her the very sort of notice she wished to avoid. Informed during an earlier visit that a particular woman was anxious to meet her, she wrote, "I should like to see Miss Burdett very well, but that I am rather frightened by hearing that she wishes to be introduced to me. If I am a wild Beast, I cannot help it. It is not my own fault." (May 24, 1813) Many of her fellow female authors published anonymously to conform to the prevailing societal opinion that writing novels wasn't quite an acceptable occupation for a lady, but it seems clear that Jane, far from feeling forced to bow to social pressure, really preferred the anonymity. While staying another time with Henry after the publication of her third novel, *Mansfield Park*, she had even turned down an invitation to meet the famed author Madame de Staël, which would surely have drawn her into literary circles had she desired it.

But now the Prince Regent himself had expressed his admiration for her works and had sent his librarian, the Reverend James Stanier Clarke, with an invitation for her to tour his London palace, Carlton House, and see his gothic-style library. If Jane recorded her impressions of the prince's exceptionally ornate palace, the letter has unfortunately not survived. Through Clarke the prince gave his permission, which amounted to a royal command, for one of her future works to be dedicated to him. Jane, though no great admirer of the profligate man who would become George IV, felt herself obliged to accept, and dedicated *Emma* to him. The Reverend Clarke amused Jane greatly by peppering her afterward with enthusiastic suggestions for the types of books she might write. Perhaps, he wrote to her, a history based on the royal house of Saxe-Cobourg (that of the future husband of the Princess Charlotte, heiress to the throne), would be popular, or what about a novel based on the life of a clergyman such as himself? Her polite and kindly responses to him, full of suppressed mirth, give us a great deal of insight into her ideas of her own role and abilities as an author. "I could not sit seriously down to write a serious Romance under any other motive than to save my Life," she wrote to him, "& if it were indispensable for me to keep it up & never relax into laughing at myself or other people, I am sure I should be hung before I had finished the first Chapter." No historical romances or moral tales, though they "might be much more to the purpose of Profit or Popularity" could be written by her, she told Clarke. "No—I must keep to my own style & go on in my own Way; And though I may never succeed again in that, I am convinced that I should totally fail in any other." (April 1, 1816)

Misfortunes continued to plague Henry Austen. A postwar economic decline led to the failure of first his Alton and then his London banking partnerships, plunging him into relative poverty. He gave up his London house, and the following year took holy orders, spending the rest of his life quietly as a well-respected clergyman. Henry's house still stands in Hans Place today, though its facade was redone in red Victorian brick, a story was added, and the garden was destroyed when a new street went through. Later division into flats further altered the interior, but it is thought that Henry's study, which Jane so enjoyed, remains relatively unchanged.

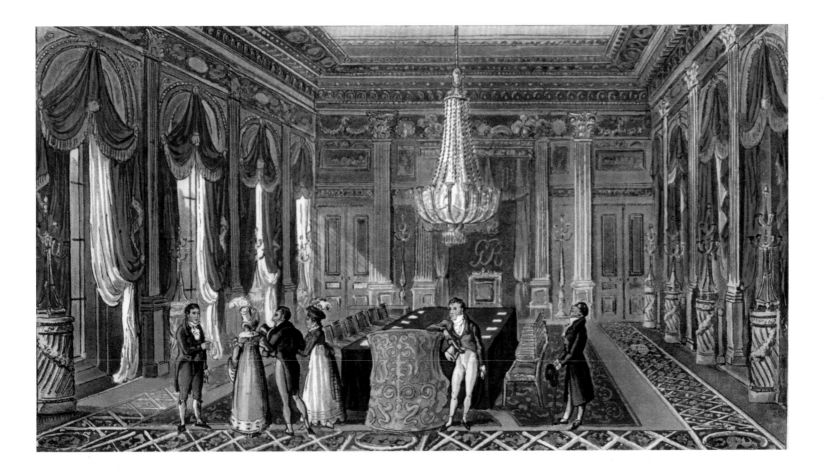

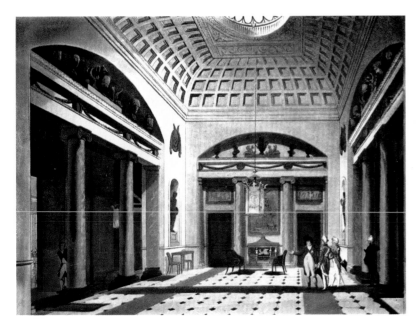

ABOVE *The "Ne Plus Ultra" of "Life in London".—Kate, Sue, Tom, Jerry, and Logic viewing the Throne-room at Carlton Palace,* by Isaac and George Cruikshank, from *Life in London,* by Pierce Egan, 1821.
LEFT *The Hall, Carlton House,* by Thomas Rowlandson, from *The Microcosm of London,* 1808.

WINCHESTER

If ever you are ill, may you be as tenderly nursed as I have been, may the same Blessed alleviations of anxious, simpathizing friends be Yours, & may you possess—as I dare say you will—the greatest blessing of all, in the consciousness of not being unworthy of their Love.

LETTER FROM JANE AUSTEN TO JAMES EDWARD AUSTEN, MAY 27, 1817

Jane and her family escort arrived in Winchester on the rainy afternoon of May 24, 1817, to the lodgings at Mrs. David's house, 8 College Street, where she was to spend her final eight weeks. Her good friend Elizabeth Bigg of Manydown Park, now the widowed Mrs. Heathcote, lived in Winchester (where her son was attending school), and had made the arrangements for the Austens. The lodgings were on the first floor (second American) and were very comfortable, Jane wrote to James Edward in her last complete letter: "We have a neat little Draw[in]g-room with a Bow-window overlooking D͏ͬ Gabell's Garden." The first few days in Winchester were encouraging, she said:

I will not boast of my handwriting; neither that, nor my face have yet recovered their proper beauty, but in other respects I am gaining strength very fast. I am now out of bed from 9 in the morn[in]g to 10 at night—Upon the Sopha t'is true—but I eat my meals with Aunt Cass: in a rational way, & can employ myself, & walk from one room to another.—M͏ͬ Lyford says he will cure me, & if he fails I shall draw up a Memorial & lay it before the Dean & Chapter, & have no doubt of redress from that Pious, Learned & Disinterested Body.

MAY 27, 1817

Her attendant, Giles King Lyford, whose treatments had helped her in Chawton, was the Surgeon-in-Ordinary at the County Hospital in Winchester, and had a thriving private practice in Winchester as well. Jane's continued improvements persuaded him to allow her outdoors, she wrote to a friend (only the copy of a fragment survives; the recipient was probably Mrs. Tilson, Henry's London neighbor) in late May: "My attendant is encouraging, and talks of making me quite well. I live chiefly on the sofa, but am allowed to walk from one room to the other. I have been out once in a sedan-chair, and am to repeat it, and be promoted to a wheel-chair as the weather serves. On this subject I will only say further that my dearest sister, my tender, watchful, indefatigable nurse, has not been made ill by her exertions. As to what I owe to her, and to the anxious affection of all my beloved family on this occasion, I can only cry over it, and pray to God to bless them more and more." At the end of the letter, her usual humor reasserted itself: "You will find Captain _____ a very respectable, well-meaning man, without much manner, his wife and sister all good humour and obligingness, and I hope (since the fashion allows it) with rather longer petticoats than last year." (May 28–29, 1817)

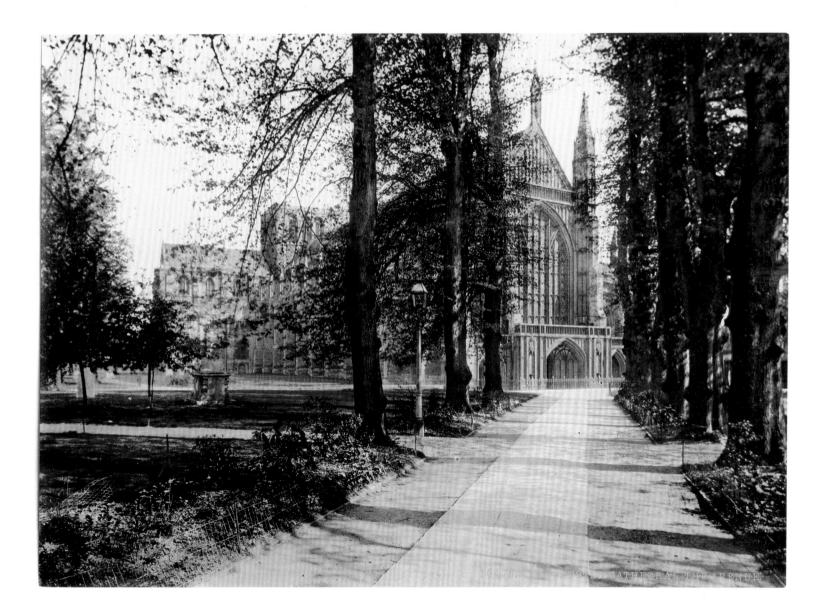

Winchester Cathedral, circa 1890–1900.

Jane's improvements unfortunately proved temporary and she had a dangerous relapse. Mr. Lyford privately told Mary Lloyd Austen, who had arrived to help care for Jane, that her sister-in-law's case was hopeless. James Austen wrote to his son, James Edward, at Oxford: "I grieve to write what you will grieve to read; but I must tell you that we can no longer flatter ourselves with the least hope of having your dear valuable Aunt Jane restored to us. The symptoms which returned after the first four or five days at Winchester, have never subsided, and Mr. Lyford has candidly told us that her case is desperate. I need not say what a melancholy gloom this has cast over us all." He and Henry attended Jane constantly in her lodgings, and Charles made a flying visit from London to see her "for the last time in this world as I greatly fear." Frank appears to have stayed in Chawton to comfort Mrs. Austen. Toward the end of June she again experienced some improvement, enough that Mary Lloyd Austen returned home to Steventon, only to return again a few days later because the nurse had been found falling asleep at night instead of watching her patient. Remarkably, Jane kept up her spirits, Caroline wrote: "Aunt Jane continued very cheerfully and comfortable… Her sweetness of temper never failed her; she was considerate and grateful to those who attended on her, and at times, when feeling rather better, her playfulness of spirit prevailed, and she amused them even in their sadness." On Tuesday, July 15, a rainy St. Swithin's Day, Jane even dictated some comic verses to Cassandra about the Winchester races and the likelihood that the old saint would curse them with rain: " … These races and revels and dissolute measures / With which you're debasing a neighboring Plain / Let them stand—You shall meet with your curse in your pleasures / Set off for your course, I'll pursue with my rain…"

That evening her condition worsened again, and she declined rapidly, dying in the early morning hours of July 18, her head pillowed in Cassandra's lap.

Cassandra wrote of her loss to Fanny, "I have lost a treasure, such a Sister, such a friend as never can have been surpassed,—

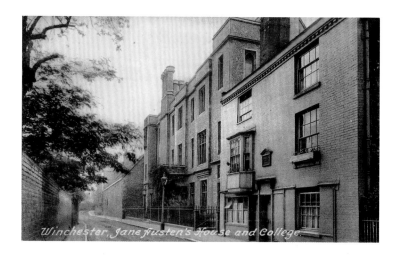

She was the sun of my life, the gilder of every pleasure, the soother of every sorrow, I had not a thought concealed from her, & it is as if I had lost a part of myself… Her dear remains are to be deposited in the Cathedral—it is a satisfaction to me to think that they are to lie in a building she admired so much." (July 20) The funeral was held on July 24, attended only by Jane's brothers Edward, Henry, and Frank and nephew James Edward, who went in his ill father's stead. Cassandra and Mary did not attend, according to the custom of the times, but Cassandra wrote to

ABOVE Jane Austen's final home, 8 College Street, Winchester, 1906 and today.

Fanny, "I was determined I would see the last… I watched the little mournful procession the length of the Street & when it turned from my sight, & I had lost her forever—even then I was not overpowered, nor so much agitated as I am now in the writing of it.—Never was human being more sincerely mourned by those who attended her remains than was this dear creature." (July 29, 1817) Jane's body was interred in the north aisle of the nave of Winchester Cathedral. A memorial stone was laid, engraved with words that told of her family's loss, but made no mention of her literary accomplishments, and only obliquely alluded to her exceptional abilities:

In Memory of
JANE AUSTEN,
youngest daughter of the late
Rev^d GEORGE AUSTEN,
formerly Rector of Steventon in this County.
She departed this Life on the 18th of July 1817,
aged 41, after a long illness supported with
the patience and the hopes of a Christian.
The benevolence of her heart,
the sweetness of her temper, and
the extraordinary endowments of her mind
obtained the regard of all who knew her and
the warmest love of her intimate connections.
Their grief is in proportion to their affection,
they know their loss to be irreparable,
but in their deepest affliction they are consoled
by a firm though humble hope that her charity,
devotion, faith and purity have rendered
her soul acceptable in the sight of her
REDEEMER.

In her will Jane left everything she owned to Cassandra, except £50 each to Henry and Madame Bigeon. It must have been some satisfaction to her that after so many years of dependence on her family, she was in a position to leave a modest but useful inheritance, the earnings from her writings, to her sister. Mrs. Austen, Cassandra, and Martha Lloyd continued to live together in Chawton Cottage until Mrs. Austen's death in 1827 at the age of 87. The following year Martha Lloyd left to marry the widowed Frank Austen as his second wife. Cassandra lived on at the Cottage alone until her death in 1845 at the age of 72. Jane's fond nieces and nephews missed their aunt greatly. Caroline, remembering that during Jane's life "not to have found Aunt Jane at Chawton, *would* have been a blank indeed!" recalled that one of her cousins "after he was grown up, used occasionally to go and see Aunt Cass[andr]a—*then* left sole inmate of the old house… His visits were always a disappointment to him—for that he could not help expecting to feel particularly happy at Chawton and never till he got there, could he fully realise to himself how all its peculiar pleasures were gone—"

ABOVE Jane Austen's gravestone in Winchester Cathedral.

ABOVE Set of Royal Mail stamps issued in 2013 to celebrate the 200th anniversary of the publication of *Pride and Prejudice*.

FURTHER INFORMATION

JANE AUSTEN SOCIETIES

Jane Austen Society (United Kingdom)
www.janeaustensoci.freeuk.com

Jane Austen Society of North America
www.jasna.org

Jane Austen Society of Australia
jasa.com.au

Jane Austen Society of Melbourne
home.vicnet.net.au/~janeaust

Jane Austen Book Club of Buenos Aires
www.facebook.com/groups/614970275188470

Jane Austen Society of Brazil
www.janeaustenbrasil.com.br

Jane Austen Society of the Netherlands
www.janeaustensociety.nl

Jane Austen Society of Italy
www.jasit.it

LIBRARIES WITH JANE AUSTEN COLLECTIONS

Chawton House Library
www.chawton.org

Goucher College, Jane Austen Collection
www.goucher.edu

British Library
(Virtual copy of *The History of England*)
www.bl.uk/onlinegallery/ttp/austen/accessible/introduction.html

Bodleian Library, Oxford
www.bodleian.ox.ac.uk

Morgan Library and Museum
("Jane Austen's Life and Legacy")
www.themorgan.org/exhibitions

Jane Austen'sFiction Manuscripts
www.janeausten.ac.uk

JANE AUSTEN'S ENGLAND

Jane Austen's House Museum, Chawton
www.jane-austens-house-museum.org.uk

Chawton Village, Hampshire
www.chawton.info

Jane Austen Centre (Bath, England)
www.janeausten.co.uk

North Waltham, Steventon,
Ashe & Deane History Society
www.nwsadhs.co.uk

Hampshire County Council
Jane Austen Website
www3.hants.gov.uk/austen

Literary Winchester
literarywinchester.co.uk/?p=534

Jane Austen Trail
www.winchesteraustentrail.co.uk

Jane Austen Places: The Astoft Gallery
www.astoft.co.uk/austen

Old Hampshire Mapped
www.geog.port.ac.uk/webmap/hantsmap

What Jane Saw (recreation of the 1813
Joshua Reynolds exhibition viewed by Jane Austen)
www.whatjanesaw.org

REFERENCE SITES

18th-Century Common –18th century studies
www.18thcenturycommon.org

Molland's (includes e-texts of all Austen's novels)
www.mollands.net

Write Like Jane Austen – an Austen thesaurus
www.writelikeausten.com

OTHER JANE AUSTEN SITES

Abbeville Press—facsimile editions of Austen's juvenilia
abbeville.com

Jane Austen Project (Oxford, England)
www.janeaustenproject.org

Republic of Pemberley
www.pemberley.com

Jane Austen Books
janeaustenbooks.net

Juvenilia Press—includes special editions
of Austen's juvenilia
www.arts.unsw.edu.au/juvenilia

Jane Austen's Regency World Magazine
janeaustenmagazine.co.uk

Pia Frauss's downloadable Jane Austen font
www.pia-frauss.de/fonts/ja.htm

BIBLIOGRAPHY

JAS *is the Jane Austen Society*
JASNA *is the Jane Austen Society of North America*

Allen, Louise. *Walking Jane Austen's London: A Tour Guide for the Modern Traveller.* Botley, Oxford: Shire Publications, 2013.

Atkinson, Edmund. "Jane Austen and Sussex" (1977). JAS *Collected Reports* (1976–1985).

Austen, Caroline. *My Aunt Jane Austen: A Memoir.* Winchester: JAS Memorial Trust, 1952, 1991.

_____. *Reminiscences of Jane Austen's Niece.* Revised ed. Winchester: JAS, 2004.

Austen, Jane. *Jane Austen's Letters.* 4th ed. Collected and edited by Deirdre Le Faye. Oxford: Oxford University Press, 2011.

_____. *The Novels of Jane Austen.* Edited by R.W. Chapman. 5 vols. 3d ed. London: Oxford University Press, 1932–34.

_____. *Minor Works.* Edited by R.W. Chapman. Vol. 6 of *The Novels of Jane Austen.* London: Oxford University Press, 1954.

Austen-Leigh, Emma. *Jane Austen and Lyme Regis.* Colchester: Ballantyne Press, 1941.

Austen-Leigh, James Edward. *A Memoir of Jane Austen and Other Family Recollections.* Edited by Kathryn Sutherland. New York: Oxford University Press, 2002.

Austen-Leigh, Joan. "Chawton Cottage Transfigured." JASNA *Persuasions* 4 (1982).

_____. "New Light Thrown on JA's Refusal of Harris Bigg-Wither." JASNA *Persuasions* 8 (1986).

Austen-Leigh, William and Richard Arthur Austen Leigh. Revised and enlarged by Deirdre Le Faye. *Jane Austen: A Family Record.* Boston: G. K. Hall & Co., 1989.

Beresford, James. *The Miseries of Human Life.* London: William Miller, 1806.

Bowden, Jean K. *Jane Austen's House.* Norwich: Jane Austen Memorial Trust, 1994 and 1996.

_____. "Living in Chawton Cottage." JASNA *Persuasions* 12 (1990).

Bown, Joyce. "The Village of Steventon." JASNA *Persuasions* 19 (1997).

Brade-Birks, S. Graham. *Jane Austen and Godmersham.* West Malling, Kent: Kent County Library and Kent County Council, reprint, 1984.

Brears, Peter, *Jane Austen's House, Chawton. Report on the Restoration of the Kitchen.* July 2004.

Britton, John and Edward Wedlake Brayley. *The Beauties of England and Wales.* London: Vernor & Hood, 1802.

Buchan, William, M.D. *Domestic Medicine: Or, A Treatise on the Prevention and Cure of Diseases by Regimen and Simple Medicines,* 14th ed. London: A. Strahan and T. Cadell, 1794.

Bussby, Frederick. *Jane Austen in Winchester.* Winchester: The Friends of the Winchester Cathedral, 1969.

Byrne, Paula. "'The unmeaning luxuries of Bath': Urban Pleasures in Jane Austen's World." JASNA *Persuasions* 26 (2004).

Cantrell, D. Dean. "A Visit to Jane Austen's Last Home." JASNA *Persuasions* 18 (1996).

_____. "The Eccentric Edifice." JASNA *Persuasions* 8 (1986).

Caplan, Clive. "Jane Austen's Banker Brother: Henry Thomas Austen of Austen & Co., 1801–1816." JASNA *Persuasions* 20 (1998).

Carpenter, T. Edward. *The Story of Jane Austen's Chawton House.* Alton, Hampshire: Jane Austen Memorial Trust, n.d.

[Clark, Edward Daniel.] *A Tour through the South of England, Wales, and Part of Ireland, Made During the Summer of 1791.* London: R. Edwards, 1793.

Copeland, Edward. "*Persuasion*: The Jane Austen Consumer's Guide." JASNA *Persuasions* 15 (1993).

Corley, T.A.B. "Jane Austen and her brother Henry's bank failure 1815–16" (1998). JAS *Collected Reports* (1996–2000).

_____. "Jane Austen's School days" (1996). JAS *Collected Reports* (1996–2000).

_____. "Mrs. Sherwood's Secrets: Jane Austen's boarding–school at Reading in the 1790s." JAS *Report* (2009).

Cottam, Graeme, Susie Grandfield, Sarah Parry, and Helen Scott. *Chawton House Library.* Great Britain: Chawton House Library, 2005.

Cowper, William. *Poems.* London: F. C. and J. Rivington, 1820.

Davis, Michael. "The Skins of Number Four" (2004). JAS *Collected Reports* (2001–2005).

Edmonds, Antony. *Jane Austen's Worthing: The Real Sanditon.* Stroud, Gloucestershire: Amberley Publishing, 2013.

Edwards, Anne-Marie. *In the Steps of Jane Austen.* Madison, Wisconsin: Jones Books, 2003.

Englefield, Sir Henry C. *A Walk Through Southampton.* Southampton: Baker and Fletcher, 1805.

[Feltham, John.] *A Guide to All the Watering and Seabathing Places.* London: Longman, Hurst, etc., 1803.

_____. *A Guide to All the Watering and Seabathing Places.* London: Longman, Hurst, etc. 1813.

Freeman, Jean, *Jane Austen in Bath.* Alton, Hampshire: JAS, 1969.

Greet, Carolyn S. "Jane and Cassandra in Cheltenham" (2003). JAS *Collected Reports* (2001–2005).

Grigsby, Joan. "The House in Castle Square" (1978). JAS *Collected Reports* (1976–1985).

Hill, Constance. *Jane Austen: Her Homes and Her Friends,* new ed., London and New York: John Lane, 1904.

Howells, William Dean. *Heroines of Fiction, Volume I.* New York and London: Harper & Brothers Publishers, 1901.

Hughes-Hallett, Penelope. "Growing Up in Steventon." JASNA *Persuasions* 14, 1992.

Hughson, David. *Walks Through London.* London: Sherwood, Neely, and Jones, 1817.

Hurst, Jane. *Jane Austen and Chawton: A Walk around Jane Austen's Chawton.* Privately printed, 2009.

_____. *Jane Austen and Alton: A Walk around Jane Austen's Alton,* rev. ed. Privately printed., 2011.

Huxley, Victoria. "Adlestrop and the Austen connection: the Leigh family." JAS *Report* (2011).

_____. *Jane Austen & Adlestrop: Her Other Family.* Adlestrop, Gloucestershire: Windrush Publishing, 2013.

_____. "The Trials and Tribulations of living in Jane Austen's House" (2001). In JAS *Collected Reports* (2001–2005).

Ibbetson, Laporte, and J. Hassell. *A Picturesque Guide to Bath.* London: Hookham and Carpenter, 1793.

Kaleque, S. M. Abdul. "Jane Austen's Idea of a Home," JASNA *Persuasions On-line* 26., no. 1 (2005).

Kulisheck, Patricia Jo. "Steventon Parsonage." JASNA *Persuasions* 7 (1985).

Lane, Maggie. *A Charming Place: Bath in the Life and Novels of Jane Austen.* Bath: Millstream Books, reprint, 2000.

_____. *Jane Austen and Lyme Regis.* Alton, Hampshire: JAS, 2003.

_____. "Jane Austen's Bath." JASNA *Persuasions* 7 (1985).

Lawrence, Robert Heathcote. "Jane Austen at Manydown" (1994) JAS *Collected Reports (1986–1995).*

"The lease of No. 4 Sydney Place," *Bath Chronicle,* May 21, 1801. Quoted in Jean Freeman, *Jane Austen in Bath.*

Le Faye, Deirdre. *A Chronology of Jane Austen and her Family.* Cambridge: Cambridge University Press, 2006.

_____. "The Austens and their Wedgwood Ware," (2005) JAS C*ollected Reports* (2001–2005).

_____. "The Austens and the Littleworths" (1987). JAS *Collected Reports* (1986–1995).

Lefroy, Fanny Caroline. "Hunting for snarkes at Lyme Regis." *Temple Bar: A London Magazine for Town and Country Readers* 57 (1879).

Lefroy, Helen and Gavin Turner, eds. *The Letters of Mrs Lefroy: Jane Austen's Beloved Friend.* Winchester: JAS, 2007.

"Letter from a young gentleman on his travels, to his friends in America, June 8, 1808." *The Portfolio* 3 (1810).

Lipscomb, George. *A Journey Into Cornwall, Through . . . Southampton, Wilts, Dorset, Somerset & Devon.* London: H. Sharpe, 1799.

Loudon, John C. *An Encyclopaedia of Gardening.* London: Longman, Hurst, etc., 1824.

"Mercure Southampton Centre Dolphin Hotel— a brief history." www.dolphin-southampton.com.

The New Bath Guide; or Useful Pocket Companion. Bath: R. Cruttwell, 1799.

Nicholson, Nigel. *Godmersham Park, Kent: Before, During and After Jane Austen's Time.* Alton, Hampshire: JAS, 1996.

_____. "Jane Austen's Houses in Fact and Fiction." JASNA *Persuasions* 14 (1992).

Northcote, Walter Stafford, 2nd Earl of Iddesleigh. "A Chat About Jane Austen" *The Nineteenth Century* 47 (1900).

Notes on key conclusions from Historic Building Survey prior to Development 2008, Jane Austen's House Museum.

Oulton, W. C., *The Traveller's Guide; or English Itinerary.* London: James Cundee, 1805.

Piggott, Patrick. "Jane Austen's Southampton Piano" (1980). JAS *Collected Reports* (1976–1985).

Proudman, Elizabeth. *The Essential Guide to Finding Jane Austen in Chawton.* JASNA, 2003.

Quin, Vera. *Jane Austen Visits London.* Great Malvern: Cappella Archive, 2008.

Ray, Joan Klingel and Richard James Wheeler. "James Stanier Clarke's Portrait of Jane Austen." JASNA *Persuasions* 27 (2005).

Reading Mercury, 22 July 1793, quoted in Robin Vick, "Rural Crime."

_____. 19 August 1793, quoted in Robin Vick, "Rural Crime."

Repton, Humphry. *Observations on the Theory and Practice of Landscape Gardening.* London: T. Bensley, 1803.

Sanderson, Caroline. *A Rambling Fancy: In the Footsteps of Jane Austen.* London: Cadogan Guides, 2006.

Sarin, Sophie. "The Floorcloth and Other Floor Coverings in the London Domestic Interior 1700–1800." *Journal of Design History* 18, no. 2 (2005).

Sheppard, F.H.W. (General Editor). "Henrietta Street and Maiden Lane Area: Henrietta Street." In *Survey of London: volume 36: Covent Garden.* British History Online, www.british-history.ac.uk.

Sherwood, Mary Martha. *The Life and Times of Mrs. Sherwood.* Edited by F. J. Harvey Darton. London: Wells Gardner, Darton & Co., 1910.

_____. *The Life of Mrs. Sherwood.* Edited by Sophia Kelly. London: Darton and Co., 1857.

Simond, Louis. *Journal of a Tour and Residence in Great Britain During the Years 1810 and 1811.* Edinburgh: Archibald Constable and Company, 1815.

"A simple experiment to prevent the dreadful effects of sleeping in a damp bed." *The European Magazine: And London Review* 18 (1790).

Slothouber, Linda. "Elegance and Simplicity: Jane Austen and Wedgwood." JASNA *Persuasions* 31 (2009).

Smithers, David Waldron. "Where Was Rosings?" (1981). JAS *Collected Reports* (1976–1985).

Southam, Brian C. "Jane Austen beside the Seaside: An Introduction." JASNA *Persuasions* 32 (2010).

_____. "Jane Austen beside the Seaside: Devonshire and Wales 1801–1803." JASNA *Persuasions* 33 (2011).

Strasbaugh, Joan. *The List Lover's Guide to Jane Austen.* Naperville, Illinois: Sourcebooks, 2013.

Sutherland, Eileen. " 'A little sea-bathing would set me up forever': The History and Development of the English Seaside Resorts." JASNA *Persuasions* 19 (1997).

_____. "Tithes and the Rural Clergyman in Jane Austen's England." JASNA *Persuasions* 16 (1994).

A tour through England: described in a series of letters, from a young gentleman to his sister. London: Tabart and Co., 1806.

University of Southampton. "Research project: The Austen Family Music Books: A major study of domestic music making in Jane Austen's family." www.southampton.ac.uk/music.

Vick, Robin. "The Alton Book Society" (1994) JAS *Collected Reports* (1986–1995).

_____. Jane Austen's House at Chawton" (1995) JAS *Collected Reports* (1986–1995).

_____. "Rural Crime" (1996). JAS *Collected Reports* (1996–2000).

_____. "The Sale at Steventon Parsonage (1993). JAS *Collected Reports* (1986–1995).

Walker, Linda Robinson. "Why Was Jane Austen Sent Away to School at Seven? An Empirical Look at a Vexing Question." JASNA *Persuasions On-line* 26, no. 1 (2005).

Warner, Richard. *Excursions from Bath.* Bath: R. Cruttwell, 1801.

Watson, Winifred. *Jane Austen in London.* Alton, Hampshire: JAS, 1960.

Welland, Freydis Jane. "The History of Jane Austen's Writing Desk." JASNA *Persuasions* 30 (2008).

White, John. *Recollections of John White.* In Caroline Austen, *My Aunt Jane Austen.*

Wilson, Kim. *In the Garden with Jane Austen,* new ed. London: Frances Lincoln, 2009.

_____. *Tea with Jane Austen,* new ed. London: Frances Lincoln, 2011.

Wilson, Margaret. "Austen and Tunbridge Ware" (2001). JAS *Collected Reports* (2001–2005).

AT HOME WITH JANE AUSTEN

DEDICATION

For Ellie and Aina

Note on the text:
Jane Austen's original, occasionally idiosyncratic spelling (for example, she often substituted "ei" for "ie"), capitalization, and punctuation appear unchanged in this book. Some abbreviations have been expanded for clarity.

ACKNOWLEDGMENTS

My first thanks are due to the many members of the Jane Austen Society, the Jane Austen Society of North America, and other Jane Austen societies around the world, whose careful research and publications have been so helpful to my work. The work of three scholars in particular has been invaluable: Maggie Lane's meticulous research into the world of Jane Austen and the places in her life, T.A.B. Corley's fascinating research into Jane's and Cassandra's time at the Reading Abbey School, and Deirdre Le Faye's painstaking and thorough collection and analysis of Austen's letters and Austen family papers and history, without which we would have a very incomplete picture of Jane Austen's life.

Thanks also go to Mary Guyatt and Isabel Snowden of Jane Austen's House Museum and Sarah Parry, Paul Dearn, and Ray Moseley of Chawton House Library for their patient assistance and valuable advice; Celia Simpson of Jane Austen's House Museum for her tour of the Museum's garden and Tom Carpenter, also of the Museum, who gave me my first tour and shared with me the story of the tea caddy in the dining room cupboard; David Standing, for his tour of the garden at Gilbert White's House; Mr. and Mrs. John Sunley of Godmersham Park and Greg Ellis, also of the Park, for his tour of the gardens there; the staff of Stoneleigh Abbey; Isil Caiazza of Bath Boutique Stays for advising me about the interior of 4 Sydney Place in Bath; author Antony Edmonds for sharing with me his research and insights into the Worthing and Sanditon connection; architectural historian Jeremy Musson for his advice about English country houses; Linda Slothouber of JASNA for teaching me about Wedgwood breakfast sets; Dr. Cheryl Kinney for sharing with me her insights about Regency medicine and Jane Austen's illness, and Joyce Bown, for her warm and welcoming tour of Steventon, St. Nicholas Church, and Deane.

Many thanks to the following for their assistance with pictures: the Banknote Education Team of the Bank of England; Damaris Brix; Loretta Chase of the Two Nerdy History Girls blog; Joy Hanes of Hanes and Ruskin Antiques; Judy and Brian Harden; author Candice Hearn of candicehearn.com; Graham Davies of the Lyme Regis Museum; Natalie Manifold of Jane Austen Tours; Kristen Mcdonald and Susan Walker of the Yale Lewis Walpole Library; Martin and Jean Norgate of the Old Hampshire Mapped website www.geog.port.ac.uk/webmap/hantsmap/; the Press Office of the Royal Mail; Blair Rogers; Lucy Ryder and Gemma Sampson of Bath Tourism Plus; and Allan Soedring of astoft.co.uk.

Warm thanks also to the outstanding publication team without whom this book would not have been possible: Andrew Dunn and Anna Watson of Frances Lincoln Publishers, Joan Strasbaugh of Abbeville Press, Caroline Clark of Caroline Clark Design, and Gavin Kingcome, who took such beautiful pictures.

And of course, as always, loving thanks to Charlie, Ellie, and Aina.